Praise for *You Must Stand Up*

"Meticulously researched and compulsively readable, *You Must Stand Up* documents in searing detail the challenges and horrors of the post-*Roe* landscape. This is required reading for anyone trying to make sense of our current moment." —Melissa Murray, author of #1 *New York Times* bestseller *The Trump Indictments: The Historic Charging Documents with Commentary*

"*You Must Stand Up* documents post-*Roe* America with care and nuance; it's a necessary book for anyone who cares about the attacks on our bodies. Amanda Becker's vivid retelling of on-the-ground activism reminds readers not only of what's at stake—but what it takes to win." —Jessica Valenti, author of *New York Times* bestseller *Sex Object: A Memoir* and founder of *Abortion, Every Day*

"In this sprawling, enraging, and ultimately galvanizing book, Amanda Becker looks at post-*Roe* America: the devastation, but also the determination; the tsunami of challenges; and the many, many women and men who rose to meet them with unrivaled courage and creativity. *You Must Stand Up* tells the definitive story of what happened when the national right to abortion ended in America—and, more importantly, looks to some of the nation's most heroic women to show us all what comes next." —Jill Filipovic, author of *OK Boomer, Let's Talk: How My Generation Got Left Behind* and *The H-Spot: The Feminist Pursuit of Happiness*

"Amanda captures a critical moment in the history of abortion rights in the United States and tells an astounding story about how outrage can be a vehicle for change even when the most powerful court in the country turns its backs on the most vulnerable of us." —Camonghne Felix, author of *Dyscalculia: A Love Story of Epic Miscalculation* and *Build Yourself a Boat*

"In this urgent chronicle of the year after *Dobbs v. Jackson*—the case that overturned *Roe*—Becker shadows a collection of individuals fighting courageously for reproductive rights . . . Her conversational tone and expertise on her subject matter render this . . . a beautifully crafted, thoroughly researched account of the state of reproductive rights after the Dobbs decision." —*Kirkus Reviews* (starred review)

You Must Stand Up

*The Fight for Abortion Rights in Post-*Dobbs *America*

Amanda Becker

BLOOMSBURY PUBLISHING

NEW YORK · LONDON · OXFORD · NEW DELHI · SYDNEY

BLOOMSBURY PUBLISHING
Bloomsbury Publishing Inc.
1385 Broadway, New York, NY 10018, USA

BLOOMSBURY, BLOOMSBURY PUBLISHING, and the Diana logo are
trademarks of Bloomsbury Publishing Plc

First published in the United States 2024

Bloomsbury Publishing Plc does not have any control over, or responsibility for, any
third-party websites referred to or in this book. All internet addresses given in this
book were correct at the time of going to press. The author and publisher regret any
inconvenience caused if addresses have changed or sites have ceased to exist,
but can accept no responsibility for any such changes.

ISBN: HB: 978-1-63973-186-2; EBOOK: 978-1-63973-187-9

LIBRARY OF CONGRESS CATALOGING IN PUBLICATION DATA IS AVAILABLE

Library of Congress Control Number: 2023951235

2 4 6 8 10 9 7 5 3 1

Typeset by Westchester Publishing Services
Printed and bound in the U.S.A.

To find out more about our authors and books visit www.bloomsbury.com
and sign up for our newsletters.

Bloomsbury books may be purchased for business or promotional use. For
information on bulk purchases please contact Macmillan Corporate and Premium
Sales Department at specialmarkets@macmillan.com.

For Raylan and Wesley,
for whom I want everything

And for Dennis and Linda,
to whom I owe everything

When I dare to be powerful, to use my strength in the service of my vision, then it becomes less important whether or not I am unafraid.

—AUDRE LORDE

CONTENTS

A NOTE ON SOURCES

On several occasions, I use only the first names of people who work in clinical settings where abortion is provided. These individuals are very proud of what they do, full stop. They nevertheless—or at my suggestion—decided that they were not ready for their full names to be forever googleable and synonymous with working for an abortion provider. As you will find out, if you don't know already, there is reason for concern, given how individuals in this role have been targeted both recently and historically.

AUTHOR'S NOTE

I was on an annual family beach trip in Florida when *Politico* magazine, shortly after 8:30 P.M. on May 2, 2022, broke the news that the Supreme Court was poised to overturn *Roe v. Wade.*

I read the story, then scanned conservative Justice Samuel Alito's draft decision in *Dobbs v. Jackson Women's Health Organization.*

I knew immediately that in just a few weeks, our country would be thrust into a period of seismic change. I knew it would likely be the most important story I'd ever cover as a journalist. I knew I wanted to do the story justice. That impetus led to this book.

I would, right off the bat, before you become immersed in their stories of unflinching fortitude, like to acknowledge the added burden that my reporting of this book placed on the people in it, and at a time when they were dealing with unprecedented challenges in their work and lives.

As one clinic worker told me early on: "The world is gawking at our trauma." The observation stuck with me as I reported and wrote about our first year in nearly fifty without a federal right to an abortion. I *was* gawking at their trauma and, by extension, intending to offer my readers the opportunity to do the same. I justified this to myself for the same reason that many individuals in this book spoke

to me: For many Americans, specifically but not limited to American women, living through the definitive loss of reproductive rights has been a collective trauma. Recording this moment in our history is a form of bearing witness to that shared trauma. It was nevertheless always in the back of my mind that I should tread as lightly as possible on the lives of others during this pivotal first year.

One in four American women will get an abortion in their lifetime—data shows they are likely to already be a mother, to have some college education, and to be unmarried, and they are often low income. You might be one of these women—or you might be someday. Women who get abortions are your friends, partners, sisters, aunts, mothers, and grandmothers.

The American Psychological Association has defined collective trauma as stemming from "an event or series of events that impact not only one person but also a group of identified or targeted people." To heal these wounds "is a challenge that requires supporting each other, and fighting together to achieve social justice," an association presidential task force concluded. The title of this book, *You Must Stand Up*, quotes Dr. Gabrielle Goodrick, whose work in Arizona you will read about in these pages—it is an homage to the type of response to a shared traumatic event that paves the way for a path forward.

You might, at some point as you read about the responses of Goodrick and others to the assault on reproductive rights in the first year after *Dobbs*, notice that the abortion buzz words you see elsewhere are largely missing from this text. "Pro-life," for example, is an identifier that the antiabortion movement has successfully lobbied the news media to use, as it serves their purpose. I have therefore declined to use it, along with "pro-choice," the analog often used to describe the abortion-rights movement. I use "the antiabortion movement" and "the abortion-rights movement." It is more specific, accurate language, and I believe that word choice matters.

You might also note that aside from direct quotes and paraphrases related to strategic thinking, I do not typically use the word "women" as a stand-in for people capable of giving birth. Not only can individuals who identify as men or nonbinary become pregnant, this book is about what the loss of reproductive rights portends writ large for the bodily autonomy of people marginalized due to their gender. For this reason, I have gravitated toward the use of "patients" or other identifiers for those seeking abortion care, with the full knowledge that one reason for the enactment of restrictive abortion policies is misogyny.

The *Dobbs* decision unleashed a not-yet-quantifiable level of chaos and disquiet for the Americans whose bodies and lives were newly ripe for religious and political regulation. I am forever grateful to the people who let me into their worlds during this time of extraordinary upheaval. These are their stories, and I hope they feel I have honored them. Any shortcomings are my own.

Amanda Becker
April 2024

Summer 2022

"STOP."

Alabama

TUSCALOOSA—Robin Marty was live on CNN's Headline News from her gabled attic home office discussing what could happen if the U.S. Supreme Court overturned *Roe v. Wade* when two texts came in from a lawyer advising the abortion clinic she runs in Tuscaloosa.

First: "Fuck."

Then: "STOP."

"And . . . I actually have to go because the Supreme Court just overturned *Roe v. Wade*, and I need to tell my staff," Marty said as she turned her attention to her cell phone just off-screen.

"Okay, we are still working to confirm this, but we do know that the Supreme Court has issued . . . a major abortion ruling," the HLN anchor said as the network cut to a live feed of a crowd gathered in front of the barricaded steps to the court.

"We are indeed getting . . . getting information that the Supreme Court has indeed overturned *Roe v. Wade*," the anchor finished.

It was 10:12 A.M. EDT on Friday, June 24, 2022, when, with the court's release of a 213-page PDF on its website, the world changed for the country's roughly 168 million women. Really, it changed for all 333 million of us. In the coming days and weeks, it would become clear just how much.

The Supreme Court's 6–3 decision in *Dobbs v. Jackson Women's Health Organization* ended the federal right to abortion care up until the point of fetal viability. This right had been protected by the court's 1973 ruling in *Roe* for almost fifty years. The 2022 conservative court said that going forward, the matter would be left up to the states. Robin Marty's home state of Alabama was one of as many as twenty-six where abortion was expected to be fully or functionally illegal when *Roe* fell.

Marty is someone who, in her own words, is known in the reproductive health space for her "ridiculous ability to see what's going to happen five years down the road." Back in 2013, she co-published a book that was predicated on the premise that *Roe* would, at some point in the not too distant future, no longer be the law of the land. Her world view—and forecasting ability—are grounded in the years Marty spent covering the antiabortion movement. She started during the explosion of the liberal blogosphere in the early 2000s, and honed her focus when she wrote for Rewire News Group, which launched in 2006 as a blog named *RH Reality Check*, then, in 2012, became a nonprofit national publication covering reproductive health and rights.

Marty embedded with the antiabortion movement for so long, she not only knew their strategy playbook, but became close to its leaders—Americans United for Life sent her flowers when her mother died; the wife of the founder of the Pro-Life Action League mailed her Christmas cards. They didn't see eye to eye on abortion—or a lot of other things—but they all knew one another, and those personal

relationships meant something. Marty felt safe writing about the future of abortion through the lens of reproductive justice without worrying that "antis," as she calls them, would target her in ways that felt scary. Things got a bit trickier, though, when she moved from writing about reproductive health care to directly supporting and facilitating abortion, first for an abortion fund, and then for the West Alabama Women's Center, where she's now the executive director. In that capacity, Marty has become more careful about giving out her address, or even posting photos on social media that might reveal too much about her life—she doesn't want her house picketed, or worse.

Marty's caution was warranted. Before her arrival in Tuscaloosa, the West Alabama Women's Center had burned to the ground, shots were fired through its window, and bomb threats were made against it. Long before she began working directly for the center, Marty already knew, on some level, that trying to keep a reproductive health care clinic open in a post-*Roe* world in the U.S. South would be a Sisyphean task.

"Five years down the road," she told me, "there's not going to be any place like us, or not very many."

Since the leak of the *Dobbs* decision the month before, the clinic had been operating on each known Supreme Court decision day as if it could be the final one for legal abortion in Alabama. They opened early to check in groups of patients seeking medication abortions who had already completed the state-mandated forty-eight-hour waiting period—that way, they could administer the first drug that starts the process to as many of them as possible by 9 A.M. local time, when the Supreme Court begins posting its opinions online. Once a procedure was started, their lawyers advised, it could be completed.

The day before the *Dobbs* ruling—a Thursday, an opinion day— had gone like this: The clinic's full-time physician, Dr. Leah Torres,

was out of town dealing with a personal matter, so the clinic brought in a fill-in doctor, not willing to miss even one day with the final decision coming at any time. In the early morning hours, the clinic's front desk would start admitting groups of patients ten at a time. The patients would sit in an initial waiting area. Then, patients had their vitals taken. Next, they migrated to a larger, more comfortable waiting area where the doctor gave them the first of two pills typically used for medication abortions. As one group of patients finished, another took its place, and by the end of the day, a total of seventy patients had cycled through the process at the clinic in the nondescript, 1970s-era office park just a few turns from the University of Alabama's campus.

When the Supreme Court announced earlier that week that it would add Friday as a decision day—the court's term typically ends in June, and the justices were running out of time to release much-anticipated decisions, including *Dobbs*—the West Alabama Women's Center, a small clinic without its usual doctor, since Torres was out of town, decided it was too late to adjust course. They would move forward with their plan to do as many first-day appointments as possible on Friday to start the waiting period, then schedule the patients to return early Monday morning, a decision day, when Torres would be back.

Still, Marty warned HLN that if the court did decide *Dobbs* that Friday morning, she would have to cut her appearance short. So as she settled into her L-shaped desk in her attic office, with several of her kids' stuffed animals strewn across the floor and plenty of coffee in the mug she'd recently received from an anonymous supporter after the leaked draft—"I didn't punch anyone today!" a cute bear in front of a rainbow proclaimed—she positioned her laptop just off-screen from the desktop computer and camera she uses for television appearances. Her laptop was open to a Twitter account that tracks the release of Supreme Court opinions.

Then it happened, and the predetermined four-letter signal from her lawyer puts Marty's day—and the clinic's future—on a different course:

"STOP."

Off-camera, Marty read her texts, then pulled up SCOTUSblog, a website started by a husband-wife team of lawyers twenty years before that has become an indispensable resource for Supreme Court watchers. There, in boldface type, Marty sees the headline SUPREME COURT OVERTURNS CONSTITUTIONAL RIGHT TO ABORTION.

Marty called the clinic. There were already twenty-four patients there for their first-day appointments, to start the waiting period for a medical procedure no longer available to them. Now, they would have to go out of state, self-administer medication, or continue a pregnancy they did not want.

DURING THOSE FIRST post-*Dobbs* hours in Alabama, one thing was certain: Abortion was now illegal in the state. What was less clear was which law applied. Was it the Republicans' 2019 abortion ban—one of the most stringent in the country, which made providing abortion care a felony but was enjoined by the courts while *Roe* was in place? Or was it an 1841 law, enacted nearly eighty years before women could vote, that established potential jail sentences and fines? Or was it the 1951 update to that law, which reduced the crime of "procur[ing] the miscarriage" from a felony to a misdemeanor but could nevertheless still result in fines and a year in jail? In addition, Alabama voters had in 2018 approved a state constitutional amendment referred from the legislature that, among other things, stated "nothing in this Constitution secures or protects a right to abortion."

Figuring out which law applied in Alabama after *Roe* fell was important: The 1841 law, as updated in 1951, could expose the patient receiving the abortion, not just the health care provider, to a

misdemeanor charge; the 2019 law, meanwhile, reestablished that providing abortion care was a felony, punishable by up to ninety-nine years in prison, but stated that "no woman upon whom an abortion is performed or attempted to be performed shall be criminally or civilly liable."

The consensus that developed among the state's health care providers and the lawyers advising them was that the 1951 update to the 1841 law would be the one that immediately took effect if *Roe* fell. As Ivana Hrynkiw Shatara, who covered criminal justice and prisons for the Alabama Media Group, explained in a video Q&A the day before the *Dobbs* opinion was released: "Essentially we'd go from a 2022 environment back to that 1951 law" if *Roe* is overturned.

So, for a brief period that Friday morning in Alabama, time rewound seventy-one years.

"We knew that there was going to be a point in which we would have patients that we had booked that we were not going to be able to get their procedures, it was just inevitable," Marty told me later. "I talked to the staff and we decided that because we'd . . . already established a medical relationship—that to not follow through by allowing them at least the information to know where to go, would essentially be medical malpractice."

The leak of the *Dobbs* ruling had provided a window during which Marty and her colleagues at the West Alabama Women's Center were able to develop a post-*Roe* contingency plan. If they were able to get there, the paperwork of any patient who had already done their first-day appointment, or who was scheduled for an abortion in the days after *Dobbs*, would be sent to the Feminist Women's Health Center in Atlanta, about a three-hour drive east. When these patients called that clinic to schedule their appointments, it would activate the state-mandated twenty-four-hour waiting period there. In 2019, Georgia had passed its own six-week abortion ban, but due to *Roe*, it was enjoined by the courts, and it would end up being another month or

so before the injunction would be lifted. For now, the gestational limit on abortion in Georgia was 20 weeks, and the Feminist Women's Health Center had the capacity to take out-of-state patients.

TRAVELING OUT OF state to access abortion care is a dynamic that predated *Dobbs*. In 1992, the Supreme Court delivered a mixed opinion in the case *Planned Parenthood v. Casey* that reaffirmed *Roe*'s "essential holding" that abortion should remain mostly legal up until the point of fetal viability, but also opened the door to state regulation, so long as regulations did not create an "undue burden" to find abortion care. "An undue burden exists, and therefore a provision of law is invalid, if its purpose or effect is to place a substantial obstacle in the path of a woman seeking an abortion before the fetus attains viability," the majority opinion stated.

For the next three decades, legislatures in politically conservative states, particularly in parts of the Midwest and the South, restricted abortion access in a variety of increasingly creative ways. Some passed parental notification laws for minors, waiting periods and cutoffs based on the gestational age of the fetus. Many state laws fell into a category of politically motivated regulation known as TRAP laws, or the Targeted Regulation of Abortion Providers, which impose additional and medically unnecessary requirements—higher licensing fees; wider hallways—on the health care professionals who provide abortions and the facilities in which they work. Between 2011 and 2017, TRAP laws resulted in the closure of half of the abortion clinics in Arizona, Kentucky, Ohio and Texas, according to the Guttmacher Institute, a research and policy group that supports abortion rights, and is also a data source often cited by the antiabortion movement. Even when the regulations were repealed or struck down, as the Supreme Court did with some of Texas's TRAP laws in 2016, the clinics that closed in the meantime usually did not reopen. Between

2016 and 2021, 113 independent clinics shuttered nationwide. When independent clinics close, it is often devastating for abortion access overall: Pre-*Dobbs*, independent clinics provided the majority of abortion care in the country, according to the Abortion Care Network.

In other words, having to travel out of state for care was the intended effect of an antiabortion movement that spent fifty years making it more difficult for people to access abortion, in the places where they could, until they could bring a case like *Dobbs* to overturn *Roe* or pass a national ban. By 2016, oases of care had already developed in states abutting regions hostile to abortion. That year 13.4 percent of all of the abortions done by clinics in Georgia were for patients who came from out of state. In North Carolina, it was 16.8 percent. In Kansas—a Midwestern oasis—a striking 49.8 percent were for out-of-state residents. In 2020, these figures rose to 17.1 percent, 17.1 percent and 51.8 percent, respectively.

When *Dobbs* was decided, Alabama already had a number of regulations in place intended to either discourage its residents from seeking abortion care, make it more difficult for doctors to provide it, or both. Alabama was one of at least twenty-eight states that required abortion-specific informed consent for all patients. It was also one of twenty-seven states that required clinics to do an ultrasound prior to an abortion, even if not medically necessary, and offer the patient the opportunity to view it—though Alabama did not force health care providers to display or describe the image, or mandate that patients view the ultrasound or listen to their providers describe it, as states such as Kentucky and Tennessee did. Health insurance plans offered on Alabama's Affordable Care Act exchange could only cover abortion in cases of life endangerment, rape or incest.

Alabama lawmakers were able to enact many of these restrictions because, starting in the wake of the 2010 midterms, the state had what is known in political circles as both a Republican trifecta and a Republican triplex. In a government trifecta, one party controls

both chambers of the state legislature and the office of governor; in a triplex, one party controls the offices of governor, secretary of state, and the attorney general. Trifectas and triplexes grease the wheels of state government, making it easy for the party in control to pass bills they know will be signed into law, then defended by the state's lawyers in courts.

Republicans' history-making 2010 takeover in Alabama was part of a larger dynamic that played out across the country that year in the midterm elections, when first-term presidents nearly always see their party suffer losses, but Barack Obama's Democrats took what he called a "shellacking." It fueled an antiabortion shift in entire regions such as the South and the Midwest.

In those 2010 midterms, Republicans netted six more gubernatorial seats, seven more Senate seats, and 63 more House of Representatives seats, along with control of the lower chamber. Republicans picked up 680 state legislative seats to flip 20 chambers from Democratic control. "2010 will go down as a defining political election that will shape the national landscape for at least the next 10 years," the National Conference of State Legislatures predicted in a news release. A "devastating" development for Democrats, the *Los Angeles Times* reported, because the GOP would now have outsized control over redrawing the boundaries for state legislative and congressional districts in the once-a-decade redistricting process that follows the release of each U.S. census. NCSL noted that Republicans had indeed gained "unilateral control of the boundaries of 190 congressional districts." Two years later, in the next congressional elections, using mostly the district maps they'd just drawn, Republicans won 49 percent of all votes cast in House races but 54 percent of its 435 seats.

Republican successes in the 2010 midterms were energized by the nascent but already politically impactful Tea Party movement.

Obama took office amid the Great Recession, and the Tea Party's self-proclaimed origin story is that they united over their shared

opposition to Democrats' $700 billion economic recovery plan and a $75 billion fund to help homeowners facing foreclosure. In reality, the backlash could not be disentangled from the race of the country's first Black president. The Tea Party takeover coincided with a divergence in levels of racial resentment among White voters in the two political parties: the sentiment among Democrats started to plummet, whereas among Republicans it was on the rise. Political scientists measure racial resentment by asking White Americans "questions about how much they attribute socioeconomic disparities between Black and White Americans to slavery and racial discrimination or to a lack of hard work and perseverance by Black Americans," wrote Theodore Johnson at the Brennan Center, where he studied the role of race in politics. The determinant used as an indicator—perceived laziness—is a racist trope that can be traced all the way back to the country's founding in the writings of Thomas Jefferson, the country's third president.

The Tea Party was meant to be leaderless, a movement of, by and for the people, and many of its ideological figureheads and financial backers—including the Libertarian mega-donors Charles and David Koch—lamented the undercurrent of racism that had taken hold in the movement, particularly in the South, where research suggested Tea Partyers were younger, less educated, and were more motivated by bigotry than their Northern counterparts. "This is not a racist movement. We don't want you here. Go away if that's what you're about. We're about the fiscal issues," Tea Party Express chair Amy Kremer pleaded on ABC's The View. But the truth is, the type of social issues that leaders urged Tea Partyers to deemphasize—race, immigration, guns, abortion—were motivators for many within its ranks, and had been since the beginning, and not solely when they intersected with the movement's small government, states-rights ethos. Kremer would go on to co-found and co-chair Women for Trump.

You can trace the political throughline from the Tea Party's fiscal revolt to the more open battles over social issues that define the conservative wing of the Republican Party today through the woman thought to be the first Tea Partyer, Keli Carender. Back when the Tea Party began, Carender was a young teacher in Seattle, raised by parents who defected from the Democratic Party over its support for abortion access and moved West. Nevertheless, Carender told her followers on social media in 2012 that she was "into fiscal issues" and not focused on abortion. When she protested on the steps in front of the Supreme Court that year as it heard a case challenging Obama's eponymous health care law—"If we know how inefficient and inept the government is, why would you want it to make this decision for you?" she asked a *New York Times* reporter—she held a "Don't Tread on Me" Gadsden flag, borrowed by the Tea Party from the American Revolution. By the time the Supreme Court overturned *Roe*, Carender—who said she had not voted for Donald Trump in 2016 but would in 2020—referred to abortion as murder on the social media platform then called Twitter and urged conservatives to "save all videos and photographs of any abortion insurrectionists, so we can put them online and help the FBI arrest and detain them for years before their trials."

"The Tea Party revolution was also when all of the model abortion bills started," Marty recalled, "and you can't tread any harder than that."

If Obama had any chance of wooing voters like Carender, or others sympathetic to the Tea Party's small-government, fiscally conservative platform—and he likely didn't—it evaporated because of the health care law she hated so much. "Obama lies, grandma dies," "Obamacare is elderly genocide," "Obamacare makes me sick!" the Tea Partyers protested. Obama abandoned his campaign promise to codify abortion rights early on, and in the fight over the Affordable

Care Act, Democrats also jettisoned provisions crafted to protect abortion access in order to get the legislation over the finish line. Democrats emerged from negotiations victorious in early 2010 but badly bruised. Obama acknowledged the day after the party's devastating midterm losses just months later that a key reason was the "ugly mess" of a process getting it enacted, and said he would rebuild trust with voters. GOP leaders likewise started paying closer mind to the needs of their party's raucous right wing—*Newsweek* tallied that by mid-2017, House Republicans had tried to repeal or "otherwise undermine" Obamacare seventy times.

ALL OF THIS—the backlash to Obama's presidency, the conservative discontentment with the health care overhaul, the Tea Party's rise, the Republican tsunami in the 2010 midterms, the GOP's unilateral control over drawing district boundaries in many states during a time of increasing racial resentment in the party—is instructive for understanding the political climate in the decade before *Roe* fell.

After the Tea Party wave swept over federal and state legislatures, states passed more restrictions on abortion between 2011 and 2013 than they had in the entire previous decade. Republicans in Alabama and elsewhere were emboldened. In 2014, 2015, 2016, and 2017, for example, they tried—but failed—to enact what's known in the parlance of the antiabortion movement as a "fetal heartbeat" law. These laws were some of the most stringent types of bans in the pre-*Dobbs* era because they prohibited abortion once embryonic cardiac tissue starts to pulse, which is about six weeks into a pregnancy. This can occur before someone knows they are pregnant, or even before they notice they have missed a menstrual period. It is not the same as a heartbeat: A fetus does not develop heart chambers that can be detected on an ultrasound until 17 to 20 weeks of gestation, according to the American College of Obstetrics and Gynecologists.

As the explosion of antiabortion laws picked up, in large part thanks to "model legislation" being offered by antiabortion groups, Marty was writing about it daily for Rewire at a time when most mainstream news organizations weren't following it closely enough to connect the dots. "At that point we were the only ones who were covering that, we were the only ones saying 'hey this bill here in Missouri is the same as this bill in Iowa, and so we need to pay attention, this is a concerted effort to take down *Roe v. Wade*,'" Marty later said on the *Visible Voices* podcast.

At the same time, Republican lawmakers began making it more difficult to vote—the first such open push since Jim Crow. Between early 2011 and the 2012 election, at least 180 bills restricting voting were introduced in 41 states, and 27 of those laws were enacted in 19 states. Though many were challenged and blocked by the courts, the Brennan Center estimated in mid-2014 that new voting restrictions would be in place in 22 states that year, collectively making it harder for half the country to vote than in 2010. Republicans were more likely to enact new voting restrictions in states where voters of color, who are more likely to support Democrats, were turning out at increased rates. Of the 11 states where Black voters turned out at the highest rates in 2008, seven had new restrictions in place by 2014. Alabama brought a case that challenged a key provision of the 1965 Voting Rights Act—a landmark civil rights law that prohibited states from enacting voting restrictions that aimed to diminish the electoral power of minority voters—all the way to the Supreme Court. In 2013, Alabama won, and the justices gutted the law, with profound implications for voting nationwide.

Trump ran for the White House in 2016, promising to appoint judges and justices that would overturn *Roe*. Once he delivered on his promise—installing on the Supreme Court Neil Gorsuch in 2017, then Brett Kavanaugh in 2018—Republican-led states, including Alabama, rushed to enact even stricter abortion (and voting) laws, knowing they were likelier to be upheld if challenged. It was a race to

see which state could bring the case that would end nearly fifty years of federal abortion rights. When Trump appointed Justice Amy Coney Barrett to replace iconic liberal Justice Ruth Bader Ginsburg after her death in September 2020, it cemented the Supreme Court's 6–3 conservative majority.

But antiabortion forces had not waited for Coney Barrett, knowing a 5–4 conservative court might be willing to at least let a six-week ban, or a 15-week ban, stand. Mississippi in 2018 passed the 15-week ban that would eventually end up before the high court and undo *Roe*. The next year, conservative-led state legislatures passed twenty-five abortion bans that were signed into law, mostly in the South and the Midwest. Georgia, Kentucky, Louisiana, Mississippi, and Ohio passed so-called heartbeat laws. Missouri banned abortion at eight weeks. Arkansas and Utah banned abortion at 18 weeks. Indiana and North Dakota banned the most commonly used type of surgical abortions after 14 weeks. Arkansas, Kentucky, Missouri, and Utah banned abortion of a fetus known or suspected to have Down syndrome. Kentucky banned the abortion of a fetus diagnosed with any genetic anomaly. And Arkansas, Kentucky, and Missouri, along with Tennessee, also enacted abortion trigger laws, which would automatically and fully ban abortion if the Supreme Court ever overturned *Roe*. Alabama enacted a full ban that was put on hold by the courts.

Advocates for abortion access had a choice: Let the laws go into effect, or challenge them in court and buy some time, even if doing so could ultimately create an opening for the conservative Supreme Court to knock down *Roe*—a legal catch-22. Advocates challenged many of the laws, and lower courts blocked most from taking effect pending appeal. Abortion-hostile states waited to see which of them had built the vehicle to overturn *Roe*—including Alabama, which created a ban so draconian that even some antiabortion advocates wondered whether it effectively served their cause.

Alabama had a Republican trifecta and a Republican triplex when state Rep. Terri Collins introduced the "Human Life Protection Act" in April 2019. It was written by Eric Johnston, the president of the Alabama Pro-Life Coalition and an attorney who focuses on "constitutional law, particularly religion issues, freedom of speech, sanctity of life, and other individual freedoms." The bill mandated that "to perform" an abortion would become a Class A felony, equivalent to rape, or murder. Health care providers sentenced under the law could face ninety-nine years in prison. An "attempt" at performing an abortion would be a Class C felony. The bill's language compared abortion to Nazi concentration camps during the Holocaust, Joseph Stalin's forced-labor gulags and the Rwandan genocide. It included an exception if the mother's life is in jeopardy, but when Democratic Minority Leader Anthony Daniels offered an amendment to also add an exception for pregnancies resulting from rape or incest, Republicans rejected it.

Johnston and Collins thought that their law would be the preferred route to overturn *Roe* because if it made its way to the Supreme Court, it would force the justices to decide on the issue of abortion itself, not whether a gestational limit, or other exceptions or restrictions, comported with the court's decisions in *Roe* and *Casey*.

The Human Life Protection Act passed along party lines, with nearly all of Alabama's house Democrats walking out rather than participating in the process by voting against it. The GOP-controlled senate quickly followed, advancing it without a single Democratic vote. Then, in mid-May, Republican governor Kay Ivey signed the bill into law. A federal judge put it on hold before it could take effect, saying the ban "contravene[d] clear Supreme Court precedent." Johnston said that he anticipated that trial courts would find his law unconstitutional, "and then we are hopeful that the Supreme Court will agree to review the case."

Some prominent Republicans worried publicly that Alabama's law was too extreme to be the right case to overturn or circumscribe *Roe*, that it might be better to choose a law with more exceptions, more in step with the country, where polls consistently showed that two thirds of Americans, including nearly all Democrats and the vast majority of Republicans, believe that a pregnant person should have access to abortion in cases of rape or incest. In Alabama, which at the time was second only to Mississippi in rankings of the most politically conservative states in the country, 65 percent of its adult residents nevertheless supported legal access to abortion in cases of rape, incest, or risk to parental health.

After Alabama passed its ban, President Trump posted on the social media site then known as Twitter that he was "strongly Pro-Life with three exceptions—Rape, Incest and protecting the Life of the mother—the same position taken by Ronald Reagan." Conservative televangelist Pat Robertson, an abortion opponent and former GOP presidential candidate, said on his Christian newsmagazine show that "Alabama has gone too far" and called the law "extreme." "They want to challenge *Roe v. Wade*, but my humble view is that this is not the case we want to bring to the Supreme Court, because I think this will lose." Republican National Committee Chair Ronna McDaniel told CNN: "Personally, I would have the exceptions." Rep. Kevin McCarthy of California, then Republican minority leader in the U.S. House of Representatives, said Alabama's law went "further than I believe" and that he supported exceptions for rape, incest or the life of the mother—exceptions he erroneously said it was national Republicans' "official position," when the party's policy platform was silent on the issue.

Even Clarke Forsythe, who has focused his legal career on overturning *Roe* as a senior lawyer for Americans United for Life—the group that sent Marty a bereavement card—was skeptical that Alabama's full ban was the best route to do it. "I doubt whether the

justices want to be characterized [by the media] as approving the Alabama law," he told PBS's *Frontline*. "It would be easier for the court to re-examine *Roe* in a case with say, a 20-week limit or an informed consent law or an ultrasound law."

Ultimately, the Supreme Court avoided weighing in on Alabama's potentially unpalatable abortion ban by deciding *Dobbs* in Mississippi's favor and allowing its 15-week abortion ban to stand. But, in doing so, the justices in the majority also allowed every other abortion ban on hold because of *Roe*—including Alabama's—to take effect.

IN MARTY'S ATTIC office, she stared at Howe's headline: SUPREME COURT OVERTURNS CONSTITUTIONAL RIGHT TO ABORTION. She called the clinic and told the front desk that they needed to stop seeing patients due to the 1951 update to the 1841 law. "The pre-*Roe* ban, it wasn't just a punishment for the person that was doing the abortion, there was a misdemeanor charge against the person who was receiving the abortion—a thousand-dollar fine and up to one year in jail—so we needed to stop immediately because we were worried about any patient potentially, because we could see a possibility of the [state] attorney general coming in and asking to look at the files and 'Okay, so which patients? What's the time stamp? Were people still getting abortions that day?' "

After her call to the clinic, Marty went back on HLN: Live, emotional, raw. "It was basically me telling people . . . that people are still going to get abortions and that people need to do whatever is necessary in order to protect themselves. And then I got off." The clinic staff sent the patients waiting home, then they went home too. "They're all trying to process," Marty told the *Daily Beast*.

But Marty, who handled communications for the West Alabama Women's Center—a role that became increasingly common as

reporters from across the world preparing for *Dobbs* flooded clinics with requests—kept working. Text after text came in from reporters, including from a woman in California who had contacted her every single Supreme Court decision day since the leak to ask how many patients were at the clinic, and what the wait times were like. Marty would end up doing three dozen media interviews the day *Roe* fell, trying to explain the new reality for reproductive health in Alabama and beyond. The clinic would cancel more than a hundred appointments scheduled for the days ahead, referring them to the clinic in Atlanta or elsewhere.

Within hours of the *Dobbs* ruling, an Alabama judge lifted the injunction blocking the state's 2019 ban, superseding the 1951 update, and the Human Life Protection Act became law.

"And then it got a little dicey," Marty told me.

The following Monday, a Democrat in the Alabama state legislature called Marty with a friendly warning: The state attorney general was talking about applying the Alabama's criminal conspiracy statute to any individual, whether health care provider or friend, who helped someone travel out of state to get an abortion. The clinic was still closed that day, but after discussions among the staff, they decided to continue doing referrals from home until they were done with their patient list. They would regroup—and reopen—after the July Fourth holiday.

Days after the clinic reopened on July 11, Alabama attorney general Steve Marshall spoke to what one attendee called a "packed-out room" at a local meeting of the Federalist Society. The conservative legal group plays an influential role shaping legal theory at elite law schools, like at Harvard and Yale, and installing conservative jurists on the federal courts—every justice who signed the *Dobbs* ruling has been affiliated with FedSoc in some capacity. Marshall assured the group's Alabama members that he would unequivocally support all legal

efforts to stop abortion in any way he could using the power of his office, and existing bodies of law, whether it be maritime, administrative or criminal.

As the West Alabama Women's Clinic started to get back on its feet, the ground continued to shift—the first aftershocks in a remade landscape.

"Women are not without electoral or political power."

Washington

W ASHINGTON—The *Dobbs* decision was expected by many but still historic in its impact.

It overturned a long-held Supreme Court precedent by taking away a constitutional right instead of extending a new one.

It prompted the public's disapproval of the court to reach a record-breaking 49 percent.

And it unleashed chaos on the legal and healthcare systems, despite the opinion's author, Justice Samuel Alito, saying it would do the opposite.

At the time of oral arguments in *Dobbs* in December 2021, the Guttmacher Institute, a research and policy group that supports abortion rights, predicted that if *Roe* fell, as many as twenty-six states were certain or likely to ban abortion as quickly as possible. There were nine states that still had unenforced abortion bans on the books

from before *Roe*; there were 13 states that had what's called a "trigger ban" that would kick into effect if *Roe* was overturned; there were five states that had enacted strict abortion bans after *Roe* that were on hold while the ruling was in place; there were 12 states with six-week bans, including Texas, where it had already gone into effect; there was one state with an eight-week ban and there were four states with constitutions stating there is no right to an abortion. Several states had more than one type of abortion ban, some of which dated to before the Civil War—which was also, of course, decades before women in this country had the right to vote.

Three states—Kentucky, Louisiana and South Dakota—had trigger bans that kicked in the moment that the *Dobbs* opinion was released. Five more—Arkansas, Missouri, North Dakota, Oklahoma and Utah—had trigger bans that require certification from government officials before they could take effect. It took then Missouri attorney general Eric Schmitt, a Republican, less than ten minutes to certify that *Roe* had been overturned and enact the state's strident ban, which made it a felony to induce an abortion at any point in pregnancy, with an exception only for medical emergencies that threatened the life of the pregnant person. It was unclear whether laws in states such as Missouri that criminalized the provision of abortion care would apply to people who self-managed their own medication abortions, acting as both patient and provider.

In many states, it was unclear what law even applied, and the interpretation changed from day to day.

In Louisiana, for example, clinics immediately shut down that Friday after receiving letters from the state Health Department about a trigger ban enacted in 2006, which had been updated in 2022 ahead of the *Dobbs* ruling to harshen sentences for abortion providers.

Three days later, on Monday, the Center for Reproductive Rights and some Louisiana health care providers filed a lawsuit challenging

the trigger ban, and clinics reopened after a judge issued a temporary restraining order.

About two weeks after that, a different judge allowed the Louisiana law to go into effect while it was challenged in the courts, and the state's clinics again shuttered.

Four days later, the case was transferred to a different court, and a different judge there granted a new temporary restraining order. Louisiana's clinics reopened.

The same judge ruled nine days later that the state's abortion bans were too vague and blocked them on a preliminary basis.

The next week, a Louisiana appeals court said the bans would remain while the lawsuit continued.

If you were a doctor in Louisiana trying to keep up, in just over a month, abortion went from legal to illegal to legal for now, to illegal for now, to legal again for now, to illegal pending the outcome of the underlying lawsuit.

The legal turmoil wasn't relegated to the South.

In Michigan, there was an 1846 ban, updated in 1931, that was still in place criminalizing abortion. Democratic governor Gretchen Whitmer had already challenged it, and a judge had already put it on hold. But the law's continued existence had nevertheless fueled a push for a constitutional amendment affirming abortion rights that would be on ballots in November 2022—and *Dobbs* in turn gave Whitmer momentum as she ran for reelection in a state that President Joe Biden wrested back from Republicans by just a few points two years before.

In Wisconsin, where Democratic governor Tony Evers aimed to repeal an 1849 ban ahead of the *Dobbs* ruling by calling a special legislative session, the GOP-run, gerrymandered statehouse instead stymied him by gaveling in, then immediately back out, paving the way for the more than 150-year-old law to take effect as soon as the *Dobbs* decision landed.

This is just a sampling of the legal entropy that blanketed the country the moment the Supreme Court's conservative majority decided *Dobbs* in a 6–3 vote, tossing out the federal abortion rights the same court, with different justices, established forty-nine years before in *Roe*.

"Physicians are struggling every day," American Medical Association president Dr. Jack Resneck testified in a House subcommittee hearing less than a month after *Dobbs*. "The lack of flexibility due to that government intrusion is very frightening."

The *Dobbs* majority opinion was written by Alito and signed by fellow conservative justices Amy Coney Barrett, Brett Kavanaugh, Neil Gorsuch, and Clarence Thomas. Chief Justice John Roberts—who was seen by abortion rights advocates as a possible *Roe* savior, even if only to preserve court precedent—wrote his own opinion that agreed with the majority's overall judgment to uphold Mississippi's 15-week abortion ban but urged a more measured approach overall. Kavanaugh and Thomas, for different reasons, filed their own concurring opinions. Justice Stephen Breyer wrote the dissenting opinion with Justices Sonia Sotomayor and Elena Kagan, who made up the court's liberal minority.

Alito found plenty of fault with his predecessor justices' reasoning in *Roe,* and the court's 1992 ruling in *Planned Parenthood v. Casey,* which affirmed the federal right to an abortion but also found that states could enact restrictions so long as they did not create an "undue burden" for people to obtain abortion care. Alito argued that one practical concern was that the standards established by the two cases could be difficult for lower courts to interpret, and it therefore made it difficult for governments to craft abortion regulations that would pass judicial scrutiny.

It was a line of reasoning that Breyer rejected outright—and one that was contradicted even the first days after *Dobbs*. "Today's ruling will give rise to a host of new constitutional questions. Far from

removing the Court from the abortion issue, the majority puts the Court at the center of the coming 'interjurisdictional abortion wars,'" Breyer wrote. "Must a State allow abortions when necessary to protect a woman's life and health? And if so, exactly when? How much risk to a woman's life can a state force her to incur, before the Fourteenth Amendment's protection of life kicks in?"

Alito's judicial philosophy is that of original intent, or scrutinizing law and precedent to see whether they are addressed by the language in the Constitution. He grounded the majority's substantive rejection of *Roe* and *Casey* in his reading of the Fourteenth Amendment—specifically, in Alito's understanding of state laws and practices that were on the books in 1868, when the amendment was ratified in the aftermath of the Civil War. The Constitution grants citizens some enumerated—that is, specifically mentioned—rights, but there are also unenumerated rights that have been established by judicial interpretation. "The Constitution makes no express reference to a right to obtain an abortion, and therefore those who claim that it protects such a right must show that the right is somehow implicit in the constitutional text," Alito wrote.

One unenumerated right is the right to privacy. Courts have established this right in the due process clause of the Fourteenth Amendment, as well as other amendments. This unenumerated right was then used in *Roe* to establish that abortion was also an unenumerated right. But, Alito said, an unenumerated right must be "deeply rooted in this Nation's history and tradition"—and, he said, it was an "inescapable conclusion" that abortion wasn't, writing: "On the contrary, an unbroken tradition of prohibiting abortion on pain of criminal punishment persisted from the earliest days of the common law until 1973."

Alito wrote that *Roe* "either ignored or misstated this history" and that *Casey* "declined to reconsider *Roe*'s faulty historical analysis. It is therefore important to set the record straight."

But historians who study medicine and the law moved to set straight Alito's own specious interpretation of abortion's place in the country's "history and tradition."

For decades after the country's founding in 1776, abortion was regulated by common law, or law that is established by courts or precedent, either here or in England. The earliest attempts at abortion regulation in the United States focused on the point after the "quickening"—the first time a woman could feel the fetus move inside the womb, about 16 to 20 weeks into pregnancy. There were no tests or ways to confirm a pregnancy other than to trust the pregnant person's reading of their own body. An abortion before the quickening would not have been considered an abortion but restoring menstruation. "That is because the common law did not legally acknowledge a fetus as existing separately from a pregnant woman" before the quickening, stated a friend-of-the-court brief filed in *Dobbs* by two national organizations representing historians.

Alito wrote that the dissenting justices in *Dobbs* did not "dispute the fact that abortion was illegal at common law at least after quickening; that the 19th century saw a trend toward criminalization of pre-quickening abortions; that by 1868, a supermajority of States (at least 26 of 37) had enacted statutes criminalizing abortion at all stages of pregnancy; that by the late 1950s at least 46 States prohibited abortion 'however and whenever performed' except if necessary to save 'the life of the mother.'" He did not explain that the understanding of abortion in the late nineteenth and early twentieth centuries was that, by definition, it took place post-quickening, since before then it was not thought of as a pregnancy loss but delayed menstruation. It wasn't the only critical context Alito left out about our country's past abortion regulation.

Alito was accurate in that there was little to no precedent in the 1800s and early 1900s for legally enshrining the *right* to an abortion—but it was equally true, though left unstated in his opinion,

that in the country's earliest years, and for many centuries before that in North America and elsewhere, abortion was essentially legal without restriction. In colonial America, abortion was not thought of as a regulatory, legal, or political issue, but a medical one—and most reproductive health care during this era was provided not by physicians, the vast majority of whom were White men, but by midwives, the vast majority of whom were women. Black women in particular played a pivotal role in pregnancy and birth in the South.

The explosion of abortion regulation in the country during the second half of the nineteenth century was not a coincidence, or an indication of public sentiment, but a concerted lobbying effort by the fledgling American Medical Association (AMA) to gain professional legitimacy.

Horatio Robinson Storer, a surgeon and graduate of the Harvard Medical School, wanted to professionalize the specialty of gynecology and obstetrics. To do that, the mostly White male physicians had to wrest control from the women midwives providing the bulk of the care. In 1860, Storer ghostwrote a letter he attributed to the AMA's president and sent it to every governor in the country. He said that the association opposed abortion, writing: "There is little difference between the immorality by which a man forsakes his home for an occasional visit to a house of prostitution that he may preserve his wife from the chance of pregnancy, and the immorality by which that wife brings herself willfully to destroy the living fruit of her womb. The child is alive from the moment of conception." The idea that life began at conception, and not the quickening, started to take legal and psychological root. By 1880, all states had regulated abortion in some way, though a few adopted exceptions when a doctor determined there was a threat to the life or physical well-being of the mother.

Storer's use of the AMA to wage his antiabortion crusade is one of the most successful political lobbying efforts in American history,

and it was rooted in Christian theology, patriarchal authority, and to some extent white supremacy. He wrote in a subsequent 1865 essay for the AMA of White Protestant women, "upon their loins depends the future destiny of the nation." Without naming Storer, or noting the AMA's role in restricting abortion, or discussing midwifery, Alito ignored a point made in the historians' brief that the country's first antiabortion laws were meant to increase birth rates among White Protestants. Alito does, however, cite a brief filed in a prior abortion case before the court in which it was argued that early advocates for abortion access were part of a larger effort to "suppress the size" of the Black population. The abortion law historian Mary Ziegler told the *New York Times* after the leaked *Dobbs* draft that "the idea the Court thinks it can weed out the nativist impulses" on one side but not the other was "historically implausible."

Despite state-level restrictions, doctors continued providing abortions in the late nineteenth and early twentieth centuries, even when it was illegal in nearly all of the states and U.S. territories—and they did so largely without legal repercussions. Prosecutions increased during the post–World War Two baby boom in the 1940s and 1950s, driving pregnant people to illegal abortion providers. As a result, by the mid 1960s, 17 percent of deaths linked to pregnancy or childbirth were associated with illegal abortion. An outbreak of rubella during the same period, which can cause severe birth defects, further shifted public sentiment toward relaxing abortion restrictions. As the years passed, doctors, as a profession, became increasingly uneasy about the health care landscape that the AMA's antiabortion stance had wrought. In 1967, the AMA reversed course and relaxed its abortion stance. By the time the Supreme Court decided *Roe* six years later, forms of legal abortion were available in seventeen states.

As Katha Pollitt, a progressive essayist, poet, and critic, wrote in 1997 in the *Atlantic*: "In one of the many curious twists that mark the

history of abortion, the campaign to criminalize it was waged by the same professional group that, a century later, would play an important role in legalization: physicians."

In determining that abortion is not "deeply rooted in this Nation's history and tradition," Alito placed far greater emphasis on the history that predates 1868, when the Fourteenth Amendment was ratified, than all that came after. His pre-1868 historical account referenced midwifery only via footnoted texts, thereby omitting altogether that these women provided reproductive health care for the first hundred years after the country's founding, and mischaracterized the public's understanding and attitudes about pregnancy and abortion in the 1700s and 1800s.

Alito's opinion also did not dwell on the fact that the Fourteenth Amendment predates by more than fifty years the Nineteenth Amendment, which established women's right to vote, or the country's rich and "deeply rooted" history of unequal treatment of women. Even when the court decided *Roe*, in 1973, pregnancy was still a fireable offense; women needed a male cosigner to obtain credit; and no state laws existed banning marital rape. Alito cited the seventeenth-century English jurist Matthew Hale among the "great common-law authorities," noting that Hale explained how a "pre-quickening abortion could rise to the level of a homicide." Alito did not share that Hale also wrote that a "husband cannot be guilty of a rape committed by himself upon his lawful wife," and this legal theory became a part of British common law, then was reflected in laws in the United States. Hale, who also sentenced women to death as witches, was "considered misogynistic even by his era's notably low standards," the investigative newsroom ProPublica wrote after the leaked *Dobbs* draft.

Alito's desire to ban abortion has animated his career—both in politics and as a jurist. The self-described "lifelong registered Republican" served in Ronald Reagan's administration, where he advised the then solicitor general—who represents the federal government in

cases before the Supreme Court—to hold off on trying to overturn *Roe* outright because it might be too soon. Alito said it was better to instead defend state laws that "advance the goals of bringing about the eventual overruling of *Roe v. Wade* and, in the meantime, of mitigating its effects." He then touted that work in an application he submitted to the Presidential Personnel Office making the case for why he should be deputy assistant attorney general. According to the conservative newspaper the *Washington Times*, Alito wrote that he was "particularly proud of [his] contributions in recent cases in which the government has argued . . . that the Constitution does not protect a right to an abortion."

President George H. W. Bush named Alito to the U.S. Court of Appeals for the Third Circuit, where he served for fifteen years. There, in the *Casey* case, Alito disagreed with his judicial colleagues when he made clear that he believed a woman should have to inform her husband before seeking an abortion. *Casey* ended up at the Supreme Court in 1992, and the court upheld the right to a federal abortion but allowed some restrictions—but not mandated spousal notification—so long as they did not present an "undue burden" on the person seeking the procedure. (*Casey*, along with *Roe*, is one of the two cases Alito eviscerated in the *Dobbs* majority opinion.)

When President George W. Bush in 2005 nominated Alito to the Supreme Court, Cass Sunstein, a constitutional law scholar then at the University of Chicago who studied Alito's work for then Democratic senator Edward Kennedy, told the *New York Times* that he "sounded less amenable to constitutional evolution than [Chief Justice John] Roberts." This ethos was evident nearly twenty years later when Alito's *Dobbs* decision nearly exclusively rested on a reading of what the Constitution and its amendments meant in 1868 and not 2022. Ahead of oral arguments in the case, Edwin Meese, Reagan's former attorney general, wrote in the *Washington Post* that the court's ruling in *Dobbs*—which ended up being written by his protégé in the Reagan

administration—would "determine whether the dominant conservative legal project of the past 40 years . . . has been a success."

When the justices heard oral arguments in the *Dobbs* case, Sotomayor raised what impact Alito's decades-long quest with an ideological bent would have on the institution of the Supreme Court. "Will this institution survive the stench that this creates in the public perception that the Constitution and its reading are just political acts?" she asked.

It took just six weeks for the *Dobbs* decision to shift public opinion. Polling by the Pew Research Center done in August showed that the partisan gap in favorable opinions of the Supreme Court were far wider than at any point in the thirty-five years the think tank has tracked the issue. Just 28 percent of Democrats and Democratic-leaning independent voters reported favorable views of the court, down nearly 40 points since 2020, and down 18 points since the beginning of 2022. Positive views of the court among Republicans and Republican-leaning independent voters ticked up slightly to 73 percent from 65 percent at the start of the year. But shortly before the first anniversary of the *Dobbs* decision, just 44 percent of Americans would hold a favorable view of the court, and 54 percent an unfavorable view. Across both parties, women, people of color, those under the age of fifty, and people with a college education were more likely to hold unfavorable views.

Civil rights battles are always intertwined, and Alito's reading of the Fourteenth Amendment in the Dobbs decision could lay the groundwork for the court to undo other widely accepted constitutional rights related to privacy, due process, and equal protection under the law. The Supreme Court also cited the Fourteenth Amendment to end the segregation of public schools in 1954; authorize married couples to use contraception in 1965; strike down interracial marriage bans in 1967; permit affirmative action so long as race was not the only determinant in 1978; and affirm the right to marry for same-sex couples in

2015. Conservative justice Thomas wrote in his own concurring *Dobbs* opinion that now that *Roe* was gone, "we should reconsider all of this Court's substantive due process precedents, including *Griswold* [contraception], *Lawrence* [adult "non-procreative"—that is, LGBTQ+—sex], and *Obergefell* [marriage equality]."

Towards the end of Alito's majority opinion in *Dobbs*, he wrote that the decision allowed "women on both sides of the abortion issue to seek to affect the legislative process by influencing public opinion, lobbying legislators, voting, and running for office. Women are not without electoral or political power," noting that women vote at higher rates than men, including in Mississippi, where the law in the case was passed. "The authority to regulate abortion must be returned to the people and their elected representatives," he concluded.

In just over four months, the 2022 midterms loomed, when all 435 U.S. House seats and 35 of 100 Senate seats would be on ballots; thirty-six states would hold gubernatorial elections, and forty-six would hold legislative elections. It would be one of the first post-*Dobbs* opportunities for the American people—women included—to tell their elected representatives what type of abortion regulations they wanted.

What new abortion restrictions or protections the elections would bring depended on where you lived, from your state down to your county and city.

"What am I going to do about it?"

Maryland

D r. Diane Horvath was unpacking a lamp on the waiting room floor of the clinic that she was about to open in College Park, Maryland, with her business partner, Morgan Nuzzo, a nurse and midwife.

It had been about six weeks since the *Dobbs* decision. When Partners in Abortion Care opened in this faux colonial-style office park in another six weeks or so, it would join only a handful of clinics nationwide that not only performed abortions later in pregnancy but specialized in providing care in the second and third trimester. Horvath explained why as she smoothed out the assembly instructions for the lamp and started screwing it together.

"We were really passionate about the work, and really both believed very strongly that you can't just say that all trimester care should be available, you need to help make it available. If you have the skill set, if you have the desire and the passion, and if you have the empathy for it, you need to do it," she said.

Third trimester care is rare and often sought by patients contending with severe or fatal fetal abnormalities, or complications that threaten their own life or health. In other cases, delays in finding or figuring out how to pay for abortion care push the procedure into the third trimester.

Horvath and Nuzzo had known each other for years. During the decade that preceded *Dobbs*, they were co-workers in two separate clinical settings. Even when they weren't, they would check in with each other every few months. Horvath's child is a couple of years older than Nuzzo's eldest, so they would meet up to swap outgrown clothing, or have coffee as their kids ran around the park. But ultimately their connection is less a social relationship than a shared dedication to their work. "She feels very passionate about this in a similar way to me, we would talk about what this could be like, and what our jobs could look like," Horvath told me.

In the autumn of 2021, Horvath and Nuzzo left their jobs at another nearby all-terms clinic, in part over a misalignment between its mission and their values. Horvath spent the next several months flying down to Alabama to fill in at two clinics there, including the West Alabama Women's Center with Robin Marty and Dr. Leah Torres. By December—the month the Supreme Court held oral arguments in the *Dobbs* case—they were already taking the first steps to open their own clinic.

Then, in April 2022, the Democratic-led Maryland statehouse overrode Republican governor Larry Hogan's veto to allow non-physician health care providers such as midwives, nurses and physicians assistants to perform abortions. Abortion was protected until fetal viability in the state, and after that, when there was a fetal anomaly or the patient's health is at risk. Shortly after Horvath and Nuzzo signed their lease on the space, the *Dobbs* decision leaked. They got the keys two days before the decision came out, then started renovations. It was only at this point that Horvath and

Nuzzo started to draw salaries—for the first six months, they worked without pay.

"For those of us who have worked in reproductive health and justice for any length of time in the last, you know, couple of decades, I think that none of this was a surprise. The SCOTUS decision was not a surprise. This is the culmination of decades of really, really, well-thought-out strategy by the antiabortion folks," Horvath told me. "So, I think a part of it also was I knew the political climate would be so different now, in so many states, that I thought: 'There's going to be places that don't have this at all, and these patients are still going to need care, and what am I going to do about it?'"

Horvath does not call ending a pregnancy in the second or even third trimester a "late-term abortion." The reason why is because that is not a medical term, but political rhetoric from the antiabortion movement. It has nevertheless crept into policy debates, newspaper stories, legislation and television news segments.

In 2021, less than one percent of the abortions in the United States were at or after 21 weeks of pregnancy, according to data kept by the Centers for Disease Control and Prevention. In 2020, when there were roughly 620,327 abortions nationwide, only about 4,382 of those were after 21 weeks. Even fewer of those were after the point at which a fetus could, in theory, survive outside the womb, which occurs about 24 weeks into pregnancy. Yet a talking point among Republican politicians in the years leading up to *Dobbs* and after was that abortion rights supporters and Democrats wanted to allow the procedure up until full-term birth.

Conservative politicians talk this way because they know that even many of those who support abortion access aren't sure whether there should be a cutoff for the procedure or what the appropriate time in pregnancy that cutoff should be. Patients who seek an abortion in the later stages of pregnancy, and the health care providers who care for them, have therefore become a convenient political

scapegoat. In 2022, a majority of Americans supported access to legal abortion—and that had been the case for decades. But public opinion polling also showed that more than half of those who supported abortion access believed that the number of weeks' gestation should be considered when determining legality. Complicating matters even further in terms of creating public policy, of the third or so of Americans who believed abortion should be mostly illegal, only about a quarter thought that it should remain so if the pregnant patient's life or health is at risk.

Lawmakers often take public sentiment into account when crafting new policy, but it has proved challenging to write laws that take into account the public's increasing discomfort with abortion as pregnancy progresses while also providing workable exceptions for rape and incest, along with fetal and parental health. Health-threatening complications can crop up at any time—and who should decide what is grave enough to merit an exception? Severe or fatal fetal abnormalities often aren't diagnosed until the "anatomy scan" prenatal appointment, which occurs around 18 to 20 weeks into pregnancy. Katrina Kimport, a medical sociologist at the University of California, San Francisco, wrote in the peer-reviewed journal *Perspectives on Sexual and Reproductive Health* that "as the gestational duration of the pregnancy increases, support for abortion wanes, potentially because of a lack of familiarity with and empathy for third-trimester abortion patients and providers."

In 2021, there were 358 independent abortion clinics in the country. Though they made up only about a quarter of overall providers, these independent clinics performed nearly 60 percent of the country's abortion procedures, with Planned Parenthood's roughly 600 clinics, hospitals and private physicians providing the rest. But as Horvath and Nuzzo prepared to open Partners in Abortion Care, there were only four facilities in the country that publicly advertised abortion care after 24 weeks. When they joined this a handful of providers

that specialize in abortion care later in pregnancy, Horvath and
Nuzzo believed their clinic would be one of the only ones owned by
women. Plus, it would be one of the only abortion clinics co-owned
by a physician and a nurse-midwife. Often, it's a businessperson who
owns a clinic, then staffs it with health care providers. In these
ways, Horvath and Nuzzo aimed to break the mold of what it means
to deliver abortion care.

One reason that there were so few clinics specializing in later-term
care even before *Dobbs* was that state-level gestational limits on abor-
tion had prompted many clinics to shutter or circumscribe the scope
of their care. There was already a lack of training—and even will—
among medical providers to provide abortion care in the later stages
of pregnancy. Abortions at this stage are often more medically
complex and more expensive—Kimport estimated a few thousand
dollars to more than $25,000, instead of $644 for a medication abor-
tion, or $1,068 for a second-trimester abortion, on average, in 2020.
They are also rarely covered by private insurance and often require
travel, with the requisite time off work, lodging for a multiple-day
procedure and potentially securing care for other children. Kimport's
survey of 28 women who had abortions at 24 weeks' gestation or later
found that there were "two pathways" that led them to obtain third-
trimester abortions: "New information, wherein the respondent
learned new information about the pregnancy—such as of an observed
serious fetal health issue or that she was pregnant—that made the
pregnancy not (or no longer) one she wanted to continue; and barriers
to abortion, wherein the respondent was in the third trimester by the
time she was able to surmount the obstacles to abortion she faced,
including cost, finding a provider, and stigmatization."

All available data supported Horvath's prediction that the fall of
Roe would lead to a country where there would be more people, not
fewer, seeking abortions later in pregnancy, and that many of them
would need to cross state lines in order to get one. Horvath and Nuzzo

wanted Partners in Abortion Care to be a beacon for pregnant people facing difficult realities and hard choices, and they had put a lot of thought into anticipating what their future patients might need as they designed every facet of their clinic.

Horvath plugged the lamp in to test it and a warm glow filled the waiting room.

"This one actually works! Do you want to walk through the clinic?" she asked.

THE SPACE THAT Horvath and Nuzzo leased was a medical clinic before, so the renovations they had done were not extensive, but tailored to the specifics of providing abortion care. The comfortable—but easily disinfectable—arm chairs in the waiting room were from an abortion clinic in Georgia that closed, as was a fair amount of their medical equipment, like autoclaves for sterilization. Horvath walked through what she described as a "big, giant, heavy steel door" that they had installed for security reasons between the waiting room and the patient care area. There was a brand-new panic button behind the check-in desk that was a direct line to law enforcement—"I don't know of a clinic that doesn't have one," Horvath said.

This button was a necessity. Over the last thirty years, there had been eleven murders, twenty-six attempted murders, and hundreds of arsons directed at abortion providers and the clinics in which they worked.

Past the steel door, there was a kitchen for clinic staff, and they installed a dishwasher. There was a small lounge with a sofa to relax, watch television, or have a quiet moment. There was a small on-site laboratory space and a medications closet. There were offices, including one that would be used by the patient care coordinator during the day, then at night, as a resting space for staff, because "it can be unpredictable when procedures finish, because many of the later procedures

are like a labor induction, so we adjust our plans to what the patient's body is doing, and what it needs, and so that sometimes means staying late, sometimes it means coming in in the middle of the night."

They added a changing area with laundry, because they decided to skip a scrub service and provide an allowance for staff to buy their own, since "anybody who has worked in a hospital knows that hospital scrubs are not made for butts," and the staff was nearly all women. "One of the things that was really important to us was that people had access to the scrubs, and the shoes, and all of stuff that they needed to do the job, but also that they come in their street clothes so that nobody can identify that they are working in a clinic, for safety reasons," Horvath explained.

For patients, there were three procedure rooms. There was an ultrasound and counseling room. There was a recovery room with medical-grade recliners, sourced from the closed clinic in Georgia, that would otherwise have cost $1,000 or more, as well as some over-stuffed armchairs. "I'm very thrifty, anyone will tell you," Nuzzo said. They decided to enlarge the recovery room during renovations, and it was partitioned, instead of having walled-off stalls, to create a flexible space where patients could opt for the level of privacy—or camaraderie—that they needed.

"One of the things that we've seen happen kind of organically in these clinical spaces is that patients who are interested in giving and receiving support will often chat with folks that are here because people are sometimes with us for a three-day process. We see them on the first day, they come back the second day, they come back the third day and they have their procedure. People start to get to know each other," Horvath said.

"There are clinics that we've worked in that were very, very private, where nobody sees anybody else. And that's really lovely for some patients, but it's really hard to staff, because you need basically sepa-rate staff for every patient. And I think it can also be kind of

isolating . . . There are private rooms if we need to put people in a private room, if they just need time by themselves. But then there's also a space where people can see they're not the only person here having an abortion today. And I think that there is power in normalizing abortion and realizing other people are experiencing the same thing that you are, particularly for later abortion because we just don't talk about it at all."

This idea, that there is power in sharing our experiences with a type of health care that has affected so many of us—nearly one in four American women will have an abortion by the time they are forty-five years old—has been a theme throughout Horvath's career. In 2016, she filed a federal civil rights complaint against her then employer, MedStar Washington Hospital Center, after she said its chief medical officer told her to "immediately cease her media advocacy on the 'topic' of abortion" because he did not want to put a "Kmart blue light special on the fact that we provide abortions at MedStar." Horvath wrote in an essay for the *Washington Post* that "I believe physicians must engage in public discourse wherever it is happening, and we must be voices for evidence-based medicine both in and out of the office. There is still an incredible amount of stigma surrounding abortion and other reproductive health issues, and I hope that doctors' willingness to share their stories will help women feel empowered to share theirs."

Horvath's complaint cited the Church Amendment, passed in the wake of *Roe*, which prohibits health care facilities that receive federal funds from requiring providers to participate in abortion or sterilization procedures if they object on moral or religious grounds. It protects any provider from discrimination "because of his religious beliefs or moral convictions respecting sterilization procedures or abortions." Horvath's case, brought via the National Women's Law Center, was thought to be a first-of-its-kind application of the statute to also protect doctors from discrimination who

provide abortions based on moral or religious grounds. The hospital eventually abandoned its push to restrict physicians' abortion advocacy, negating the need to continue the case.

Five years later, when Horvath and Nuzzo decided to strike out on their own, they met with a business consultant who used to work at a Planned Parenthood to figure out an opening budget, settling on $750,000 to open their doors and $1.2 million to operate for six months while they waited for reimbursements from abortion funds and other entities to cover the care they would provide. Horvath and Nuzzo put initial expenses on their own credit cards, then raised $25,000 from family and friends to sign the lease and put down a deposit. Talking about abortion has helped Horvath and Nuzzo not only be "voices for evidence-based health care," but muster the resources to open their clinic, and there have been what Horvath calls "surprising advocates" at many turns in their journey.

"I wish that there had been a roadmap. I wish that there had been a manual, or even mentorship to talk about how to do it," Horvath said. "We've been really scrappy about trying to figure this out on our own—we've also had a lot of really phenomenal people kind of nudging us and helping us and folks that were able to give us advice about things when we couldn't pay for it yet."

The broker and property manager who helped Horvath and Nuzzo find the clinic space but likely didn't consider that "abortion was his issue," had been "behind us the entire time," she said. "He met us, and he did some research, and he talked to people in his family and his friend circle, and they were like: 'You have to do this, you have to help these people start this clinic.'" So he did. Another man with an office in the same complex bought the clinic space, then leased it back to them as a form of investment. "Again, not expected and just totally welcome and made us feel like there are people who want us to succeed." They found a banker who was "delighted to help," along with a supportive building contractor. Their cleaning service "stopped

us to tell us they thought what we were doing was great," she said. The Baltimore chapter of Bakers Against Racism hosted a bake sale and sent them $2,000 they weren't expecting. By July, nearly $350,000 had poured into a GoFundMe campaign from supporters near and far. "I certainly didn't expect that kind of response, and it's been pretty awesome to have that lift from people," Horvath said.

There had also been key showings of support from within Horvath's innermost circle. Horvath grew up in Cleveland, Ohio, where she attended a Catholic high school, and her household, including her physician father, opposed abortion. But her parents supported her on her journey from college undergraduate student inspired by a women's studies course, to her externship in reproductive health between her first and second years of medical school. They continued to support her when she made the decision, about three years into a general OB-GYN practice, after realizing that the most fulfilling part of her work was the couple of days a month she spent at Planned Parenthood, that she wanted to focus on abortion care full time.

"There's so much in medicine that I can't actually fix," she said. "Abortion is one of the only things that consistently fixes a problem—and I don't want that to sound blasé, but the fact is, when someone comes to you needing an abortion, they leave and that problem is fixed. It doesn't fix people's bad relationships, it doesn't fix poverty, it doesn't fix any of those things, but when someone is pregnant, and they can't continue to be pregnant, I can help with that."

"My dad, who is a physician also, we have differing views on abortion, but I think the processes that we use to come to the conclusions that we've reached are very similar, so he gets how I got here, what I saw, and the decisions that I've made based on the experiences that I've had as a clinician, and as a person, and as a mom," Horvath told me.

"I know that it's been hard for them, but they're also really proud of me, and my mother in particular is a little bit awestruck by the

fact that we're opening a business, she's very impressed with that, and has told me many times that she is making us a beautiful piece of fabric art for our wall—to me, that is my mom extending support," Horvath finished.

We arrived back in the clinic's future waiting room, in the space secured with the help of a sympathetic broker, a supportive real estate investor, an engaged banker and hundreds of thousands of dollars raised by family, friends, College Park residents, and a larger community of people who support legal abortion and had put their money into action to help create what could become the southernmost point to access all-terms abortion after *Dobbs*. The word Horvath comes up with to describe the past whirlwind six months preparing to open the clinic is "profound."

"As we are starting this up, there are dozens of clinics that are figuring out whether or not they're going to have to close. The grief . . . I think we're all still in crisis mode, so I don't think that we've been able to grieve, there is trauma, but also so much anger and frustration and betrayal, we are carrying that with us—I have a really great therapist, I think we all do, actually. But to be able to produce something from this mess of things that are happening, it is both very uplifting, and really, really extra hard," Horvath said.

Across the country, in Phoenix, Arizona, another doctor who opened her own abortion clinic years before was, as Horvath said, trying to figure out how she could keep her clinic running. The clinics were twenty-three hundred miles apart—and they existed in totally different worlds.

Fall 2022

"You must stand up."

Arizona

P HOENIX—By the time Arizona's 15-week abortion ban was set to take effect on September 24, 2022, Dr. Gabrielle Goodrick had been trying to keep caring for patients at her clinic, Camelback Family Planning, during a three-month period after the *Dobbs* decision that could only be described as turbulent.

In the fall of 2022, there were seven clinics that performed abortions in Arizona, and five of them were located in the greater Phoenix area. Due to overlapping and conflicting laws dating back more than 150 years to when Arizona was a territory, the leaders of these clinics spent the months after *Dobbs* discussing options on the phone with their lawyers and conducting personal risk assessments in order to decide whether they could stay open, and what types of care they felt comfortable providing. There were periods when Camelback Family Planning was one of just a couple of clinics—and at times the only clinic—seeing abortion patients in a metropolitan area with nearly

five million people, in a state where some fourteen thousand patients had received abortions the year before.

Goodrick had been practicing medicine in Arizona since the 1990s, when she headed west after finishing medical school in Vermont. First, she worked at an area Planned Parenthood, then as a family doctor at a local hospital, continuing to moonlight for Planned Parenthood on the side. In 2000, she was the first physician to dispense medication abortion in the Southwest. Then she decided to start her own clinic focused on reproductive health care. When I asked her whether she planned to be a doctor who primarily provides abortion care, she said: "Maybe not consciously, but unconsciously, maybe."

At first, Goodrick rented space for Camelback Family Planning across town from its current location in northeast Phoenix. When her lease there was up, she looked at what seemed like hundreds of suites suitable for a medical practice. As soon as she mentioned what type of health care her clinic provided, though, her offers went unaccepted and rental deals fell through. She decided to be her own landlord. In 2006, she bought a medical suite in a nondescript office building. Renovations were completed the week before the *Dobbs* decision, bringing the total number of Camelback's patient rooms to seven, five for exams and two for procedures. Inside, a framed poster in the waiting room honors 4,000 YEARS FOR CHOICE by describing the use of willow bark as an abortifacient, and above a computer workstation in the staff area, cross-stitch artwork says DO NO HARM BUT TAKE NO SHIT and UTERUSES BEFORE DUDERUSES. More than a decade later, when the clinic's adjacent neighbor left, she decided to expand into the office suite next door.

Goodrick, like Robin Marty and Dr. Leah Torres in Alabama and Dr. Diane Horvath and Morgan Nuzzo in Maryland, had been preparing for a case like *Dobbs* for years, sounding the alarm whenever she could. As Republican-led legislatures in Arizona and elsewhere started passing increasingly restrictive abortion laws,

Goodrick started a blog to examine the policies from a doctor's point of view.

In 2018, Goodrick surveyed the political landscape in states like Alabama and Arizona and warned doctors nationally what they should expect if *Roe* fell. She told them it was time to "step up" and protect abortion care. "Doctors, including those of you who have kept abortion in the distance and out of your practices, it is imperative that you understand you are now in professional jeopardy," she wrote. She predicted this would be the "last generation" of physicians to be trained in the "full spectrum of reproductive health care," that hospitals would be forced to provide emergency abortion care if clinics closed, and that doctors would have to "fight your own hospital administration" in order to provide even life-saving care.

"For those of you who haven't [been trained in abortion care]— because you believe your faith would oppose it, because it was too difficult to access it in med school, or because your current hospitals won't let you and it is more important that you stay in your financially secure job and not make any waves—understand that you are the ones who opened this door . . . You've allowed a procedure that is conducted more than any other in the nation to be moved to the fringes. You've encouraged medical schools to make it elective, and to cave to political pressures to block training and end fellowships teaching the skill," she wrote.

"Decisions won't be based on medical best practices. They will be made based on hospital policy, political fear, and financial interests. And as a result, more of your patients may die," she continued. "This is the new normal unless you finally say 'enough is enough' and demand to treat each and every patient with whatever medical service they may need. You must stand up against it now—as this may very well be our last chance to save our profession."

Goodrick was speaking to doctors not only in Arizona but also nationwide—and anyone else who cared about abortion access, too.

After Alabama approved its near-total abortion ban in 2019, she predicted what was in the national pipeline and wrote: "Many people across the United States feel like they have woken up to a fantasy world . . . But sadly this isn't a fantasy—it's a reality. Given unlimited power in dozens of states and in the White House, antiabortion activists have stopped playing pretend when it comes to ending reproductive rights." In another post that year, she lamented that the GOP-led legislature in her state was working with antiabortion activists to enact an agenda that was "death by a thousand paper cuts."

Arizonans support legal abortion at slightly higher rates than residents of many other states, and they oppose abortion at much lower rates. When *Dobbs* was decided, 64 percent of Arizonans believed abortion should be legal in all or most cases, while just 7 percent thought it should be mostly illegal in all or most cases, according to the nonpartisan Public Religion Research Institute, a nonprofit group that researches religion, culture and public policy.

Yet in 2018, as Goodrick pleaded with fellow physicians to prepare for the fall of Roe, Americans United for Life named Arizona the "most pro-life state in the country." How a state where less than a tenth of its population believes abortion should be mostly illegal won this recognition requires understanding Arizona's unique political history, and the power that little-known political interest groups can wield in American politics.

For starters, Arizona's electorate is unique. Its voters are split into roughly equal thirds between the Democratic Party, the Republican Party, and political independents who align with neither. There is also a deep tradition of small-government, antiregulatory Libertarianism in the western state, both within the Republican Party and outside it. This uniquely Arizonan political characteristic is one reason why the state's residents are more likely to support legal abortion access, given that Libertarianism emphasizes personal autonomy and freedom from governmental interference.

Arizona was the birthplace of Goldwater Republicanism, a Libertarian-leaning strain of the ideology that espouses a smallest-government-possible, antiregulatory ethos. It is named for Barry Goldwater, who represented Arizona in the U.S. Senate for a total of five terms over two separate periods in the 1950s through the 1980s, and who was also the 1964 Republican White House nominee. Goldwater's unsuccessful presidential bid, along with the 1960 book *The Conscience of a Conservative* that bore his name, is thought to have helped define what it meant to be a Republican in Arizona and elsewhere during the years leading up to Ronald Reagan's presidency.

But when Reagan was elected to the White House, his party's base was starting to change. The coalition Reagan built that delivered him the presidency—traditional Republican voters, plus historically Democratic Catholic voters, along with previously politically disengaged White evangelicals—marked the point at which the national GOP began to definitively move away from the Libertarian values championed by Goldwater, a man who had in not-so-distant history been referred to as both the "father of modern conservatism" and the "Grand Old Man of the Republican Party." By the end of Reagan's presidency in 1989, the Republican Party's alignment with the religious right, and with it the full-throated adoption of antiabortion and anti-LGBTQ+ stances, had put Goldwater at odds with the party he once helped shape.

Goldwater wasn't the only prominent Arizona Republican resisting the national party's push to restrict abortion. Mary Dent Crisp had worked on one of Goldwater's campaigns before rising in Arizona, then national politics, to become co-chair of the Republican National Committee—a position she ended up leaving in 1980 after clashing with Reagan over her admonitions to keep abortion restrictions out of the party's platform. Crisp went on to co-found the National Republican Coalition for Choice, and Goldwater sat on its board. His wife, Peggy, was a founding member of Planned Parenthood of Arizona.

Goldwater echoed the concerns Crisp brought up with Reagan a decade later, with a different president, when he warned President George H. W. Bush in 1992, as he sought reelection, that if the GOP adopted increasingly stringent antiabortion stances it would be disastrous for the party. "The convention will go down in shambles, as will the election," he wrote to Crisp in a letter that was made public. (Bush lost nationally but won Arizona by about 2 points that year, with just 38.5 percent of the vote, because a whopping 23.8 percent of Arizona voters backed third-party candidate Ross Perot. Democrat Bill Clinton, who won the White House, got 36.5 percent.)

By 1994, Goldwater spoke openly about how he no longer recognized the party for which he was once a figurehead. "A lot of so-called conservatives today don't know what the word means," Goldwater said in an interview with the *Los Angeles Times*. "They think I've turned liberal because I believe a woman has a right to an abortion. That's a decision that's up to the pregnant woman, not up to the Pope or some do-gooders or the Religious Right. It's not a conservative issue at all." He told the *Washington Post*: "When you say 'radical right' today, I think of these moneymaking ventures by fellows like Pat Robertson and others who are trying to take the Republican Party away from the Republican Party, and make a religious organization out of it."

Over the same period of time, Arizona voters were leaving the Republican Party. In 1992, independent or unaffiliated voters made up just 11.6 percent of Arizona's electorate; by 2014, the proportion of voters that were independent or affiliated with a minority party exceeded the proportions registered as Democrats or Republicans. Some of these independent voters were new to Arizona, but many others were Arizonans who had defected from the Republican Party to become political independents.

As Arizona's electorate shifted, the Center for Arizona Policy became an influential power player in the state's increasingly distilled

Republican politics, making it a testing ground for socially conservative policies, starting in the mid- to late 1990s and gathering steam into the 2000s.

The Center for Arizona Policy was founded in 1995 by the conservative attorney Len Munsil, who left the organization in 2005, handing over the reins to Cathi Herrod, who still helmed the organization when the *Dobbs* decision came down. By that time, CAP had become the dominant force shaping restrictive abortion and anti-LGBTQ+ policies in the state. J. Charles "Chuck" Coughlin, a longtime GOP operative in Arizona, described an annual CAP-hosted dinner as "Oscar night" for Republican politicians. "CAP's endorsement is critical . . . their stamp of approval became the Good Housekeeping seal of approval for Republican politicians during that time," Coughlin told me. Herrod specifically helped "turn CAP into a very powerful fundraising machine in the state and they continue to be that to this day," he added.

The Center for Arizona Policy is one entity in a vast network of often-affiliated tax-exempt groups that have become enormously influential in U.S. politics at every level. CAP is a structured as a 501(c)(3) nonprofit organization, which means that its purpose must be charitable, religious, scientific or educational in nature. Donations are tax deductible and do not have to be disclosed, making it impossible to fully trace its funders. These "charitable" nonprofit groups have the limited ability to lobby government officials and entities, and to participate in politics by hosting nonpartisan debates or offering nonpartisan education materials and voter guides. They are permitted to support or oppose ballot measures in a limited capacity but cannot do the same for candidates. But CAP, like many 501(c)(3)s in the political realm, has an affiliated 501(c)(4) that allows it to expand its political influence without running afoul of tax and campaign finance laws.

CAP's affiliated 501(c)(4) group is the Center for Arizona Policy Action, or CAP Action, which was founded in 2001. Its tax filings

state that its mission is to educate "Arizona citizens on public policy issues pertaining to sanctity of life, marriage, the family, and religious freedom, and encourages civic engagement." 501(c)(4) groups are also nonprofits known as social welfare organizations, and their donations are not tax deductible. They are part of what's known as the political "dark money" universe because they can receive unlimited contributions from corporations, individuals, and labor unions. (They too do not have to disclose their funders.) Though political activity still isn't supposed to be their primary purpose, the IRS has done little to enforce this provision, and the influence and impact of 501(c)(4) groups has exploded over the past twenty years, particularly after the Supreme Court's decision in the 2010 case *Citizens United v. Federal Election Commission* opened the floodgates to outside political spending.

Still another type of political influencing organization are super PACs, which are attractive vehicles for special interests because they can be overtly political in purpose. You can give them unlimited sums of money; the only catch is that super PACs, like candidate campaigns, must disclose their donors. When a 501(c)(4) social welfare organization transfers funds to a super PAC, it's a way to move money without disclosing the 501(c)(4)'s original donors. At that point, it can be commingled with other transfers for political spending.

The money that CAP Action spent on behalf of candidates in the 2020 election cycle was modest, given that House and Senate races can attract millions of dollars in outside spending. But the candidates it supported indicated the organization's ideological bent. CAP Action helped far-right Wendy Rogers unseat a Republican incumbent to win a seat in the state senate—Rogers has spoken at white nationalism conferences and was a member of the Oath Keepers, an antigovernment militia group that participated in the January 6

insurrection at the U.S. Capitol. CAP Action also supported Nancy Barto, a former state representative who successfully challenged another Republican incumbent state senator from the right and went on to sponsor antiabortion measures that included the 15-week abortion ban.

The Center for Arizona Policy's most potent role, though, was as a clearinghouse of proposed conservative legislation like the 15-week abortion ban. CAP advertises that it has supported more than two hundred laws and resolutions that have gotten support from the Arizona legislature, though some did not ultimately pass both chambers, and others were vetoed by the governor, blocked by the courts, or later repealed. Dozens of these—a parental consent law in 1996, a requirement for pre-abortion ultrasounds in 2011, the abortion bans sponsored by Barto—make up the "death by a thousand paper cuts" Goodrick described when writing about how abortion access would end.

There is the in-kind support, too: Herrod served on the campaign steering committee of Governor Doug Ducey, previously a state treasurer, when he first ran for governor in 2014. Ducey would go on to sign a series of CAP-backed bills that restricted abortion access and limited the rights of transgender people, including the 2021 package of antiabortion measures and the 15-week ban enacted as the country awaited the Supreme Court's *Dobbs* ruling.

As GOP-controlled state legislature passed CAP-supported abortion bills in the years before the Supreme Court overturned *Roe*, the electorate in the state was changing, fueled, as political realignments often are, by demographic change—in Arizona's case, by an influx of residents from places like California and Washington that put it among the fastest-growing states in the country.

Many, if not most, of these new voters did not hold views that aligned with CAP's antiabortion vision for Arizona. A not

insignificant portion of the state's Libertarian-leaning Republican voters didn't either. The gulf between CAP's vision for Arizona and the state's voters was growing, even as the organization became so entrenched in GOP politics that Herrod was often referred to as the state's unelected thirty-first senator.

Ahead of the 2016 election, when Arizona State University's Morrison Institute for Public Policy analyzed the state's independent voters, they found that "three-quarters of registered Arizona voters support[ed] women's rights to abortion services. Liberal independents (99 percent), Democrats (82 percent) and moderate independents (82 percent) overwhelmingly favor[ed] women's rights to abortion services. Even among Republicans, the party that has most vocally opposed abortion, six in ten support[ed] the right to abortion services." But CAP was still busy pushing antiabortion laws, and the candidates who supported them. In 2015 and 2016, for example, CAP backed bills to ensure that "women are informed that the abortion pill may be reversed," that "the abortion industry does not hide or withhold potentially life-saving information from women who have taken the first abortion pill but question or regret their decision," and that "Arizona's pro-life laws are not circumvented through reciprocity agreements for medical licenses for doctors."

Arizona's changing electorate is one reason why Hillary Clinton held one of her final White House campaign rallies there ahead of the 2016 elections, even though the last Democrat to win the state was her husband, back in 1996. She lost Arizona by about 3.5 points to Republican Donald Trump, as well as the overall election, but still, it was clear that Arizona was a state newly in play. In 2020, Democrat Joe Biden achieved what Clinton had not when he beat Trump by less than half a percentage point, setting off Republican claims of election denialism within the state party that would reverberate for years. Arizonans also elected Democratic senator Mark Kelly in a

special election to fill the seat of Republican John McCain after his death. For the first time since the 1950s, the state had two Democratic U.S. senators. In the state legislature, though, Republicans remained in control.

Political observers worried that one way the state's political representation had become distorted was by a partisan primary process that made it difficult for unaffiliated voters to help pick eventual party nominees. Save Democracy Arizona, formed in 2022 by a bipartisan group of political operatives and current and former elected officials, estimated that just 10 percent of the state's unaffiliated voters were participating in party nominating contests, in large part due to partisan primary rules. They began calling for a series of changes aimed at increasing participation, with the thinking being that it would result in more mainstream candidates poised to win general elections. The group's president, Sarah Smallhouse, noted in an op-ed for the *Arizona Republic* that in the 2022 primaries, GOP candidates were nominated to top offices with support from less than 10 percent of all registered voters.

As the country waited for the Supreme Court's decision in *Dobbs*, Ducey signed a 15-week abortion ban that had an exception only for medical emergencies but not rape or incest. In Arizona, new laws typically take effect ninety days after the legislature adjourns, which teed the ban up for autumn 2022.

The 15-week ban joined multiple preexisting antiabortion laws. There was a near total abortion ban from 1864 still on the books— enacted before Arizona was even a U.S. state—that mandated jail time for those who provided abortion care. There was also a sweeping 2021 antiabortion bill that, among other things, contained a vaguely written fetal personhood provision; made it a crime to perform an

abortion based on a non-lethal fetal genetic abnormality alone; and forbade the mailing or delivery of medication abortion.

In June 2022, when the Supreme Court released *Dobbs,* it was just after 7 A.M. local time. By lunch, a Republican rift had developed over which of Arizona's laws—the dormant 1864 law, the 2021 personhood measure, or the not-yet-in-effect 15-week ban passed earlier that year—was in place. Goodrick had a full day scheduled, with dozens of patients coming for their consent appointment, for a procedure, or to receive medication.

Around noon, Goodrick got a message from a *New York Times* reporter asking her about reports that some GOP state legislators, along with Herrod, were arguing that the territorial-era law was now in place, preempting the 15-week ban that was supposed to take effect in September. "That law should now be enforceable, prohibiting abortion in the state except to save the life of the mother," Herrod told the *Arizona Mirror.*

Goodrick always wondered what qualified Herrod to be her foil on television segments and in newspapers: "They'll get me and they'll get her, and I'm always like: 'Why are you getting her?' She's a lobbyist, a paid lobbyist, not a doctor. She's not even a politician, not even an elected official," she said.

Goodrick scrambled to protect her patients and her clinic. Planned Parenthood paused abortion care in the state, as did independent clinics in Phoenix and Tucson. One was Desert Star Institute for Family Planning run by Dr. DeShawn Taylor, who later told the *Guardian*: "We know that Black people are the first to be criminalised in this country . . . I am a Black woman, all my staff and many of our patients are people of color." Goodrick decided to shutter at least for the remainder of that Friday afternoon: "We have a lot of nurses, there was a lot at stake. We had to cancel the rest of the afternoon to figure it out."

The ACLU of Arizona, the Center for Reproductive Rights and other groups that support abortion access immediately asked the courts for an injunction against the 2021 personhood statute that classified fetuses, embryos, and even fertilized eggs as "people."

Arizona Republican attorney general Mark Brnovich, meanwhile, said within the week that he too believed that the 1864 law was in place and that he would move to enforce it.

Camelback Family Planning remained closed to patients for about two weeks, until a judge granted the request for an injunction on the fetal personhood provision, which came in at about 6:30 P.M. local time on a Monday. Goodrick and her team were ready. "That night, we called patients and we got patients in again. So we started on Tuesday, but no other clinic opened that day," she said. Desert Star soon joined them, but reduced the services they offered to patients.

The hostile political climate continued to create uncertainty for Arizona's abortion providers throughout that summer and into the fall. Lawyers advised many clinics to remain shuttered until there was further clarity about how the laws would or would not be enforced. Funders such as the National Abortion Federation stopped working with Arizona providers and did not resume offering financial assistance until October. Goodrick's staff struggled to keep up with patient demand. Lines started to form that stretched from the clinic's front door to the back of the parking lot. People came the night before to camp out in their cars or in lawn chairs.

Then, three months after the *Dobbs* decision landed, Goodrick was driving home on a Friday afternoon when, for the second time, a text from a reporter came in that changed her world: "How do you feel about abortion being banned now in Arizona?" she recalled it saying.

The 15-week ban was set to take effect the next day. But a judge in Pima County had just lifted an injunction on the 1864 law, so it was

unclear whether it would supercede the 15-week ban and in what parts of the state. Even Arizona's Republican leaders had discordant interpretations: Ducey, the governor, said the 15-week ban was the law of the land; Brnovich, the attorney general, said the 1864 ban applied. The advice Goodrick was getting from her lawyers wasn't making much sense—everyone was operating in an uncharted legal gray area.

Camelback Family Planning closed again and remained closed for another two weeks.

Exasperated, Goodrick and her team decided it was time to get creative. One of Camelback Family Planning's doctors is a semi-retired OB-GYN based in California, in the Palm Springs area who flies in to work several days at a time to work at the Phoenix clinic and stays with her sister. During this period of utter legal confusion, this California connection became a lifeline for the clinic's Arizona patients seeking abortions early in pregnancy.

Camelback Family Planning's employees located three post offices along the Arizona-California border. Patients scheduled telemedicine appointments with the California-based doctor, then that doctor used an online pharmacy to ship medication abortion to the border-area post offices. One of the clinic's nurses, Ashleigh, started to feel fed up. "It's not ethical, and it's not moral, and the more time we spend letting politicians tell us what to do, tell us what's moral, when we know what is right—it's just ridiculous. We should do what the right thing is to do, these laws and policies aren't informed, they're not made by people who have any kind of medical degree," she told me.

The pharmacy they worked with was Honeybee Health, which had also been preparing for a time when abortion patients might need to cross state lines to get the medication they need. "They were fantastic, they were so good, they had these little kits put together that had the first medication, the second medication, some ibuprofen, some Zofran. It was so nice, how they package it up, they're a fantastic,

fantastic pharmacy, and they're really pro-choice and have helped us a lot," Ashleigh said.

Then, on October 7, the Arizona Appeals Court put the 1864 abortion ban on hold again, pending arguments in the case, and Camelback Family Planning resumed providing abortions on site up to 15 weeks' gestation. It was one month before the 2022 midterm elections, when the state would elect a new governor and attorney general, and there were just four more days for voters to register.

The Republican candidate in the gubernatorial race was Kari Lake, a former local Fox news anchor who left the business—and the Democratic Party—to launch her campaign, which was built on a self-created rivalry with the national media, a fervor for Trump, and conspiracy theories. CAP- and Trump-backed Lake won her primary with support from 9.5 percent of the electorate—the kind of candidate Save Democracy Arizona aimed to prevent from prevailing in partisan primaries.

Though Lake had trailed Democratic nominee Katie Hobbs, the secretary of state, for months in the general election, the gap was narrowing between the two women. On the day Goodrick's clinic resumed providing abortions through 15 weeks, Hobbs led Lake by less than half a percentage point in their race to be Arizona's next chief executive, who would be able to either sign future abortion restrictions passed by the state legislature or veto them.

Some Democrats were worried that Hobbs wasn't visible enough on the campaign trail—weeks before, she'd refused to debate Lake, her campaign manager telling local and national news organizations that it "would only lead to constant interruptions, pointless distractions, and childish name-calling."

Goodrick prepared for the worst, applying for medical licenses in California, Nevada, and New Mexico.

The year before, Republicans had made what NPR called "sweeping changes" to the state's early voting system that had the potential to

remove tens of thousands of Arizonans from the list of voters who would automatically receive ballots to vote by mail—changes that would likely disproportionately affect low-income voters and people of color who tend to back Democratic candidates.

Goodrick's thinking was that if voter turnout was high, Hobbs would pull it off. If it wasn't Lake would win and she might have to think about leaving the state.

But *would* voters turn out?

Goodrick, along with the rest of the country, would soon find out.

CHAPTER FIVE

"It's up to you to decide whether that is a risk you're willing to take."

Louisiana

NEW ORLEANS—After a whirlwind week of appearances and panels in September at Tulane University in New Orleans, Robin Marty opened her final event—a Friday lunch among Newcomb Institute interns—by asking the students what they wanted to know. "I can answer questions, especially questions about what's going on in the South," Marty said.

The thirteen students at the lunch were participating in an internship program run by Tulane's Newcomb Institute, which aims to cultivate leaders who will "discover solutions to the intractable gender problems of our time." Their internship assignments included conducting research on maternal health, distributing clean needles and emergency contraception, working on a film about Indigenous

midwives, and crafting digital resource booklets about sex education. Most of the students had been at one or more of Marty's events earlier in the week.

"And I'm always saying the stuff that I'm not supposed to be saying, so if you have questions about organizations . . ." Marty continued.

"Or doing illegal stuff?" interjected internship coordinator Clare Daniel, an American Studies professor who teaches courses on gender studies and reproductive rights, and who helps direct the institute's community engagement program.

"Or doing illegal stuff," Marty responded, "but I think I probably told most of you how to be illegal—have I told you how to be illegal?"

The students smiled and nodded.

"But I'd like to hear more about specific illegal things," one ventured.

"Okay," Marty said, "how many people agree with the statement that any person who becomes pregnant has the potential to die in childbirth?"

Every student raised a hand.

"All right," she continued as the hands went back down, "how many people agree with the statement that an abortion in the first trimester is 14 times safer than childbirth? You can agree with that because it's actually true."

The hands went back up.

"We are working under the concept, then, that because those two things are true, that means that providing somebody with information or access—in any way shape or form—to an abortion that will allow them to terminate a pregnancy in the first trimester is in fact life-saving information and medication. You are saving a person's life," Marty said.

The students around the horseshoe-shaped conference table were rapt.

By the time Marty arrived for these speaking events in New Orleans in late September, the city's only independent abortion clinic, the Women's Health Care Center (which since the 1980s had provided reproductive and abortion care) was vacant, its metal gate padlocked shut and the lawn gone to seed. The doctors and activists who worked in reproductive health care and justice were wondering what to do next, now that the eight thousand or so people who typically received abortions in the state of Louisiana each year would need to travel out of state. A slide that Marty showed in her Tulane appearances showed the time it would take for a person in New Orleans who needed an abortion to drive to get one in a state where it was still legal: six hours to southern Georgia; ten hours to southern Illinois; thirteen hours to Kansas; sixteen hours to New Mexico.

But, Marty tells the interns, there was one way that people in New Orleans wouldn't have to travel for abortion care: medication abortion obtained out of state.

At that point in time, patients could schedule telehealth appointments with health care providers in states where abortion was still legal and have their prescriptions for medication abortion filled by an online pharmacy.

As a result, movements to encourage those in abortion-hostile areas to stockpile medication abortion and contraception were already underway. Some liberal-leaning states were already amassing medication abortion and coming up with creative ways to protect their prescribing doctors from retaliation by antiabortion prosecutors inclined to look across state lines. Knowing the potential for medication abortion to stymie the push to ban access, an alliance of antiabortion health care providers had already incorporated in a friendly jurisdiction in Texas that would challenge the Food and Drug Administration's 2000 approval of the abortion drug mifepristone in a case that would end up going all the way to the Supreme Court.

"Now, a lot of people will ask: 'If this is true, why are there not illegal abortions happening all over the place? Why are doctors not providing illegal abortions? Why is there not more activity on this?'" Marty said, noting that to do so would carry legal risk. "But it's up to you to decide whether that is a risk you're willing to take, whether you have the privilege to be able to take that risk and whether you are the person who is best suited for that."

It was a risk that on some level Marty was taking herself. At every event in New Orleans that week, at Tulane and during a reading at nearby Blue Cypress Books, Marty was careful to note that she was there as an author, not as the director of the Alabama clinic where she worked, to shield her medical team from legal liability and make it her own, and not as a physician or clinical health care provider.

Marty's second book, *Handbook for a Post-Roe America*, had published in 2019, and an updated version, *The New Handbook: The Complete Guide to Abortion Legality, Access, and Practical Support* in 2021. She always remembers when it first published because "that was the year that everybody started passing antiabortion legislation that was ridiculously unconstitutional because they were no longer worried about possibly reaffirming *Roe v. Wade*," she told me.

Marty's book tour is how she ended up making the shift from writing about abortion to facilitating it. She remembered talking a "lot about what was going on in Alabama, because Alabama had just introduced the first total abortion ban, and we knew it was going to be the first whole abortion ban to actually pass." When it did, with an exception only to save a pregnant person's life but not rape or incest, money started pouring into the Yellowhammer Fund, which provides financial abortion support to patients in that area of the South. To promote the handbook, Marty traveled to Alabama from Minneapolis, where she was living at the time, and was already encouraging activists to start building a reserve of

medication abortion and preparing for mass civil disobedience after the fall of *Roe*.

When Yellowhammer Fund asked if she wanted to come on as their communications director, at first she hesitated, because "I'm a White lady in Minnesota, I'm not the person to be doing communications for a Black-led and Brown-led fund in Alabama." But it was clear that it was a good fit and came at the right time. She told me she remembers thinking: "I can't be a reporter right now, this is too much, I need to directly, actively do something." The book tour eventually turned into a job at Yellowhammer, then to one at the West Alabama Women's Center when the fund took over management of the clinic.

By the time Marty was in Louisiana, in the fall of 2022, her updated handbook had become a cult bible of sorts for activists working in the reproductive rights space, with chapters on "Finding Your Personal Cause," "Knowing Your Comfort Zone," "Avoiding Surveillance in a Post-*Roe* America," and "So You Want to Be the Next 'Jane'," referencing the underground network of Chicago-area women who facilitated abortions pre-*Roe*. After the *Dobbs* decision, its teal cover could be spotted across the country in the windows of independent bookstores, which, during the Trump administration, had taken on a renewed role as hubs of progressive civil resistance, especially in conservative states.

At woman-owned Blue Cypress—their tote bag and T-shirt slogan: BAD BITCHES READ GOOD BOOKS—Marty's *Handbook* shared a display table with the Nobel Prize winner and French feminist writer Annie Ernaux's *Happening*, which tells the story of her abortion at age twenty-three; a zine about herbal abortions; and *Controlling Women: What We Must Do Now to Save Reproductive Freedom* by Kathryn Kolbert and Julie Kay, two prominent lawyers in the abortion rights movement.

Marty had appeared at Blue Cypress the night before her meeting with the interns. She'd been in conversation with Amy Irvin, a local reproductive justice advocate who co-founded the New Orleans Abortion Fund and helped establish Newcomb's internship program. Irvin had also stepped in to handle the flood of press inquiries for Louisiana's three remaining clinics after *Roe* fell and they closed, then reopened, then closed for good. The two discussed how pre-*Dobbs*, independent clinics had provided the bulk of abortions in the South, including in Louisiana, where the state's elected officials also had yet to define what conditions would be covered by the "life-threatening" exception to its abortion ban. The women fielded questions about *Dobbs*'s potential impact on midwives, attempts to use the 1873 Comstock Act to restrict the shipment of medication abortion across state lines, and how to progressive movement-build in rural areas.

To the people at the reading, Marty was like a reproductive rights rock star, with a pleasantly messy bun, sensible shoes and thick-framed glasses instead of a flashy outfit and a guitar. To the Tulane students, she was the cool activist they wanted to be when they were older; or maybe reminded them of a favorite aunt. Privately, Marty was an exhausted working mom. All she could think about was getting back to her hotel room and running a hot bath. It had been a rough week being away from her three kids. Her son is on the autism spectrum and struggles with changes to his schedule. There had been a phone call from his school about an outburst. This would be her last work trip for awhile. The next morning she would take a 7-hour train ride back to Tuscaloosa—flying makes her nervous, so she tries to avoid it.

Marty walked the interns through the various ways they could get an abortion or help someone find one. There was a website based overseas that would ship medication abortion pills to states where it was newly illegal. But, she warned, if they then provided the

medication to someone else, they could face legal liability. She urged them to take precautions: Don't send texts about it, don't send emails, don't post on Facebook, use a private Internet browser, use encrypted messaging.

Plan ahead: Getting the medication can take up to five weeks but if you order it now, you'll have it on hand when it's needed.

The type of pills: Aim for the ones you can place in the cheek that are absorbed and cannot be traced by a blood test.

If there are problems: There are clinics that will provide after care.

"But *DO NOT* call a CPC," she said, using the acronym for crisis pregnancy centers, most of which aren't actual medical clinics and are therefore not bound by health privacy laws, and run by the anti-abortion movement. If they felt scared, they should go to the emergency room—but they needed to know what to say.

"All a person needs to do is state: 'I am pregnant. I think I'm having a miscarriage. I'm scared.' There is no other information that a medical provider needs," Marty told the interns. "They do not need to know that you took a medication abortion, they do not need to know anything else, and there is something about saying 'I'm scared' to an emergency room physician or a surgical physician," she continued, "because they are still a very racist, patriarchal sector, they suddenly feel that you are behaving properly as a person who is having a miscarriage, and they're much less likely to question a person because they're having a bad pregnancy outcome."

If they or someone they know *are* questioned, Marty told the students to contact the organization If /When/ How. They will connect those facing legal liability with attorneys and bail funds working in this space, she said.

Much of Marty's talk with this next generation of reproductive rights activists in the U.S. South focused on legal liability and risk assessment because it was her new reality. By this time, Alabama Republican attorney general Steve Marshall had already said his office

was "reviewing" whether the state's abortion ban or other laws related to criminal conspiracy could be used to prosecute health care providers, or those who facilitate abortion in other ways, such as funders or people who advised friends on interstate travel or who helped someone obtain medication to self-manage an abortion. Texas had a vigilante-style enforcement mechanism in place that allowed private citizens to bring lawsuits against anyone who helped someone obtain an abortion.

Facing criminal liability for providing abortion was quickly becoming the new reality in Louisiana, too. Just a couple of days before the *Dobbs* decision, Louisiana governor John Bel Edwards—a rare antiabortion Democrat in executive office—had signed legislation updating the state's 2006 trigger ban and adding increased criminal penalties for abortion providers: up to ten years in jail and fines between $10,000 and $100,000. While Edwards or Republican attorney general Jeff Landry had not yet made any move to punish private individuals for aiding and abetting people seeking abortions, questions remained about how these news laws would be interpreted by prosecutors, and Landry and other antiabortion lawmakers were particularly focused on blocking the shipment of medication abortion.

Marty walked the interns through what Marshall's interpretation of various laws meant for her and others in neighboring Alabama. "That means we are not allowed to tell people where the closest clinic is, we are not allowed anymore to provide financial support, we cannot talk to them about what they could do in order to access an abortion, we cannot do any of that, anymore. And the attorney general has specifically said and targeted ourselves and the Yellowhammer Fund and said that he knows that there are groups that are doing such things and that he will bring charges if he needs to," she said.

The West Alabama Women's Center had recently had to decide whether it would advertise itself as a safe space where patients could come who were miscarrying, or who had complications after a self-managed medication abortion, or who needed to know whether it was complete. Other Alabama clinics had decided advertising this type of care was too risky since miscarriage care is often indistinguishable from abortion care on a medical chart. But Marty's clinic decided that was "bullshit," she told the interns.

"That is something that we are now going to start promoting, essentially, because we want to see what happens next, because at this point, we, as well as many people who are living in states where we're hearing about criminalized information, are essentially reacting to things that we do not know for sure, because we do not know what the rules are," Marty continued. "[Marshall] has managed for three months now to silence us and stop our work by saying that there is a conspiracy out there but not saying specifically how that would be enforced."

"We know the First Amendment should allegedly still exist in Alabama—fingers crossed," she added wryly.

Throughout Marty's hour-long meeting with the interns, Jordan Williams, a freshwoman, was diligently taking notes. The color of the typeface on her SEX WORK IS POLITICAL T-shirt—from her internship with the Lousiana organization Women with A Vision, which supports marginalized women—matched her red Converse hi-top sneakers. She told me after the lunch meeting that when she got to college, she started to realize how limited her understanding was of gender, feminism, and LGBTQ+ communities—now she was doing everything she could to learn more.

When *Roe* fell, Williams knew that, as always, marginalized communities like her own on Chicago's West Side would be among those hardest hit, even in a state like Illinois where abortion was

protected. She had learned about Newcomb's internship program earlier that fall from her Black Student Union group chat. Then, just days before Marty's visit, Williams applied to the Newcomb Scholars Program, which annually selects twenty "intellectually curious and motivated first-year students" who want to spend the next three years focused on "feminist leadership" in a "community of diverse thinkers, leaders, and activists." Williams told me that she "did not see many Black kids in the program, so I thought: 'Well, let me try.'"

Williams said that Marty's talk that afternoon had reinforced that she wanted to be a Newcomb Scholar, and it "changed my life, quite literally, something as short as that."

On Halloween, a month later, as I was wrapping up a trip to Louisville, Kentucky, Williams sent me a text: "Hi hi just wanted to give you a brief update on my Newcomb Scholars decision!" Attached was a photo of her acceptance letter for the Class of 2026 cohort. She'd highlighted the first word: "Congratulations."

The next generation was entering the fight.

"Which way do I need to vote to support women's rights?"

Kentucky

L OUISVILLE— On a warm, sunny Saturday in late October, Laura Weinstein and Emily Albrink Katz met in front of a branch of the Louisville Free Public Library to receive a street assignment from a field organizer with Protect Kentucky Access.

The dozen or so women who showed up—it was all women who volunteered that afternoon—picked up flyers, yard signs, and bumper stickers that urged "Vote 'No' Amendment 2" from the organizer. Then, they loaded a list of voters' addresses onto their phones and prepared to go door to door.

It was ten days before the 2022 midterms. Kentucky's six U.S. House seats were on the ballot. Republican U.S. senator Rand Paul was cruising to a third six-year term. There were mayoral races in Louisville and Lexington, liberal-leaning urban dots in a state that is mostly conservative and rural. Then, at the very bottom of Kentucky

ballots, after state representatives, circuit court judges, and nonpartisan city council seats—sometimes buried as deep as the seventh page, depending on the county—were two potential amendments to Kentucky's constitution.

The second proposed amendment was the reason Weinstein and Albrink Katz met at the library that day instead of raking leaves at home or putting the finishing touches on their families' Halloween costumes. It asked:

> *Are you in favor of amending the Constitution of Kentucky by creating a new Section of the Constitution to be numbered Section 26A to state as follows: To protect human life, nothing in this Constitution shall be construed to secure or protect a right to abortion or require the funding of abortion? "Yes" or "No"*

The two friends were determined not to let the amendment pass. So Weinstein, a petite blonde with an easy smile, looked at their doorknocking assignment on her cell phone: a couple of dozen voters along nearby Goddard Avenue. It was in an area of Louisville known as the Highlands, a dense suburban neighborhood of mostly single-family homes and independent businesses.

Weinstein and Albrink Katz left the shopping center that houses the library, along with a range of local businesses that include ramen and Mediterranean restaurants and an eight-screen movie theater that shows foreign and independent films. The athleisure-clad women crossed its rear parking lot and began walking down Goddard, a single but extended block of turn-of-the-century colonial and Craftsman style homes. Mature oak and maple trees created a street canopy of resplendent autumnal reds and yellows. Plump pumpkins sat on porches, ready for carving.

It was the first time that Weinstein had volunteered with Protect Kentucky Access but not the first time she had participated in a

political canvass. Weinstein graduated from the University of California, Los Angeles, and worked or volunteered on campaigns in other states before moving back to Louisville to be closer to her and her husband's families.

For Albrink Katz, though, it was her maiden voyage into grassroots political activism, and she was a little nervous. How would they be received? Would there be confrontation? Hostility? Slammed doors? She started to relax as they walked past houses that already had "No on 2" yard signs and porches featuring Progress Pride flags—the traditional LGBTQ+ rainbow with a chevron of black, brown, pink, and light blue to represent communities of color and transgender rights.

As they approached the first house on their list, Weinstein read from her phone: "They're 39 and 41—about our age—and the 'D' means they're registered Democrats." Two firm knocks on the door. No answer. They slid a flyer under the handle of the storm door and the two women continued to the house next door.

Why, Albrink Katz wondered aloud, given the "no" signs and other intentionally public indicators of left-leaning politics along Goddard, were volunteers sent there instead of to a neighborhood more like their own, where there were fewer "no" signs and even some urging "yes"?

"What's important is getting people out to vote," explained Weinstein, who teaches government at a local community college. "This is the time for mobilization, this isn't the time for persuasion. Because it came up so quickly, because a lot of people don't know about it, at this point it's really making sure voters get out and know about this issue."

"Interesting, got it," Albrink Katz said. "Maybe I should do the knocking and you'll do the talking."

The two friends laughed.

Weinstein and Albrink Katz were engaged in a form of civic participation that is nearly as old as democracy itself—canvassing

began in ancient Rome when candidates would meet with voters in the Forum. It was also used in nineteenth-century Great Britain. Though in the earliest U.S. elections it was considered unseemly to court voters this way, the use of canvassing increased as the country's two-party system matured. Canvassing has fallen in and out of favor here over the past two hundred years. By the 2022 midterms, it was considered a key component of grassroots organizing, or building social and civic movements locally from the ground up.

Before signing up to canvass, Albrink Katz had been feeling discouraged. The word that kept popping into her head was "dire." She voted, but like the vast majority of Americans, her political involvement mostly ended there, save for some Facebook posts about issues she cared about. Then, her participation in a Jewish mothers' group presented an opening to get more involved in defeating the measure.

First she was invited to an informational house party organized by a network of Jewish women working to defeat the proposition. Albrink Katz said yes. She is a soprano who teaches voice at a local university and has performed with the Kentucky Opera, so at the house party held the prior Sunday, she had even performed a song from the Broadway musical *Waitress*, about the protagonist struggling with an unintended pregnancy. Singing was something she was used to, so it didn't feel scary.

After the house party, a friend from their book club—an offshoot of a Jewish mothers' group—texted Weinstein and Albrink Katz to say she was going to volunteer to go door-knocking at 1:30 P.M. the next Saturday. Would they like to join? Albrink Katz thought: "I can do that."

"She made it easy," Albrink Katz said of her friend's text with information about how to support their cause.

Albrink Katz and Weinstein both signed up for a shift with Protect Kentucky Access, a coalition of groups supporting civil rights and reproductive health that were working to defeat Amendment 2. The coalition included the Kentucky chapter of the American Civil Liberties Union, the regional Planned Parenthood, the Kentucky Religious Coalition for Reproductive Choice, and Sister Song, a national organization supporting reproductive justice for women of color.

By signing up at the information session and canvassing with Weinstein that Saturday, Albrink Katz joined a small percentage of Americans who have volunteered for a political cause. A Pew Research survey from 2018 showed that over the five preceding years, 42 percent of Americans reported posting about politics on social media, and 28 percent had attended an event or rally, but just 16 percent had volunteered or worked for a political campaign. It felt "exhilarating" to Albrink Katz to play even this small role in the machinery of her democracy, she said.

One reason? Canvassing works. This type of face-to-face interaction has been shown over and over again to be more effective at getting voters to the polls than sending direct mailers, or even phone banking.

In Italy, economists found that canvassing increased turnout in 2014 municipal elections by 1.8 percent. Former French President Francois Hollande's team said canvassing increased turnout in his 2012 reelection campaign by 3 percent, and he won by just 3.3 points in a runoff.

Nonpartisan canvassing in New Haven, Connecticut, ahead of the 1998 elections is thought to have increased turnout there by about 6 percent. Former Democratic President Barack Obama's 2008 White House campaign was heralded for its so-called "ground game"—and canvassing played a central role. The relatively unknown first-term senator from Illinois predicted in June 2007 (more than a year ahead

of the election) that his campaign would conduct one of the largest door-knocking efforts in the history of presidential politics.

To lead this "ground game," Obama tapped Marshall Ganz, a senior lecturer at Harvard University's Kennedy School of Government, who dropped out when he was a student to move to the South and register Black voters during 1964's Freedom Summer. Then, he organized Mexican American farm workers under Cesar Chavez before returning to the university nearly thirty years later to finish his undergraduate degree. Now he teaches an organizing course that in 2023 I was able to audit. Ganz begins the course with the same questions he asks when designing an organizing campaign. Quoting Hillel the Elder, an influential Jewish rabbi in ancient Babylon, Ganz asks: "If I am not for myself, who will be? And if I am for myself alone, what am 'I'? And if not now, when?" Ganz teaches organizing via these questions by asking activists to develop a "story of self," a "story of us," and a "story of now." In 2008, Ganz's organizing framework helped about a million and a half volunteers and some three thousand full-time organizers use personal stories to knock on millions of doors on Obama's behalf.

On Election Day, the onetime underdog Obama notched a 7-point victory. Obama's—and Ganz's—ground game has been studied ever since.

When political scientists Donald P. Green and Alan S. Gerber assessed dozens of U.S. canvassing efforts from 1998 to 2018 across a variety of categories—by nonpartisan academics, for progressive issue campaigns, on behalf of Republican Senate candidates, and by Democrats encouraging youth turnout in key battleground states—they found that going door to door increased voter turnout in 49 of the 56 cases they studied.

But, the researchers found, there were a variety of factors that affect the efficacy of door-knocking efforts. For starters, canvassing is most effective in increasing turnout, as opposed to changing voters'

minds. It is best done in the week before an election. It works better if the person doing it is a member of or in some way reflects the community in which they're canvassing. And it can be particularly effective when canvassers ask a voter to walk them through their plan to cast a ballot. "Many nonvoters need just a nudge to motivate them to vote. A personal invitation sometimes makes all the difference," Green and Gerber concluded.

Back on Goddard Avenue, a retiree answered the door at the third address on Weinstein and Albrink Katz's list. He said that it was a house, and marriage, divided. He told Weinstein and Albrink Katz that he would be casting a "no" ballot on Amendment 2. His wife—a "single-issue voter" who opposed abortion—would be voting "yes." Weinstein asked if he knew where his voting precinct was and whether he had a plan to get there. He assured the women that he knew where to go, and that he would be casting his "no" ballot on Election Day.

Next, the friends crossed the street and approached a man outside mowing the lawn—both he and his partner were listed as likely "no" voters in the Protect Kentucky Access database. He powered down the mower to better hear their pitch. He and his partner would definitely both be voting "no" on the ballot initiative, he said.

"We were just talking about this last night. I'm not really informed on Louisville politics and at dinner they were explaining it and I thought: 'How could that be'? Thank you all for stopping by, I appreciate what you're doing. Be careful," he said, powering the mower back up as they walked to the next house.

In theory, ballot initiatives—also known as ballot measures, referendums, or propositions—are the most direct form of democracy: voters decide to adopt or reject policies, laws and state constitutional amendments without their first going through a legislature.

Headed into the 2022 elections, Kentucky was one of 26 states along with the District of Columbia that had some type of citizen ballot initiative process. There are direct initiatives, when citizens

collect signatures to get a measure onto the ballot on their own. Another type of initiative, called a veto referendum, asks voters whether they want to repeal a law that was already enacted by a governing body like the legislature or a local government such as a city council. State legislatures in forty-nine states can also put what are known as referred initiatives onto the ballot that they have not been able to pass, or language they wanted added to the state constitution, so that voters can decide whether to approve it—this was the case in Kentucky.

In practice, ballot initiatives have become tools favored by moneyed interests like corporations and labor unions, and not rank-and-file voters, in large part because crafting the language, collecting the signatures, and putting up a statewide information campaign can be prohibitively expensive. In 2018, for example, groups spent nearly $1.2 billion supporting or opposing ballot 106 certified measures in the states where they were on the ballot.

And when it comes to ballot initiatives, money wins.

An analysis by the nonpartisan website Ballotpedia showed that of the 48 measures on which interests collectively spent $5 million or more in 2018, the side that spent the most money won in 42 cases.

In liberal-leaning California, for example, there was a 2018 citizen-referred proposition to repeal a 1995 law that prevented local governments from imposing rent controls on some types of units. The Coalition for Affordable Housing, the AIDS Healthcare Foundation, and the Alliance of Californians for Community Empowerment led the "yes" campaign, collectively raising $25.3 million. The "no" campaign, led by the California Apartment Association and the California Rental Housing Association, raised $71.4 million, with multi-million-dollar donations coming from the California Association of Realtors and the investment firm Blackstone Property Partners. The proposition failed by 19 points, with just 40 percent of California voters supporting it.

In 2020, again in California, there was a proposition to exempt companies like Uber, Lyft, DoorDash, and Instacart from complying with a state law that required them to provide employee benefits to so-called "gig" workers. Proposition 22 became the most expensive in the country's history—more than $194 million poured in, with more than 90 percent of it on the side of the tech companies, not their gig workers. Uber kicked in more than $59 million and Lyft $49 million. DoorDash spent $52 million and Instacart $31.6 million. The proposition passed by 17 points, with 58 percent of California voters agreeing that Uber, Lyft, and other gig workers would go without otherwise standard employee benefits. As "No on 22" spokesman Mike Roth told the *Los Angeles Times*: "The 'no' side always knew it was going to be outspent, but we didn't think we'd be outspent 13-to-1 . . . no corporations should be able to buy their own laws."

One reason that money has such an impact on the success or failure of ballot initiatives is because these initiatives are almost always complicated and confusing, so getting voters to approve or reject one can require a large-scale education effort—it also makes the process vulnerable to misinformation campaigns.

On Goddard, Weinstein and Albrink Katz continued to the next house, admiring Halloween decorations along the way. A man answered the door at the brick colonial with his two elementary-school-aged children.

"Hi!" Weinstein said brightly. "We're volunteers with Protect Kentucky Access and we're talking to voters about the abortion amendment, Amendment 2, do you know much about that?"

"Vaguely."

"Essentially," Weinstein continued, "what it does is permanently outlaw abortion in Kentucky."

"Which way do I need to vote to support women's rights?"

"You need to vote 'no.'"

"That's what I needed to know. I kept hearing about it. But when you read it, they're incredibly difficult to understand. You have my support," he said.

"Thank you so much," Weinstein said, handing him a flyer to give to his wife.

"That," she said, turning to Albrink Katz as they walked down the sidewalk back to the street, "is the type or person we're out here for."

The man at the brick colonial wasn't the only voter who found ballot amendment language confusing. When Ballotpedia analyzed twenty-seven measures in 2017 across nine states, they found that merely understanding the titles would require seventeen-to-twenty years of formal U.S. education—in other words, a graduate degree. Understanding the actual text of the measures would require an extra year, according to the Flesch-Kincaid Grade Level formula developed in 1975 for the U.S. Navy. Citizen-offered initiatives had an average score of fourteen years, while those offered by legislatures had an average score of twenty-three years.

But here's the reality of literacy in America: About half of adults read at middle school level—on par with someone who has had seven to nine years of formal education. In Kentucky, just 10 percent of the population has a graduate degree; another 15 percent have a bachelor's degree and 8 percent an associate's degree. About 13 percent of adults did not graduate from high school.

When a doctoral candidate at Georgia State University analyzed nearly twelve hundred ballot measures over a ten-year period ending in 2007, she found that voters were more likely to skip complex ballot initiative questions, presumably because they are difficult to understand. Confusing ballot proposition language is increasingly seen by their critics as an intentional feature, not a bug. Good government groups and voting rights activists have started filing lawsuits in recent

years over ballot initiative language they found unnecessarily confusing. But courts give states a lot of leeway in how elections are administered, and the lawsuits have met with limited success.

On Kentucky's ballot in November 2022, for example, Amendment 2 was preceded by Amendment 1, which asked:

Are you in favor of amending the present Constitution of Kentucky to repeal sections 36, 42, and 55 and replace those sections with new sections of the Constitution of Kentucky to allow the General Assembly to meet in regular session for thirty legislative days in odd-numbered years, for sixty legislative days in even-numbered years, and for no more than twelve additional days during any calendar year if convened by a Joint Proclamation of the President of the Senate and the Speaker of the House of Representatives, with no session of the General Assembly to extend beyond December 31; and to provide that any act passed by the General Assembly shall become law on July 1 of the year in which it was passed, or ninety days after passage and signature of the Governor, whichever occurs later, or in cases of emergency when approved by the Governor or when it otherwise becomes law under Section 88 of the Constitution?

Then, over ten more paragraphs, before getting to the "yes" or "no" bubbles, it delineated the actual language that would be substituted into the Constitution. It was essentially a measure that would empower Kentucky's General Assembly to set when they were in session and more easily call special sessions. It was a 744-word hurdle voters would need to either decipher or skip before arriving at the question of whether they wanted to amend Kentucky's constitution to permanently ban abortion.

Weinstein first heard about the abortion amendment on Kentucky's ballot over the summer. So, when classes began in August, she pulled

it up for her government class at the community college to talk through the language—something she does often in election years. Though she answered their questions about what a "yes" or "no" vote would mean, she did not tell her students how she thought they should mark their ballots.

But when she started discussing the amendment with her friends and family, Weinstein started to grow alarmed that an education effort was needed outside her classroom and in her social circle as well. Even her mother, a lifelong proponent of women's rights and an activist who took Weinstein to abortion rights marches in Washington as a teenager, didn't fully realize what Amendment 2 meant.

"This was in September, so it wasn't really too far away from the election," Weinstein told me. "I was concerned because when I was talking to people, no one really seemed to understand it, or what it meant, or which way they should vote on it. Even after talking to my students about it, they would ask: 'So what does "yes" mean and what does "no" mean?'"

Albrink Katz, meanwhile, practiced explaining Amendment 2 in the simplest of terms for an audience even closer to home: her seven-year-old son. He'd noticed a "yes" sign with an image of a fetus in their neighbor's yard, then his own parents' "no" sign, and asked: "What is this war between 'yes' and 'no,' Mommy?"

"I'm very direct with him, for the most part, about everything, so I said: 'It's very complicated, but sometimes when a woman gets pregnant, they don't always want to have the baby that's inside them. Sometimes they don't mean to get pregnant. Sometimes when they get pregnant, it's really bad and it could hurt them to have the baby. So Mommy and Daddy think that the person whose body it is should have a choice about what they want to do. And our neighbors, or people who are saying "vote yes," they think that they shouldn't have a choice, and that the government should make

that choice for them and they would have to have the baby no matter what.'"

"Well, that's not good," he said.

THE FIRST TEST of abortion policy's salience at the ballot box after the Supreme Court overturned *Roe v. Wade* was not in Kentucky but in Kansas, where in their August primary elections, voters had soundly rejected the proposed Value Them Both amendment to the state's constitution. It asked:

> *Because Kansans value both women and children, the constitution of the state of Kansas does not require government funding of abortion and does not create or secure a right to abortion. To the extent permitted by the constitution of the United States, the people, through their elected state representatives and state senators, may pass laws regarding abortion, including, but not limited to, laws that account for circumstances of pregnancy resulting from rape or incest, or circumstances of necessity to save the life of the mother—Yes or No*

A vote for the amendment would affirm that there is no right to abortion in the Kansas Constitution and therefore the state legislature could pass laws to regulate it in various ways or outright prohibit it. A vote against the amendment would leave the state Constitution as it was and, by doing so, also leave in place a 2019 Kansas Supreme Court ruling that the state Constitution protected the right to abortion, thereby preventing state lawmakers from passing any law that would ban abortion outright.

When the "no" campaign won in Kansas on August 2 with 59 percent of the vote, it was hailed as a major win for abortion rights. Nearly two hundred thousand more people voted on the amendment

than in the gubernatorial or Senate primary races on the ballot, and overall turnout far exceeded that in the 2018 and 2020 state primaries. Kansans for Constitutional Freedom ran the "no" campaign, as a coalition effort by groups including the state chapter of the ACLU, Planned Parenthood Great Plains Votes, the abortion clinic Trust Women, and United for Reproductive and Gender Equity (URGE).

Rachel Sweet, who managed the Kansas coalition, then the one that formed in Kentucky, was struck by two blocs within the Kansan electorate that converged to help deliver the resounding victory. "The first is that the electorate was significantly more female than on average, it was almost fifty-six percent women—that's huge; that in and of itself is amazing," she told me. "But the biggest thing that was surprising, or interesting, to me is the amount of independent voters who showed up, the people who showed up literally just to take a ballot that only had this question on it (because they cannot vote in partisan primaries) . . . those are the people that I think we should be the most focused on."

As attention turned from Kansas to Kentucky and other states where abortion would be on the ballot in November, President Joe Biden said the Kansas outcome "makes clear what we know: the majority of Americans agree that women should have access to abortion and should have the right to make their own health care decisions."

Meanwhile, Sweet wound down her work in Kansas and packed her bags, and within two weeks she was in Louisville, where Protect Kentucky Access had already launched their campaign and was attempting to build a movement with less than three months before Election Day. "Kansas sucked all of the oxygen out of the room. I really believe that, we sort of took all the attention, and all of the money, and all the resources, and it wasn't until that campaign was over that we were able to leverage the attention and the resources that we needed for Kentucky," Sweet said.

To an outsider, the political dynamics in Kansas and Kentucky might look a lot alike. Kansas had a GOP supermajority in its house of representatives; in its 40-seat senate, Republicans outnumbered Democrats by a nearly 3-to-1 margin; and its Democratic governor, Laura Kelly, was elected in 2018. In Kentucky's general assembly, Republicans outnumbered Democrats in the house by a 3-to-1 margin; its 38-seat senate had 29 Republicans and 8 Democrats; and its Democratic governor, Andy Beshear, was elected in 2019. Both of Kansas's U.S. Senate seats have been held by Republicans since the 1940s; both of Kentucky's have been since the late 1990s. Republican Donald Trump won the 2016 White House race by more than 20 points in both places and saw little-to-no erosion in his support in the states in 2020, when he nevertheless lost nationally to Biden.

But there were some key political and on-the-ground differences between the two states. In Kansas, for example, nearly half of voters believed abortion should be legal in "all or most cases," while Kentucky was one of just seven states—all in the U.S. South or Appalachia—in which a majority of adults believed the opposite. Less than a third of Kansas adults reported being evangelical Christian, a group that is historically opposed to abortion, while 49 percent of Kentuckians did.

In 2019, Kentucky was one of the states that approved both a "trigger ban"—a total abortion ban that would kick in if *Roe* ever fell—and a six-week abortion ban that was tied up in the courts. In April 2022, the state legislature passed another law that banned abortions after 15 weeks and mandated that "birth-death certificates" be issued after abortions. These laws, which require death certificates for aborted fetuses, create public records that identify people who have had abortions and can therefore have a chilling effect on pursuing abortion care. Kentucky's two remaining clinics said the law's provisions were so onerous they would have to close unless the courts intervened.

Even before the Supreme Court decided *Dobbs* and Kentucky's trigger ban took effect, Kentucky already had one of the lowest per capita abortion rates in the country: there were just two clinics operating to serve the state's 120 counties, and more than three quarters of Kentucky's women lived in a county without one.

A challenge for Sweet and Protect Kentucky Access was that they would have to convince funders that defeating the constitutional amendment was a worthwhile endeavor, even though the coalition's success would not result in immediate improved access to abortion.

But, as Sweet had told me earlier in September, she believed the same practical realities that might make funders wary would help motivate voters on the ground: "Abortion is already illegal in Kentucky, so we don't have to sell someone on a dystopian future—it's already there."

Their job was to make sure it wouldn't be permanent.

A lot was riding on their fight to beat back the amendment. For one thing, failed initiative efforts—or at least the type that don't directly benefit corporate interests—are rarely funded a second time. If the coalition failed to defeat the amendment, there would be little to no recourse in the legislature, the constitution, or the courts—unless political representation in the state dramatically changed.

Sweet distilled the coalition's message as: "For most people, they are somewhere in the middle on the issue of abortion, and the argument that we need to make is not that they should support abortion as an issue, but that these are decisions that do not belong in the hands of politicians, and that they should vote to protect the rights of their friends and neighbors. Our goal is not to dissuade anyone from continuing to hold the deeply held and conflicted feelings that they've always had. It's just to try and get them to be open to the fact that when we vote on this issue, we shouldn't vote to ban abortion or to take rights away from women."

By Election Day, Protect Kentucky Access had raised more than $6 million and organized volunteers like Weinstein and Albrink Katz, who knocked on thousands of doors across the state, particularly in its urban centers. Many of them were first-timers newly engaged in the political process. Sweet called it inspiring. "Their enthusiasm," she said, "is a general indicator of how motivating an issue this is."

On election night, a week and a half after they canvassed, Weinstein and Albrink Katz assumed the defensive mental crouch familiar to any left-leaning voter in a conservative state: They braced for defeat.

Weinstein put her son to bed, then tried to avoid the television until it was time to go to call it a night herself. Still, she woke up every hour to check the returns on her phone.

After a full day of teaching, Albrink Katz headed to an evening rehearsal of the Austrian composer Joseph Haydn's *The Creation*, which depicts God's creation of the earth as told in the book of Genesis. She was trying not to seem distracted as polls closed and results started coming in, but she too couldn't resist checking her phone. She texted with her husband shortly after the polls closed at 6 P.M., and the earliest batches of results trended in the "no" campaign's direction. "At the very beginning, there was like seven percent that had come in, and my husband was like 'it's only seven percent, Emily, don't get your hopes up.'" She nevertheless started to mentally climb out of what she called her "pessimistic hole."

By the time Tuesday night rolled into early Wednesday morning, news outlets had started calling Amendment 2 for the "no" campaign—an early conclusion in a midterm election where voters had prepared themselves not to know the outcome of key races for days, or even weeks. Sweet called it a "very good night all around" because their margin of victory was large enough to make a definitive call before many people went to bed.

Albrink Katz said the best word to describe her emotions that night was relief.

To Weinstein, it felt like an actual miracle. "I was in disbelief," she said.

By the time the results were certified later that month, Kentuckians had rejected Amendment 2 by a roughly 5-point margin, with 52.4 percent opposing it and 47.7 percent supporting it. In Louisville's Jefferson County, where there were 362,025 registered Democrats heading into the election and 206,205 registered Republicans, a significant bipartisan coalition formed, with 73 percent of the electorate voting "no" on the amendment. The same was true in Lexington's Fayette County, where there were 132,139 registered Democrats and 88,452 registered Republicans, and more than 70 percent voted "no." The high "no" margins in Kentucky's urban enclaves more than made up for the "yes" votes in the state's rural areas. But even there, Sweet said, there were some pockets where the "no" campaign overperformed compared to the modeling the coalition had done throughout the fall.

Votes were still being counted as political prognosticators started to debate what it all meant for 2024.

Starting with Kansas, abortion rights had won every time the issue was put directly before voters in the form of a ballot measure. In addition to Kentucky, voters in Montana—another solidly red political state—rejected by a 5-point margin a ballot measure known as the Born-Alive Infant Protection Act. Voters in the liberal states of California and Vermont had approved measures to enshrine abortion rights in their state constitutions by 67 percent and 77 percent respectively. In the political swing state of Michigan, where the stakes for abortion access were especially high—a 1931 state law banning abortion was on hold as Democratic governor Gretchen Whitmer challenged it in the courts—57 percent of voters approved an amendment to the state constitution guaranteeing the right to abortion and other reproductive health care services.

Abortion rights activists in Arizona, Colorado, Florida, Missouri, Nebraska, Ohio, Oklahoma, and South Dakota—all places where state law and legislatures are out of step with voters to some degree on abortion—began discussing whether to pursue affirmative ballot measures enshrining reproductive rights. Sweet said that while she thought it was a "worthy thing to explore, it's much harder to get people to vote 'yes' on something than it is to get them to vote 'no.'"

High-level conversations were already taking place within national groups like Planned Parenthood and the ACLU to determine how to deploy funding to the activists in states considering offensive ballot measures affirming constitutional abortion rights. Activists in Ohio, Kentucky's neighbor to the north, were already talking about pursuing a ballot initiative in 2023, without waiting for the national elections in 2024.

"Not every single state that wants to do one of these is going to be able to do one in 2024 and get adequate funding to run really strong campaigns," Sweet cautioned, "and it's harder when you are in a conservative state to get multiple bites at the apple, you don't really get to fail."

Sweet pointed out that in Kentucky, the "no" campaign outspent the groups urging a "yes" vote by a 6-to-1 margin, and that "if everyone tries to do this in 2024, there will be a point in time where some of the wells run dry."

In Kentucky, with the ballot initiative defeated, abortion rights supporters turned their attention from the ballot box back to the courts. The state's Democratic governor, Andy Beshear, said he hoped the courts would "listen to the will of the people, and know that the people have rejected extremism, and rule accordingly."

One lawsuit had been filed shortly after *Roe* fell by a group of former abortion providers in the state.

Another had been filed the month before by three Jewish women who argued that Kentucky's abortion laws violated their religious rights under the state constitution and law because sacred Judaic texts state that life begins "from the moment the fetus emerges from the womb."

Now that the amendment was defeated, the providers and women could pursue their days in court.

Winter 2023

"We are at a total stalemate in Congress."

Washington

WASHINGTON—When the 118th U.S. Congress was sworn in on January 3, 2023, the Senate was split 51–49 in favor of Democrats and the House of Representatives 222–213 in favor of Republicans. Democrats performed better than expected in the midterm elections based on historical precedent, when the president's party often suffers calamitous losses, but neither party had the numbers it would need to pass meaningful legislation related to abortion—both would still try.

During the first full week of congressional business, GOP representative Ann Wagner of Missouri, where abortion was banned, introduced the Born-Alive Abortion Survivors Protection Act. It was a bill Republicans had introduced every Congress since 2015—as stand-alone legislation but also as an amendment to unrelated bills, like one in 2020 regulating e-cigarettes. It would establish criminal

penalties for health care providers who fail to care for infants "born alive" after an abortion attempt. It is not based in science or medical reality but teed up what's known in Washington as a messaging vote, when lawmakers know a vote won't have a real-world impact but will provide them with a record to tout on the campaign trail.

"It pains me," Wagner said, "that this fight has to be fought at all, but medical care for babies should not be a partisan issue." It sailed through the House in a 220–210 vote, with support from only one Democrat, Rep. Henry Cuellar of Texas, the last member of his party in the House who opposed abortion. It was then introduced in the Senate, where it would go nowhere.

Wagner's introduction was followed by Sen. Tammy Baldwin of Wisconsin and Rep. Judy Chu of California, both Democrats, introducing the Women's Health Protection Act in their respective chambers. The WHPA was a bill Democrats had introduced every Congress since 2013 that would prohibit states from passing most abortion restrictions prior to fetal viability. *Dobbs* increased the bill's urgency but some abortion-rights-supporting Republicans said it went too far, beyond the scope of *Roe*.

"In Wisconsin, women are living in 1849, where a near-total abortion ban that pre-dates the Civil War is in effect that is putting women's health and well-being in jeopardy," Baldwin said. The year before, the WHPA had passed in the Democrat-led House but stalled in the evenly split Senate, where most legislation requires sixty votes to overcome a procedural hurdle known as the filibuster. In the 118th Congress, the WHPA would likewise go nowhere.

Democrats, led by President Joe Biden, had cast the 2022 midterms as an opportunity for voters upset about the *Dobbs* decision to make their anger heard. Two weeks before the elections, Biden promised the American people that he would veto any antiabortion bills passed by a GOP-led Congress as long as he was in the Oval Office. Plus, if voters helped Democrats pick up the "handful of votes" they

needed, "the first bill that I will send to the Congress will be to codify *Roe v. Wade* . . . I'll sign it in January, fifty years after *Roe* was first decided the law of the land," he said.

It was a bold promise that had very little chance of coming to fruition.

In the five states where abortion was put directly before voters in the form of a ballot initiative or measure, abortion rights won. The *Dobbs* ruling helped Democrats hold on to key Senate seats and pick up Pennsylvania. But Donald Trump's 2020 voters turned out at higher rates than Biden's 2020 voters did, and Democrats lost control of the House by a nine-seat margin. Even though it was a fifty-year turnout high for a midterm election year, just 46 percent of Americans who were eligible to vote in 2022 cast ballots. It would remain politically impossible, even if Democratic leaders took on the uphill battle of changing Senate filibuster rules, to get a bill codifying *Roe* through the 118th Congress.

By *Roe*'s fiftieth anniversary on January 22, 2023, its constitutional protections were six months gone, and there was no clear legislative path to restore them nationwide except to wait and bring another case before a friendlier, or at least less hostile, Supreme Court.

Leaders on both sides acknowledged they were at a stalemate on federal legislation—but it wasn't always that way.

There was a time not too long ago—maybe within your lifetime—that abortion wasn't a political issue at all. The legislative impasse at the federal level is the product of a decades-long political calcification that kicked off when savvy strategists explored using reproductive rights as a wedge issue in the 1980s. It drove a political realignment that put the two major parties at odds with many of their voters to the extent that by 2019, as many as 3 in 10 voters did not agree with their party's stances on abortion, Pew Research Center polling showed. "The increasingly partisan nature of abortion politics represents a case of issue evolution driven by party elites

and filtering down to the masses," the political scientists Scott Ainsworth and Thad Hall wrote in the 2010 book *Abortion Politics in Congress.*

Alisa Von Hagel, a political science professor and coordinator of the University of Wisconsin–Superior's gender studies program, said that she can see how stark the shift has been in such a short amount of time through the experiences of her students in classes on abortion politics and policy. She remembered one "doe-eyed" student who came to class one day after spending some time with her grandmother and others from that generation. The student told Von Hagel that "they were asking her about what they were learning at school" and said she was reluctant to bring up abortion politics. When the student did, the older women were floored that abortion was being taught in a political science class: "They were just like: Why in the world is this a political issue? We never talked about it that way in the past," Von Hagel recalled the student relaying. "I can still picture her face, thinking: 'How is this possible?'" Von Hagel added: "It was a very, very purposeful realignment that happened."

The first rumblings of realignment were when Republican president Richard Nixon began talking about the rights of the unborn as he ran for reelection in 1972. Even absent meaningful policy proposals to restrict abortion, Nixon's rhetoric helped him make inroads with Catholic voters, who had traditionally backed Democratic candidates. It also, along with his public-facing friendship with televangelist Billy Graham, started to draw White evangelicals into the Republican Party, though they were not yet a political force. Democrats, meanwhile, considered including abortion rights in their 1972 party platform, but presidential nominee George McGovern thought it was a private matter that didn't belong in politics.

Nixon won a second term in a landslide, and exit polls showed the nascent abortion-related political shift. "A key ingredient of McGovern's defeat was the crumbling of the old Roosevelt coalition of

blacks, Jews and Catholic voters," *Congressional Quarterly* reported, citing a CBS News survey that showed Nixon winning 59 percent of the Catholic vote, when Democrats had carried 55 to 70 percent of the same voting bloc in recent elections.

Nixon's reaction to the Supreme Court's *Roe* decision early in his second term illustrates how politicians during this period adopted abortion positions they thought would be politically expedient even when they did not personally support the same positions. Publicly, Nixon said nothing. Privately, the president expressed his ambivalence, telling an aide: "There are times when abortions are necessary. I know that. When you have a Black and a White—or a rape."

Two years after *Roe*, in 1975, Gallup polling showed that 19 percent of Democrats believed that abortion should be "legal under any circumstances," 51 percent said it should be legal in certain cases, and 26 percent said it should be illegal in all cases. Meanwhile, among Republicans, 18 percent said abortion should be legal under any circumstances, 55 percent said it should be in some, and 25 percent said it should be illegal in all.

The abortion law historian Mary Ziegler said it is during this period, right after *Roe*, and before the parties were backed fully into their abortion-related corners, that the Senate likely had a large enough bipartisan majority to overcome the filibuster and pass some type of federal legislation protecting abortion—but advocates didn't feel the need to because everyone's focus was on the courts. "It seemed to be kind of like overkill, because at the time, the abortion rights movement trusted the courts to protect abortion rights for some time," she said.

Their trust in the courts was so great that in 1977, some abortion-supportive Democrats helped the antiabortion movement notch its first federal post-*Roe* legislative win with the passage of the Hyde Amendment, which barred the use of federal money for abortion. The Hyde Amendment was attached to the annual appropriations bill and

Ziegler said more Democrats voted for it than Republicans in part because many believed that the Supreme Court would invalidate the provision. "So if you liked other stuff in the appropriations bill, that was fine, because the Supreme Court would take care of it," she said. But in 1980, in the case *Harris v. McRae,* the Supreme Court instead found the Hyde Amendment was constitutional.

Hyde took effect and became a congressional abortion battlefront that persists to this day, with low-income Americans who rely on the government's Medicaid health insurance program the most impacted. Over the years, the antiabortion movement has succeeded in having allied lawmakers attach Hyde-like measures to appropriations bills that created bans on using federal dollars for abortions for women in federal prisons, for federal workers on government health insurance plans, for women serving in the military and for Peace Corps volunteers. Exceptions for rape, incest and the health of the mother were added, then taken out, then added back in again. As Biden prepared for his 2020 White House run, his support for the Hyde Amendment as a U.S. senator from Delaware came back to haunt him. In June 2019, Biden reversed his position and said the Hyde Amendment should be repealed.

It was around the time of Hyde's initial passage that "abortion started to become linked to ideology and party in ways that had not occurred before," according to Ainsworth and Hall. The Republican alignment evolved at a faster clip than the Democratic one. 1976 was a presidential election year and both party nominees—Republican Gerald Ford, Democrat Jimmy Carter—expressed opposition to abortion. But only one party would begin incorporating abortion policy into its national platform. At the Republican National Convention in Kansas City, the GOP for the first time added an antiabortion plank to its national party platform, over the objections of a "Feminist Caucus" that was also leading an effort to ratify the Equal Rights Amendment. The Democratic platform adopted at its party

convention that year did not take an affirmative stance on federal abortion rights and said only that a constitutional amendment to overturn *Roe* was "undesirable."

Four years later, the 1980 presidential campaign featuring Republican Ronald Reagan marked a turning point. Reagan, who as California's governor had signed one of the most expansive pre-*Roe* state laws protecting abortion, campaigned for the White House on the promise to appoint antiabortion judges. Though his Democratic opponent, Carter, was a practicing Southern Baptist—the largest group of evangelical Protestants in the country—Reagan ended up getting a whopping two thirds of the White evangelical vote. For the first time, evangelicals joined Catholic voters to become a determinant bloc, and they aligned with the Republican Party, thanks in part to heavy lobbying by the recently formed Moral Majority, headed by the Baptist minister Jerry Falwell Sr.

"Opposition to abortion, therefore, was a godsend for leaders of the Religious Right because it allowed them to distract attention from the real genesis of their movement: defense of racial segregation in evangelical institutions. With a cunning diversion, they were able to conjure righteous fury against legalized abortion and thereby lend a veneer of respectability to their political activism," Randall Balmer, a historian at Dartmouth College, wrote in *Politico* magazine shortly after the leak of the draft *Dobbs* decision.

Balmer has studied how another architect of the religious right, Paul Weyrich, worked closely with Falwell to mobilize evangelical voters around abortion to Reagan's benefit—but only after concluding that continued defense of segregated religious schools was "not likely to energize grassroots evangelical voters."

The Republican Party's continued embrace of antiabortion policies in its platform at the 1980 national convention—along with the party's full abandonment of the Equal Rights Amendment—is what prompted the departure of RNC co-chair Mary Dent Crisp. She had

warned that if the party "bur[ied] the rights of over 100 million American women under heaps of platitudes," it would be disastrous for the GOP. She went on to co-found the National Republican Coalition for Choice and would eventually leave the party she loved over its antiabortion stances and rejection of the Equal Rights Amendment, which would have guaranteed equal rights to all genders but has never been adopted. Once elected, Reagan nominated more federal judges over the next decade than any president before—and many opposed abortion. Abortion rights groups began to realize "we can't really rely on the courts anymore, we need to find a way through the political process to protect access to abortion," Ziegler said.

By the early 1990s, nearly a decade after the Republican Party waded into the abortion wars in earnest, reproductive rights started to cement its status in the Democratic platform. When Bill Clinton campaigned for the White House in 1992, he did so with the message that abortion should be "safe, legal, and rare." It seems outdated now—when Rep. Tulsi Gabbard repeated it during the 2020 Democratic White House primary, it was criticized as a concession to the antiabortion movement—but at the time of Clinton's first campaign, it was the most forceful support from a president elected after *Roe*.

Clinton marked Roe's twentieth anniversary in 1993 by reversing abortion restrictions put in place by Reagan and President George H. W. Bush, including a so-called "gag rule" that restricted abortion counseling at publicly funded clinics and a ban on federal research using fetal tissue. He also signed into law a measure that would block some of the most virulent forms of antiabortion protests that blocked access to clinics. "Clinton's actions made it clear that for the first time in 12 years, political momentum has shifted to the side of abortion-rights forces," the *Chicago Tribune* reported.

Despite the momentum, enacting legislation to protect the right to abortion itself proved more difficult. Though Clinton began his presidency with Democrats in control of both the House and

Senate—and likely with another majority that backed abortion rights, according to Ziegler—there wasn't a consensus among Democrats about how to handle the Hyde Amendment. The Supreme Court's 1992 decision in *Planned Parenthood v. Casey* had affirmed the right to an abortion but also found that states had some leeway to restrict it. Democrats revived a bill called the Freedom of Choice Act—that era's attempt to codify *Roe*. After it failed in 1993, Democratic leaders turned their focus to health care legislation, which would also falter. According to Ziegler: "You see the Democratic Party essentially saying: Well, we're not going to worry about this, we'll get to this later"—except they never did.

In the 1994 midterms, which are often disastrous for a sitting president's party, Republicans ran on Rep. Newt Gingrich's Contract with America, which focused on "60 percent issues" that had broad support from the electorate, like slashing welfare programs and a balanced budget amendment—overturning *Roe* was not one of them. Though the contract was silent on abortion, it fueled Republican victories in the House and Senate, putting them in control of both congressional chambers for the first time since the 1950s. Many of these Republican lawmakers opposed abortion rights.

The next year, the Christian Coalition released its own "contract with the American family" at a news conference alongside recently installed House Speaker Gingrich. The Christian Coalition's "contract" did not propose a constitutional amendment to ban abortion outright due to practical concerns but it did call for restrictions on abortions later in pregnancy.

It kicked off a period when increasingly socially conservative Republican lawmakers and abortion opponents became more tenacious in supporting incremental abortion restrictions. They attached abortion-related riders to appropriations bills and repeatedly introduced what would become known as the Partial-Birth Abortion Ban Act, which banned abortions by "dilation and extraction" in the

second trimester of pregnancy. The Republican-controlled Congress passed the Partial-Birth Abortion Ban Act twice only to have it vetoed by Clinton. It was eventually signed into law in 2003 by his Republican successor, George W. Bush.

It was during debate over the Partial-Birth Abortion Ban Act that public opinion about an absolute right to legal abortion began to shift, according to tracking polls and Ziegler's research—and reproductive rights advocates worried that they were losing the messaging battle. Even the name of the law, which is another political term not used in medicine, was seen as a victory for abortion opponents. In the House, the final version of the legislation was backed by 218 Republicans and 63 Democrats; in the Senate, 47 Republicans and 17 Democrats. Its constitutionality was upheld by the Supreme Court in 2007.

Former Planned Parenthood President Cecile Richards said that when she arrived at the organization in 2006, the Democratic Party was still recruiting congressional candidates who did not support abortion rights. Under her stewardship, which lasted until 2018, Planned Parenthood's political arm "really worked hard to establish that [abortion] was a fundamental right, and that it was something that the Democratic Party needed to lead on." The party, in many ways, would still be sorting out how to best do this when the *Dobbs* decision came down.

During Richards's tenure, Planned Parenthood and other advocates for abortion rights found another potential White House ally in then senator Barack Obama, who said early on in his 2008 White House bid that "the first thing I'd do as president" would be signing the latest iteration of the Freedom of Choice Act, a bill that stated Americans had the right to abortion care. But just four months into his presidency, Obama reversed course, saying it was no longer his "highest legislative priority" and his administration would instead focus on reducing unintended pregnancies.

Then, abortion threatened to derail Obama's namesake health care law. Republicans were united in opposition and Democrats could not

afford to lose a single senator. Senator Ben Nelson, an antiabortion Democrat from Nebraska who has since retired, was the final holdout. To win his support, party leaders included a version of an amendment that does not mandate state Affordable Care Act plans cover abortion. Biden pointed to his own support for the Hyde Amendment as he negotiated with Democratic holdouts. Obama issued an executive order that reiterated a version of the Hyde Amendment. Abortion rights advocates, largely left in the cold by the president they worked to elect, tried to take solace in the fact ACA plans would at least cover some forms of contraception.

In the 2010 midterm elections—a historically catastrophic year for Democrats due to the rise of the Tea Party—Republicans picked up more than sixty House seats to retake control of that chamber and added six Senate seats. Their efforts intensified to "defund" Planned Parenthood by denying the organization government money to underwrite the non-abortion services provided by its clinics. Many of these bills were introduced by then representative Mike Pence from Indiana, who would go on to be Donald Trump's vice president.

In January 2016, with the first presidential nominating contests looming to pick Obama's successor, Planned Parenthood made its first endorsement in a White House primary, backing Hillary Clinton. When she accepted, Clinton stunned political observers by saying that she supported repealing the Hyde Amendment—the *Guardian* newspaper called it "truly surprising," the progressive-leaning news website Salon said it could be a "game changer." Democrats incorporated Hyde Amendment repeal into the official party platform at the Democratic National Convention in Philadelphia.

Clinton went on to lose the November 2016 election to Trump, who said he was running to be a "pro-life president" and adopted a number of antiabortion stances during his campaign, along with picking Pence as his running mate. Trump went on to become the first sitting president to attend the annual March for Life rally. He

also appointed three Supreme Court justices—Neil Gorsuch, Brett Kavanaugh and Amy Coney Barrett—who cemented the high court's conservative antiabortion majority, emboldening abortion-hostile state lawmakers to enact increasingly restrictive laws.

Four years later, with *Roe* in clear jeopardy, Biden was forced to continue his evolution on abortion as he moved to secure the 2020 Democratic presidential nomination. As a senator, in addition to opposing exceptions to the Hyde Amendment, Biden voted for a failed constitutional amendment that would have allowed states to overturn *Roe*. He told the *Washingtonian* magazine at the time: "I think [Roe] went too far. I don't think that a woman has the sole right to say what should happen to her body." In a 2007 memoir, Biden wrote that he had since arrived at a "middle-of-the-road position on abortion." In 2008, he described *Roe* as "close to a consensus that can exist in a society as heterogeneous as ours." As Obama's vice president, Biden said the government had no "right to tell other people that women, they can't control their body." By the 2020 presidential primary, after he backed Hyde repeal, his abortion politics matched the party's base.

Biden beat Trump, but it was difficult for him to protect abortion access as he promised during his campaign. He did drop the Hyde Amendment from his first budget proposal—which is essentially a president's spending wish list and is rarely enacted by Congress in the form it is submitted. He also rescinded what is known as the Mexico City Policy, or a global gag rule that requires foreign organizations to certify they will not promote abortion in order to receive U.S. aid for reproductive health care. Then, in October 2021, Biden's administration reversed a Trump-era regulation that prohibited health care clinics that received federal family planning funds from mentioning abortion care to patients.

But with only a narrow Democratic House majority, and an evenly split Senate, Democrats could not get legislation through Congress to codify *Roe* during the first half of Biden's first term.

"We are in a total stalemate in Congress," Richards told me at the time.

When *Roe* fell in June 2022, Biden was on an official trip to Madrid attending a NATO summit. "I believe we have to codify *Roe v. Wade* into law, and the way to do that is to make sure that the Congress votes to do that and if the filibuster gets in the way, [there] should be . . . an exception," the president told reporters. But the reality was that while changing the Senate filibuster would require only a simple majority instead of sixty votes, there were at least several Democratic senators who did not support it, including Joe Manchin of West Virginia, the last Democrat in the upper chamber who opposed abortion.

For Democrats, the only remaining route to pass legislation that protected abortion after the fall of *Roe* was to pick up enough seats during the 2022 midterms that overcoming a filibuster would not be necessary. While Democrats did better as a party than historical precedent portended, they fell far short of the margins they needed in the Senate and lost the House in the process.

There would be no opening for congressional action until at least 2024.

"That's the whole purpose of the clinic existing."

Maryland

C OLLEGE PARK—In Maryland, it had been three months since Partners in Abortion Care opened its doors to patients, and the clinic had quickly assumed its role in the new national ecosystem of abortion care.

Its opening was slightly delayed—mid-October, instead of just after Labor Day. A data breach at a state regulatory agency led to lost paperwork, and Dr. Diane Horvath enlisted the help of a state legislator who she'd previously worked with on issues of reproductive rights to speed things up. But, all things considered, things went smoothly.

As soon as the paperwork was processed and everything was in place, Partners reached out to other Washington, D.C.-area clinics, asking if there were any patients on waiting lists who needed abortion care, especially in the later stages of pregnancy. Several of their

initial patients were referred in this way, and it felt "really lovely" for the area's clinics to be working together, Horvath said.

Partners had been scheduling up to seven patients per day, knowing that an average of five would show up—since the clinic specialized in second- and third-trimester abortion care, there are more barriers to access it as people get further into pregnancy, such as costlier procedures, time off work, travel costs, and childcare.

In early January, Horvath and her business partner Morgan Nuzzo, the nurse and midwife with whom she co-owns the clinic, were able to turn off the GoFundMe they'd set up to finance their opening after raising nearly $425,000. They took out a business loan that was small and manageable, and they had already started making payments. The influx of patients had been steady enough—from the southwest and even states like California and Washington, where abortion is legal but people still struggled to find later-term care—that they gave their seventeen-member staff year-end bonuses. They were also able to make a donation to a couple of people who operate a Reddit thread that helped people find abortions.

Now Horvath and Nuzzo are focused on long-term sustainability—for their clinic, for abortion access overall, and for themselves.

When I met Horvath for coffee in mid-January, she had just looked at new office space, because they were considering moving the clinic's administrative functions offsite. At Partners, she and Nuzzo were sharing a small office, and not only did they need their own space, and privacy—dueling phone calls were a common occurrence—but Horvath had essentially given up on trying to get administrative tasks done at the clinic because patient care always came first.

They were also exploring opening a second clinic in Colorado. A physician based there had been flying to Maryland about once a month to backstop Horvath, but he didn't want to permanently relocate. Despite abortion being legal in Colorado, and without a

gestational limit, the need for abortions later in pregnancy surpassed the availability of care. The Colorado-based doctor had already toured a potential clinic space, and Horvath and Nuzzo were looking into what it would take to secure a loan to buy the building. Horvath said they also had not ruled out finding either a larger or secondary clinic space in Maryland so that they could take care of more patients, and potentially earlier in pregnancy, given the overall demand.

"There is no shortage of people who need abortions. Particularly, now, in a state like Maryland, where we have a really good legal environment and regulatory environment. We're by three airports, we're on a train line, we're a place people can get to," said Horvath, adding that investing in the abortion infrastructure in the area would help "establish us as a place where people can come for care."

The Society of Family Planning's #WeCount project, which was tracking the changes in total abortions per state in the months after *Dobbs*, showed that in Maryland, when compared to the study baseline of April 2022, there were 90 more abortions in August, 150 more in September, 210 more in October, 240 more in November, 700 more in December, 730 more in January, and 740 more in February. The states showing the biggest increases month over month included California, New Mexico, Illinois, Florida, and North Carolina.

Horvath and Nuzzo knew that if Maryland was going to become an abortion haven for those traveling from relatively nearby states with abortion restrictions, like Kentucky, Ohio, and West Virginia, there would need to be additional infrastructure beyond expanding their own clinic and its services—and they wanted to figure out a way to help with that, too.

When they first started on the path to opening Partners in Abortion Care, more than a year earlier, Horvath had discovered there was no guidebook. Physicians don't learn many, if any, entrepreneurship skills in medical school. Small business mentorship in the field is hard to come by from other health care providers.

Horvath said there are no flow charts to explain how to open a new clinic: "First, you do this, then you do this, and all of these moving parts were interlocking, you needed this permit before you could get this other thing, and you needed that thing to get this thing, it was like a puzzle."

So she and Nuzzo had been "writing a lot of this down, and taking really extensive notes" to potentially write the guidebook themselves, she said. While at first Horvath thought the clinic would expand care by moving into training physicians, nurses, and midwives to provide abortions later in pregnancy—and that is still a goal—she now believed that the more immediate need was to offer the type of counseling and mentorship on the business development side that they sought but did not find. Horvath was focused on the regulatory side; Nuzzo on the financials.

"I would love to be available for other places, and to make that part of this work, and Morgan wants that also," Horvath told me.

Horvath and Nuzzo have also navigated how to best support each other—and to some extent, that meant maintaining boundaries, even with each other, so that this work did not take over all aspects of their lives. They are both mothers. Nuzzo was pursuing her doctorate in nursing practice. They are "purposeful about not spending time together as friends as much as we can," Nuzzo said. "Diane can't be my whole world and I'm not hers— and this work can't be our whole world, either."

"I think before when I was working as an employee, I kind of let myself kind of go down that path, and now I have to make sure that we protect ourselves from letting it consume us. Diane is a really good person to do that with; we try and do that for each other," Nuzzo added.

While Partners in Abortion Care was on solid footing, at least for the time being, and Horvath and Nuzzo were on their way to figuring out an occupational equilibrium, the first three months of

the clinic's existence were not entirely smooth, and there were bumps along the way. One of the biggest, Horvath said, was a "clinic invasion" that got "pretty serious."

Two women showed up one day at the clinic who did not have an appointment. One said she was pregnant and scared; the other said she was there to support her friend in crisis. It wasn't a day when the clinic was seeing patients, but the staffer at the front desk buzzed them in. When they were asked for identification, the friend said she needed to retrieve it from the car. Something seemed off. The front desk staffer texted the clinic's group Signal message and asked for backup. The prospective patient and her friend turned out to be two known local antiabortion activists attempting what is known as a "pink rose rescue" protest.

In a pink rose protest, antiabortion activists gain entry to an abortion clinic and hand out pink roses, along with antiabortion information, to the patients in the waiting area, hoping that they will reconsider. Many of these protesters refuse to leave when asked, and clinics often have to engage the police to have the activists removed for trespassing. These types of protests were popular in the 1980s and 1990s but have fallen out of favor—in part because President Bill Clinton signed a law in 1994, the Freedom of Access to Clinic Entrances Act, or FACE, that made it a crime to impede access to abortion clinics. The law was a response to the "Summer of Mercy" in 1991, when thousands of antiabortion activists descended on Wichita, Kansas, to protest at clinics. Over six weeks, there were more than twenty-five hundred arrests. The group protest action culminated with a stadium rally headlined by the televangelist Pat Robertson.

When the pink rose protesters showed up at Partners in Abortion Care, since there were no patients there, clinic staff was able to scare them off. On their way out of the clinic's complex, the antiabortion activists took selfies in the courtyard, then left it littered with their

roses and pamphlets. Now the clinic will not open its door for anyone who does not have an appointment. "What would have happened if that waiting room had been full of people? I can't expose other patients to that," Horvath said, adding that it was a "jarring" experience for the staff there that day.

But Nuzzo said there has "also been a lot of joy." She cited the clinic's "incredibly talented team," whom she credits for "amazing Google reviews" from patients who have received care at Partners since it opened. She is continually amazed by the tenacity of the patients, too, some of whom reported having never left their state before coming to Maryland seeking abortion care. Horvath and Nuzzo were in the process of incorporating a separate 501(c)(3) nonprofit group for which they would be able to solicit tax-deductible donations to underwrite medical training. The clinic had an Amazon Wish List, which provided its supporters with a route to underwrite patients' ancillary needs. "Every once in a while we get a few gift cards, and then give it to a patient and get to say, 'Somebody gave this for you, go and get what you need'," Nuzzo said.

I asked Nuzzo if there was a "high point" she could point to, a day, or a patient, or an experience, that made her think: "This is why we opened this clinic." She didn't miss a beat.

Nuzzo described a developmentally disabled adult patient who came to the clinic with a parent. The patient was nonverbal and understood a non-English language. One of Nuzzo's young children was in an immersion program in the same language, and she found herself using the preschool-level command she'd picked up from her own child to communicate with her patient. "I stopped for a minute in the middle of her procedure and realized: 'I'm talking to her like I talked to my baby,'" Nuzzo recalled. Local detectives needed to come to the clinic to collect samples for evidence in their investigation. Nuzzo knew that members of the clinic's staff, and many of their

patients, had "complicated" relationships with policing. She made sure that the officers were going to "do this the way that we wanted them to do this, this need[ed] to be patient-centered, this need[ed] to be trauma-informed, gentle," she told me.

"It hit all the values for me. We gave this person as much dignity as we could. We did everything we could to make sure justice happened. I know that that sounds like a low point, because it's so dramatic—but that's the whole purpose of the clinic existing, is to serve people who are going through really difficult times and need to be cared for gently, and with love and respect and dignity," Nuzzo said.

"I want to be the safety net."

Alabama

TUSCALOOSA—When Dr. Leah Torres graduated from the University of Illinois Chicago's medical school in 2008 and began her residency in obstetrics and gynecology at a Philadelphia-area hospital, she anticipated that someday she would be in the position to provide the full scope of care to her patients—she was, after all, training for it.

"I thought: I'm going to do everything. I'm going to do prenatal care, I'm going to do gynecological care, I'm going to do abortion, I'm going to do infertility, I'm going to do sexual health," she said.

But as Torres took postresidency jobs at clinics in Utah, then in New Mexico, she was never able to figure out a way to include abortion care in the spectrum of services she offered to patients. Abortion was legal in both Utah and New Mexico, and in the latter state there was no gestational limit at all, but there were just too many barriers at the clinics where Torres worked. For starters, the doctors

she worked for didn't want to provide abortion as part of their practice. If Torres wanted to, she could travel to other abortion clinics, or work for Planned Parenthood on the side. But time is in short supply for a young doctor on call, and she would have to add it to the demanding hours she was already working.

When Robin Marty called Torres in March 2020 and asked her if she would come be the primary physician at the West Alabama Women's Center, Torres hadn't been in New Mexico long. She nevertheless thought: "I'm done." She packed up and moved to Alabama, where the GOP-led legislature and governor had already enacted the near-total abortion ban in 2019 that was on hold. When Torres arrived in Tuscaloosa in late July, it was about six months into the uncertainty of the intensifying COVID-19 pandemic, and the window was already closing in which she would be able to provide the full spectrum of reproductive care she'd moved here to do.

"I graduated from a fellowship after being trained in abortion care and specialized contraception care—and no job that I ever took allowed me to do abortion care until I moved to Alabama," she told me, shaking her head at the irony. "I could not incorporate one thing, into the many, until I came to Alabama, where the one thing . . . went away."

Over the past two and a half years, the West Alabama Women's Center had gone through two metamorphoses. First, when the Yellowhammer Fund, a nonprofit abortion advocacy organization focused on Alabama, Mississippi, and the Deep South, purchased the clinic from its previous owners and Marty recruited Torres. Then, after the Supreme Court heard the *Dobbs* case in December 2021. With the writing on the wall that *Roe* would likely fall, Marty began the process of spinning the clinic off from the fund and establishing it as an independent nonprofit health care center. When the *Dobbs* decision landed, the abortion clinic closed and its board met to dissolve the for-profit entity.

"On July 11 . . . 17 days after our last day of providing abortions, we opened again, this time as a new entity. West Alabama Women's Center—the for-profit abortion provider established in 1993—was gone. But what came back was West Alabama Women's Center, a new full-spectrum reproductive-health center dedicated to meeting the needs of the uninsured, underinsured, and Medicaid patients neglected in our region. We are also now a nonprofit, a move that had been in the works for months, because we believe no one should ever be making money off someone else's health needs," Marty wrote in *Time* magazine.

Historically, the West Alabama Women's Center had been both an abortion clinic and a broader medical practice like the new nonprofit aimed to be. Founded by Gloria Gray in 1993, it was able to provide comprehensive reproductive care—the type of practice Torres looked for more than a decade later but was unable to find. Patients came to access abortion care but also for healthy pregnancy visits. The clinic's two waiting rooms were vestiges of this earlier time—one for prenatal patients; one for abortion patients.

But antiabortion activists didn't differentiate between who was going into which door, recalled longtime clinic employee Chad Jackson, who left the West Alabama Women's Center briefly but returned in March 2023. "There would be protesters out there taking photos of you, yelling at you, screaming at you," he said.

A September 2010 article in the academic journal *Perspectives on Sexual and Reproductive Health* noted that "abortion services have increasingly become consolidated into the socially insulated settings of specialized abortion clinics."

"These clinics, which provide 93% of abortions, are largely segregated from other medical settings," the authors continued; "as a result, they are vulnerable to harassment, violence and targeted legislation, such as laws that impose burdensome and unnecessary requirements on their architecture, landscaping or staffing."

When *Roe* was decided in 1973, hospitals braced for an influx of abortion patients that they feared could stress the system, or that their staff could object to treating. Since hospital-based care, even then, could be expensive, "freestanding clinics seemed like the ideal remedy, which is why reproductive rights advocates spearheaded the call for their creation," Eyal Press wrote in the 2006 book *Absolute Convictions*, which recounts the assassination of his abortion-provider father due to the nature of his work.

Regulations—including TRAP laws—and a lack of other abortion providers in the area also led to West Alabama Women's Center focusing more on abortion care and ceasing to be a general OB-GYN practice. By 2021, the last full year that abortion was legal in Alabama, the state had five clinics—two Planned Parenthoods, three independent. Of the 6,489 abortions that these clinics collectively provided, 2,140 were done by the West Alabama Women's Center. The only clinic that did more, by about two hundred, was the Alabama Women's Center for Reproductive Alternatives in Huntsville, which has double Tuscaloosa's population. "When I got here," Torres remembered, "we were too busy really for anything other than abortion care."

Another reason that abortion has been segregated into its own category of health care has to do with the rules and standards set by or imposed upon health care networks, HMOs, and hospitals. Sometimes it's a matter of religious affiliation. In 2020, four of the ten largest health systems in the United States were affiliated with the Catholic Church and therefore beholden to antiabortion Ethical and Religious Directives, or ERDs, that are overseen and enforced by the U.S. Conference of Catholic Bishops. But in other cases, states enacted laws that restricted public hospitals from offering abortion care—a type of legislation that was upheld by the Supreme Court in its 1989 decision in *Webster v. Reproductive Health Services*, regarding a Missouri law.

But antiabortion sentiment within health networks and restrictions at hospitals did more than push physicians who want to provide abortion care into abortion-specific clinics—it threatened the ability of the clinics to exist at all, even before *Roe* fell. Restrictions on hospital transfer agreements and admitting privileges, for example, created a unsolvable quagmire for clinics in states led by antiabortion lawmakers. States have restricted the use of transfer agreements between abortion clinics and hospitals, while requiring that clinics have these agreements in place. Hospital admitting privileges have also been used to restrict abortion access, because hospitals routinely deny them to clinic abortion doctors "due to anti-abortion ideology, stigma, and fear of harassment," according to the American College of Obstetricians and Gynecologists.

Ohio is a good example of how restrictions on transfer agreements can be used to curtail access to abortion, even at clinics. There was a 1990s law that required all abortion clinics to have a written transfer agreement with a hospital, along with a 2013 law that banned public hospitals from making such agreements, leaving private hospitals as the only option. But one of Ohio's largest health networks, Premier Health, was partially owned by the Catholic Health Initiative. A 2020 report from the nonprofit consumer advocacy organization Community Catalyst detailed how Premier Health did not identify any religious restrictions placed on care at its five network hospitals—but one of them nevertheless would not establish a transfer agreement with the region's only remaining abortion clinic, citing the Catholic Health Initiative's 22 percent ownership stake. The impact of state and hospital denial of transfer agreements was stark. In 1992, Ohio had forty-five abortion clinics. In 2018, it had ten. By the time *Roe* fell, the state of nearly twelve million had just six clinics offering abortion care.

Admitting privileges have also been a battlefront for hospitals that oppose abortion and the doctors who provide it in a clinic setting.

Between 2011 and 2014, nine states—including Alabama—passed
laws requiring that doctors providing abortion care have hospital
admitting privileges. In the three years after Texas enacted a statute
mandating that abortion providers have admitting privileges at a
hospital within thirty miles of their clinic, the number of abortion
clinics dropped from forty-two to nineteen in a state of about thirty
million people.

In 2015, the West Alabama Women's Center challenged Alabama's
admitting privileges law, with the help of the American Civil Liber-
ties Union, and a federal judge rejected the statute, noting that it
would have forced the closure of at least two of the state's five
clinics. The Supreme Court in 2016 struck down Texas's law in *Whole
Woman's Health v. Hellerstedt*, finding it created an "undue burden"
for those seeking an abortion in violation of the standard set by its
1992 ruling in *Planned Parenthood v. Casey*. The very next day, the
court declined to hear appeals of similar admitting privileges laws in
Mississippi and Wisconsin that were on hold, permanently blocking
them from taking effect—but that didn't stop more antiabortion
states from trying.

While the West Alabama Women's Center was able to remain
open, in part due to court intervention, it created a maze of catch-
22s that made it more difficult for them to provide non-abortion
care—both before *Dobbs* and after.

The need for broader obstetric and gynecological care was clear.

Much of Alabama meets the definition of a maternal care desert.
In about 40 of its 67 counties, there is little-to-no access to OB-GYNs,
birthing centers, hospitals with obstetric services, or certified nurse
midwives. The United States has one of the highest maternal mortality
rates of its peers. In 2020, there were 23.8 deaths per 100,000 live
births. In Alabama, which has the third-highest maternal mortality
rate among the states, it was 36.4 deaths per 100,000 live births—
similar to Tunisia. In 2021, Alabama also had the sixth-highest infant

mortality rate in the country, with 7.6 deaths per 1,000 live births. As is the case nearly everywhere, outcomes were worse for both Black mothers and Black babies.

For a brief period, it seemed Alabama's health department was taking steps to ease the maternal health care crisis. The Alabama Department of Public Health, or ADPH, in 2010 repealed 1987 regulations on freestanding birthing centers. In 2020, ADPH said that it was never their responsibility to regulate them, and several health care providers moved to open birthing facilities. But in July 2022, less than a month after the *Dobbs* ruling, ADPH announced a series of birthing center regulations. One required that the centers—which are often intentionally placed in maternal care deserts—be within a certain distance of hospitals with a labor and delivery unit, where they weren't as badly needed. Another required written transfer agreements with hospitals. Still another barred certified midwives from working in birthing centers at all. The ACLU would eventually sue the state, arguing that the regulations "essentially give hospitals and EMS providers veto power over the ability of birth centers to operate."

Alabama's policymakers were simultaneously making it harder to obtain an abortion while also ensuring it would be more dangerous to carry pregnancies to term.

The reopened West Alabama Women's Center added gender-affirming care, which started to make up more and more of its patient base. They could provide basic reproductive and prenatal care, but only if the patients could pay out of pocket, were covered by the government's Medicaid program for low-income people, or the clinic was willing to provide the care for free. Reimbursement from many private insurers—including the state's largest, Blue Cross Blue Shield, which is headquartered in Birmingham—initially seemed out of reach. "One of the biggest reasons that we have spent so long trying to get our medical insurance in place is because Blue Cross Blue Shield

in Alabama will not accept an OB-GYN into their network if that OB-GYN does not have admitting privileges," Marty told me.

Jackson explained that they'd come up with a plan: The clinic found an outside OB-GYN with admitting privileges who is willing to affiliate with the clinic for insurance purposes so it can start accepting Blue Cross Blue Shield prenatal patients. Marty believed it could be what, at the end of the day, helps the West Alabama Women's Center keep its doors open. But it would exact a price on the clinic's patients, whose continuity of care would be disrupted at the very time they likely need it most: delivery of their babies. Torres would be able to care for patients throughout their pregnancies, but then they would have to show up at the local emergency room to give birth without her.

Torres said that she moved to Alabama because "I want to be the one who catches those who are falling through the Swiss cheese, I want to do that, I want to be the safety net, that's where I'm happiest."

But many days, it felt as if the state was doing everything it could to stop her.

In other states, though, lawmakers were working to make providing reproductive care easier.

"We had to meet their really hellacious creativity."

Massachusetts

B OSTON—During its first regular meeting of the year, the Cambridge City Council in January 2023 approved an ordinance that aimed to regulate "deceptive advertising practices by crisis pregnancy centers."

Also known as CPCs or pregnancy resource centers, crisis pregnancy centers are often funded by religious groups or antiabortion groups and usually provide little to no health care, though their staffs often dress in white coats and some provide medical-seeming services, like ultrasounds. CPCs have become masterful at using search optimization techniques so that when someone searches for "abortion clinic near me" or even "planned parenthood," it yields the closest CPC as a top result.

The Cambridge City Council did not want any of their residents seeking an abortion to instead end up at an antiabortion counseling center.

In Massachusetts, as in much of the country, there were more anti-abortion centers than actual abortion clinics. Though there were none in Cambridge, there were several in the greater Boston area. The Cambridge City Council had first explored whether they could prevent CPCs from opening within their jurisdiction at all, before abandoning that effort toward the end of 2022 due to legal issues and pivoting to regulating how these centers present and advertise themselves.

Councilmember Quinton Zondervan, who worked on the ordinance with Cambridge vice mayor Alanna Mallon, said that after *Roe* fell, all of the council members were really upset. Then Mallon said something Zondervan had also heard his wife say: Men needed to step up and help fight for abortion access. When you're a man, Zondervan said, it can be "very easy to sort of delegate that work to the women, and say 'Well, this is a women's issue, I don't know anything about it, so I'm not getting involved.'" But Zondervan considers himself a "male feminist," so he tried to be "very intentional" about heeding Mallon's call to action. "It was a partnership between us to move this ordinance forward," he told me.

Zondervan said initially he "literally had no idea" what a CPC was. He wanted to be an ally, and he knew that in allyship, you have to make the effort to educate yourself and not put that burden on others. His first step was to do what most of us would: He Googled CPCs. What he learned was that these centers "present themselves as offering services to pregnant people but when someone seeks out their services, that person is receiving a heavy dose of persuasion not to get an abortion, and any sort of abortion-related services are not offered or made available to them, and they're not getting a referral to an abortion clinic or anything like that."

He also knew that there is a "limited window during pregnancy when you can have an abortion." He worried that if someone first went to a crisis pregnancy center, it could lead to delays during which that window might close. Zondervan said he's not "pro-abortion" but does believe that "people should have the opportunity to make an informed decision" about how they want to deal with an unplanned pregnancy, or one with complications.

Cambridge is home to Harvard University and the Massachusetts Institute of Technology. It is the type of place where a "Black Lives Matter" sign hung above the entrance to City Hall when I met with Zondervan in mid-March, and Progress Pride flags were painted on the benches out front. It is a liberal city in a state that is considered by many metrics to be the most liberal in the country. Since 1980, it has been represented by two Democrats in the U.S. Senate, except for a three-year period when Republican Scott Brown won a special election after the death of Democrat Ted Kennedy. Massachusetts last sent a Republican to the House of Representatives in the mid-1990s. Democrats have controlled both chambers of the state legislature since the late 1950s, often by large or veto-proof majorities.

The state's political leanings are evident in how its electorate views abortion rights. At the time of the *Dobbs* decision, a whopping 79 percent of its residents said abortion should be legal in all or most cases, a percentage surpassed by only Nevada and Washington, D.C., according to polling done by the Public Religion Research Institute. Just 3 percent of Massachusetts residents thought abortion should be illegal in most or all cases, according to the same survey.

Zondervan, Mallon and the other members of the council were part of a larger constellation of lawmakers, advocates, activists and health care providers in Massachusetts that was trying to get as creative as it could to protect abortion access—because that is what the residents of their state wanted. In the six or so months since the

Dobbs ruling, Massachusetts had already established itself as a model for how blue states could ensure their citizens' rights would not be leached away by out-of-state lawmakers and interest groups that were getting increasingly bold in their efforts to restrict abortion access in ways that would cross state lines.

One reason that so much progress had been made in just six months was that this group of abortion rights supporters had seen the writing on the wall long before the Supreme Court even heard oral arguments in *Dobbs*. The preparation for a world without *Roe* started in earnest after Texas, in September 2021, enacted Senate Bill 8, or SB8, which not only banned abortion after the detection of embryonic cardiac activity, but established that private citizens could bring lawsuits against anyone who helped a person obtain an abortion. To those paying close attention, it was clear that this vigilante-style provision—hailed as "genius" by those in the antiabortion movement—had the potential to impact abortion care outside Texas, even in blue states like Massachusetts, thousands of miles away.

IN WESTERN MASSACHUSETTS, Rebecca Hart Holder watched the enactment of SB8 with growing alarm. The organization for which she was the executive director, Reproductive Equity Now, had been part of a coalition that pushed to get Massachusetts's ROE Act over the finish line at the end of 2020. The legislation affirmed the right to an abortion up to 24 weeks, expanded the situations in which an abortion could be obtained after that point, and lowered the age at which minors could seek abortion care without parental or guardian notification. The Republican governor at the time, Charlie Baker, vetoed the bill, but the Democratic-led Massachusetts legislature overrode it.

The coalition let up briefly but not for long. When the Supreme Court in October 2021 declined to intervene and let SB8 stand, in

the case *Whole Woman's Health v. Jackson*, the ROE Act coalition knew, as one involved in the effort put it, that it was "time to officially get the band back together." The coalition's founding member groups—Reproductive Equity Now, ACLU Massachusetts, and the Planned Parenthood Advocacy Fund of Massachusetts—told the Democratic lawmakers they'd worked with on the ROE Act that in the very near future it would likely prove insufficient to protect the state's residents. More needed to be done. According to Hart Holder, with *Dobbs* already in the pipeline, the coalition told elected officials: "The voters of Massachusetts are very, very clear. They're going to be looking to you to say what you are going to do to help us." The coalition started "talking to everyone we could to try to figure out 'What can we do?' because we felt like what they've done [in SB8] is the newest and most creative stuff in the fifty-year antiabortion playbook," Hart Holder told me.

Jonathan F. Mitchell, a former Texas solicitor general and law clerk to Supreme Court antiabortion stalwart Justice Antonin Scalia, was the brains behind what Hart Holder called the "newest most creative stuff" contained in SB8—a provision that barred the government from enforcing the law and instead outsourced enforcement to private plaintiffs, who needed no connection to the defendant. This provision made it more difficult to challenge the law before it took effect, because if no state or government official is charged with enforcing the law, you have no one to preemptively sue. The American Bar Association described the enforcement mechanism as "specifically designed to thwart judicial review." The *New York Times* called it an "audacious legislative structure" that "flummoxed lower courts and sent the Biden administration and other supporters of abortion rights scrambling for some way to stop it."

Mitchell was a known figure in Texas's antiabortion movement but not prominent outside the state. He was a member of the conservative Federalist Society, the antiabortion legal group legal group that

has become a sought-after stamp of approval by Republican presidents picking judges and justices—including those who denied Texas abortion providers injunctive relief from SB8. Mitchell has also worked with the Arizona-based Alliance Defending Freedom, which helped write, then defend, the Mississippi abortion ban at the heart of the *Dobbs* case. After writing SB8, Mitchell would go on to file a friend-of-the-court brief on behalf of Texas Right to Life in *Dobbs* that argued the court should overturn *Roe*—and also overturn the high court ruling that established the right to same-sex marriage.

The lawmaker who introduced SB8, meanwhile, was Texas state senator Bryan Hughes, a former state house member who has tried to roll back voting rights and authorized legislation to bar public schools from requiring students to read the writings of civil rights leaders. When SB8 was met with an uproar, Hughes defended it in a piece for the *Wall Street Journal*, acknowledging that it departed from "conventional enforcement channels, obviously" but "like it or not, states will keep crafting unconventional means of regulating abortion." Antiabortion conservatives, though, praised Mitchell's ingenuity. In the *National Review*, Roger Severino, a former senior fellow at the Ethics and Public Policy Center, which instills "Judeo-Christian moral tradition" into public policy, praised SB8 in an article titled "Texas's Absolutely Genius Victory for Life."

Hughes was a member of the National Association of Christian Lawmakers, or the NACL, which helped export SB8-like statutes to other states. The NACL was founded in 2019 to "formulate model statutes, ordinances and resolutions based upon a biblical worldview." In 2021, the NACL adopted SB8 as a legislative template to promote around the country. The group does not publish a list of its full membership, but in the months after that meeting, lawmakers from Arizona, Arkansas, Missouri, Ohio, Oklahoma, and South Dakota affiliated with NACL were among those who introduced or

co-sponsored SB8-like bills with private enforcement mechanisms. The Arkansas lawmaker who founded NACL told the *Deseret News*, a Mormon news organization, that SB8's use of private citizens for enforcement was like "putting a SCUD missile on that heartbeat bill—they can't stop it."

The Beyond Roe Coalition knew that if they wanted Massachusetts to become a haven for reproductive autonomy, they needed to figure out a way to protect doctors and other health care workers in their state who might end up caring for patients from Texas and other states with similarly designed vigilante statutes. The coalition "knew we had to meet their really hellacious creativity with the boldest possible policy to protect people," Hart Holder said.

Hart Holder described the months between the *Dobbs* oral arguments in December 2021 and the decision in the case in June 2022 as the "most intense lobbying, communications and organizing work of my life." What the coalition and its partners accomplished during this period is, according to ACLU Massachusetts Executive Director Carol Rose, a story "about being in a state where I think the elected officials are trying to listen to the people and the people have an opportunity to have their voices heard."

A top priority for the Beyond Roe Coalition was a shield law for doctors and other health care providers. Since ACLU Massachusetts is a multi-issue organization that works on a breadth of civil liberties issues, it was ideally positioned to act as the fiscal and organizing umbrella for the coalition. The organization itself is nonpartisan, but given the state's progressive makeup, the ACLU had preexisting relationships with labor unions, LGBTQ+ groups, racial justice organizations, advocates in the domestic violence space and voting rights advocates—it wasn't difficult to connect the dots between their issues and reproductive justice. The abortion rights groups, meanwhile, immediately saw that protecting bodily autonomy was about more than abortion care—doctors providing gender-affirming care would

also need protection. "We were all very clear, never once in disagreement, that we would not only be fighting to protect abortion care providers, but that we would be fighting to protect providers of gender-affirming care. It's the same fight," Hart Holder said.

Polly Crozier, with GLBTQ Legal Advocates & Defenders, agreed. "We all do work that is intersecting. When the *Dobbs* draft came out, shield laws became a part of the conversation . . . and it was really important to make sure that transgender people were included in that conversation," she told me.

Coalition members collaborated on press releases, shared mailing lists and held joint working groups. ACLU lawyers ensured that operations were legal and transparent. "When you're part of a political movement that is a larger tent, a more diverse tent, across many issues and many types of views and people, it can be easy to fall into the trap of fighting within a movement about who gets credit or who's the leader and in fact, it takes all of us, all of us playing in our lanes and bringing a generosity of spirit to the way we do our work," Rose said.

One of the coalition's strengths, according to Hart Holder, was that each of the member groups had a history with different legislators. Reproductive Equity Now, for example, had worked closely in the past with state senator Cindy Friedman, who was a community organizer for Planned Parenthood, and Rep. Lindsay Sabadosa, a longtime Planned Parenthood volunteer who served on the board of an abortion fund and an abortion doula network. The ACLU had long worked with Representative Michael Day, who chairs the House judiciary committee. GLBTQ Legal Advocates & Defenders, or GLAD, which worked hand-in-hand with the coalition, had a long-standing relationship with state senator Julian Cyr, whose online biography says his "legislative priorities are primarily informed by the unique needs of the Cape and Islands district and his perspective as a member of the LGBTQ community." Other allies in the statehouse

included Sen. Jo Comerford and Rep. Aaron Michlewitz. Hart Holder recalled that there was no time to be territorial because "it was all about who is in the best position to move the ball forward" and they were aiming to do it fast.

The Beyond Roe Coalition was still working on developing the shield law and other essential protections the day the *Dobbs* decision came down.

Baker, one of the last remaining Republicans in an elected state-wide office who by-and-large backed abortion rights despite his earlier veto of the ROE Act, within moments of the decision signed an executive order promising to "protect reproductive health care providers who serve out-of-state residents." His order would "provide certainty for people out there who may be feeling some anxiety after this decision," he said. The shield law was still a priority, though, because Baker's executive order, like all executive orders, only covered areas of law within the discretion of the executive branch, and therefore could never be as broadly protective as legislation. Plus, the midterms loomed, and while it looked close to certain that then attorney general Maura Healey, a Democrat, would win the gubernatorial race, executive orders may or may not be continued when an executive administration changes over.

The week after the *Dobbs* decision, the Massachusetts house passed the shield law, known as An Act Expanding Protections for Reproductive Rights. The state senate followed two weeks later. By the end of July, the two chambers had reconciled their bills and sent the legislation to Baker, who swiftly signed it into law.

Massachusetts wasn't the first state to pass a shield law—Connecticut did so in May 2022, followed by New York, Delaware, and New Jersey in quick succession. But the Massachusetts shield law contained some key provisions that others lacked. For starters, in addition to abortion, it explicitly protected the provision of gender-affirming care, which red-state lawmakers were

moving to restrict, especially for minors. And, critical to the law's ability to provide the broadest-possible protections for health care providers, it covered the provision of care via telemedicine, which would be key in a remade world where patients in abortion-restrictive states would seek medication abortion prescribed by out-of-state providers.

David Cohen, a law professor at Drexel University who studies reproductive health from an abortion rights perspective, told me that at the time it was enacted, "only the Massachusetts law tries to protect providers who prescribe pills across state lines into a state where it is illegal." He, along with frequent collaborators Greer Donley, a law professor at the University of Pittsburgh, and Rachel Rebouché, a law professor at Temple University, were among the many experts with which the Beyond Roe Coalition consulted as they figured out how to include telemedicine in an expanded version of an abortion shield law.

On the day the *Dobbs* decision landed, Healey had promised to do "everything we can to ensure patients from across the country can receive needed care and to support and protect our providers who are offering that care." Backers of the shield law could be confident that if it was challenged in court, it would be defended.

Healey's office then issued a consumer warning about crisis pregnancy centers: "WARNING: CPCs do NOT provide comprehensive reproductive healthcare. CPCs are organizations that seek to prevent people from accessing abortion care," the consumer advisory stated. "Most CPCs are NOT licensed medical facilities, CPCs are NOT typically staffed by licensed doctors or nurses, even though some people who work at CPCs may try to look the part . . . Unlicensed CPCs are NOT required to follow codes of ethics or standards of care that govern healthcare professions because they are not healthcare providers." Healey, who was already running for governor, said that she also supported a public

education campaign related to CPCs—a coalition priority that was not supported by Baker.

When Healey won her gubernatorial race in November 2022, it ensured that abortion rights would be protected across the board up to the highest levels of state government. Her victory wasn't close: She and Kim Driscoll, who ran on the same ticket for lieutenant governor, won their race by nearly 30 points. Andrea Campbell was elected to succeed Healey as attorney general by about 26 points, becoming the first Black woman in Massachusetts statewide office. During her election-night speech, Healey noted the historic nature of the victorious candidates: "I stand before you tonight proud to be the first woman and first gay person ever elected governor of Massachusetts," she said to cheers. After promising to make Massachusetts more affordable, cut taxes, and fix roads and bridges, Healey delivered the line that drew such a raucous response she could barely be heard above the crowd gathered at her victory party: "And as long as I'm governor, women will always have the freedom to control their own bodies—and our state will provide access to safe, legal abortion. We will protect women, we will protect patients, and we will protect providers in Massachusetts!" Healey declared.

The impact of the election manifested within days of the three women being sworn in.

In late January 2023, Campbell, who had pledged during her campaign to create a cross-bureau reproductive justice unit, held a press conference with Hart Holder and other high-profile leaders in the state, including U.S. senator Elizabeth Warren, to show her support for an abortion legal hotline launched by Reproductive Equity Now, ACLU Massachusetts, the Women's Bar Foundation, and five private law firms that would offer pro bono legal assistance. Two months later, in March, Healey signed a $389 million supplemental state budget that included $1 million for a public awareness campaign

focused on antiabortion centers—funding Baker had line-item-vetoed on his way out the door.

Cambridge had already enacted its CPC advertising ordinance, after borrowing the concept from Kristen Strezo, an at-large member of the council in neighboring Somerville, home to Tufts University. Strezo, in turn, had gotten the idea from a 2017 CPC advertising ordinance enacted in Hartford, Connecticut. Strezo told me that CPCs had been on her radar since she was the frontwoman of a feminist punk band in her twenties. She ended up running for her council seat in 2020 in part because she kept thinking about how Jello Biafra of the Dead Kennedys—the lead singer and songwriter of the genre-defining punk rock band, who ran for mayor of San Francisco in the late 1970s—would talk about how "nobody really considers municipalities," she said.

In much of New England, including Massachusetts, the municipality—or town—is the main form of local government. Adjoining towns cover the entirety of most New England states. The towns hold their own meetings, have their own legislative bodies, and function the way cities and counties do in other states—but they are smaller and not as far removed from the populace. Counties still exist, but they serve mainly as geographic borders with no stand-alone government of their own and provide limited services. In Connecticut and Rhode Island, there are no county governments at all.

This New England system of municipal government helped make Massachusetts a laboratory where innovative ideas to protect abortion could spread quickly at the local level, even before they bubbled up to the state. When Cambridge approved its CPC ordinance in January 2023, half a dozen other towns across the state were considering their own. "I think there's some certain Goldilocks things in Massachusetts that make it easier to do some of the things that we're talking about. I don't think it's because we're better advocates than

people in other states or anything like that, I just think that the unique geographic and geopolitical situation in Massachusetts enabled us to align the stars and move really quickly," Rose said.

While the Beyond Roe Coalition did not see its work as finished— they still aimed to fully repeal the state's gestational 24-week cutoff for abortion; enact stronger digital privacy laws to protect data related to reproductive health; and raise the state's MassHealth reimbursement rates for abortion care—they had, together with state and local lawmakers, and in a short period of time, taken definitive and impactful steps to protect abortion access in the state.

"What we saw," Rose told me, "was a historic moment of the people coming together with their leaders, with the advocacy groups and everybody was aligned—that's how we were able to do so much so quickly."

Spring 2023

"We need to dig in and really hold the line."

Wisconsin

MILWAUKEE—On April Fool's Day, Daphne Blount and several of her friends headed to Red Arrow Park, a pocket of open space in downtown Milwaukee, across the street from City Hall and a block from the river.

The day was chilly, windy, and gray.

Blount handed out blankets from her car and they bundled themselves up in what she called "burrito style." They'd probably be there for a while—and it wasn't for pranks. Their excursion that Saturday felt existential: In just three days, there would be a state Supreme Court election that could eventually determine the future of abortion access in Wisconsin.

Blount and her friends drove downtown to support Judge Janet Protasiewicz, the candidate who believed that abortion was a right—not former justice Daniel Kelly, the antiabortion candidate

who had recently appeared alongside a pastor who, years before, had signed a letter saying that killing an abortion provider met the definition of "justifiable homicide."

For Blount, the stakes in the election weren't theoretical.

She was a first-year medical student, having returned to her home state of Wisconsin after graduating from the University of Minnesota. She'd been thinking of specializing in women's health care—now she wasn't so sure. Weeks before she started med school, the U.S. Supreme Court overturned the constitutional right to abortion in *Dobbs*, and a Wisconsin abortion ban from before the Civil War kicked in. Passed in 1849, then updated in 1858, before women could vote or even own property, it criminalized the provision of abortion at every stage of pregnancy. Its only exception was to prevent the death of the person who was pregnant.

"Choosing to go into that specialty if you're going to stay in the state of Wisconsin, it is going to constantly be an uphill battle," Blount told me. "So that has certainly been a component of me deciding to open my mind to looking at other specialties . . . I do hope to practice in Wisconsin as a physician, I just don't know if I want to sign myself up to be constantly needing to fight for my patients to have access to human rights, basic reproductive care."

Several days after the *Dobbs* ruling, Wisconsin governor Tony Evers and attorney general Josh Kaul, both Democrats—and both up for reelection—filed a lawsuit challenging the 1849 ban. "Half the people who live here are now second-class citizens," Evers said at a press conference.

The case started making its way through the court system. No matter how a lower court might rule on the century-plus-old law, its supporters and critics both knew that the case would be appealed and end up at the Wisconsin Supreme Court, which—going into the April 2023 election—was split 4 to 3 in favor of conservative

justices. But Justice Patience Roggensack, a conservative who sat on the court since 2003, was retiring rather than pursuing a third ten-year term. State supreme court elections in Wisconsin are nonpartisan, but Protasiewicz, a county circuit judge in Milwaukee, said that she was running to take on "radical right-wing extremists" who were jeopardizing Wisconsinites' "most closely held constitutional rights." Kelly, a conservative appointed to the bench who served for four years before losing reelection in 2020, had also made his politics clear: He was a paid adviser to the state and national GOP as former president Donald Trump ran for reelection in 2020 and contested the former president's loss in Wisconsin and nationally. "If an activist were to win next April, Wisconsin's public policy would be imposed by four lawyers sitting in Madison instead of being adopted through our constitutional process," Kelly said when he announced. "I won't let that happen on my watch."

The parameters of the battle to regain abortion rights in Wisconsin were set. Because Wisconsin has no citizen ballot initiative process, courts would be the only realistic route to seek relief from the pre–Civil War abortion ban—as well as from GOP-drawn gerrymandered maps that distorted party representation in the legislature in favor of Republicans. The outcome of the Supreme Court race would determine whether the state's voters would get a chance for fairer representation in the state legislature—and whether Blount would have the chance to learn how to perform an abortion, not to mention whether she would be able to offer it as an option to her patients when she begins practicing, if she decides to be an OB-GYN in her home state.

Blount was at the pro-Protasiewicz rally due to her involvement with the group Medical Students for Choice, a national nonprofit that was founded by student activists back in 1993. When she arrived in Milwaukee for medical school, Blount went to a student

organization fair and her school's chapter of MSFC (as its members often call it) had a table that caught her attention because it seemed like they, in particular, were being "very proactive in trying to make the situation better, get answers for students and fight for better educational access," she told me.

Blount said she "kind of knew from the moment that *Roe v. Wade* fell that reproductive justice was going to be an important piece of going to medical school, because how are all the residents and med students in Wisconsin going to get their OB-GYN, family care and primary care education effectively when a very important piece of our education is now up in the air and in limbo?"

Fortunately, Blount entered medical school at a time when many in her chosen profession were newly energized about taking on the role of activist.

After the Affordable Care Act was enacted in 2010, there were immediate and continued attempts to repeal it that prompted some physicians to advocate for a universal health care system. Pediatricians joined the front lines of the fight against gun violence. Doctors watched as the country's rejection of science worsened during the COVID-19 pandemic. When a Minneapolis police officer killed George Floyd in May 2020, it kicked off a series of nationwide racial justice demonstrations, and members of the national student-run group White Coats for Black Lives took to the streets to protest police violence and systemic racism as a public health crisis.

Blount, who was in Minneapolis the summer of Floyd's murder, had thought about advocacy as a necessary part of urban and community health as she considered that as a career focus, but it wasn't until *Roe* fell that she realized other areas of medical practice—pediatrics, women's health—might require activism in order to care for her future patients. "I think a big component for me has been feeling this kind of call to advocacy. That wasn't really on my radar when I applied to medical school," she said.

When I asked Blount why she might have a greater degree of comfort about activism as compared to medical students more broadly, she pointed to her undergraduate experience at the University of Minnesota, where students were open about changes they wanted to the curriculum and administration; her interest in community health, which brought her to medical school in the first place; and physician mentors who she has been able to emulate.

"I've kind of had the perspective that you can't improve a system without identifying its flaws, so I think I'm a little bit more open to identifying areas where patients care is really limited and where we can improve," she said.

As the contours of Wisconsin's Supreme Court election began to take shape, the MSFC chapter at Blount's school kicked into action. They created informational, nonpartisan flyers that listed candidate endorsements and quotes, noting that Protasiewicz had said "a woman's right to make decisions over her own body should be just that, not made by the government, but made by the person who's ultimately being affected." Kelly, meanwhile, had called abortion "a policy deadly to children." As the general election drew closer, they distributed leaflets that advised potential voters on how to make sure they were registered, how to find their polling place and provided the deadline for requesting absentee ballots. "The candidate elected in April will play a decisive role in upcoming cases that may include the legality of Wisconsin's near-complete 1849 abortion ban, fights over legislative redistricting and the power of the executive branch in administering laws," one leaflet read. MSFC members staffed tables on campus that registered people to vote.

Blount's membership in the group was how she found herself bundled up like a burrito on a cold Saturday in a downtown park instead of studying or relaxing with her friends.

"I think the biggest thing that has arisen for me over the last year has been this feeling that I can't be in this profession and not do

everything in my power to improve the systemic issues that are really creating barriers for patients," she said.

MEDICAL STUDENTS FOR Choice was founded in 1993, the year after the Supreme Court affirmed the constitutional right to an abortion in *Planned Parenthood v. Casey*, but said states could pass restrictions so long as they did not create an "undue burden" for patients seeking abortion care.

It was a time when violence against abortion providers was in the headlines. In December 1991, a masked gunman with a sawed-off 12-gauge shotgun shot and injured two clinic workers at Center Health Center for Women in Springfield, Missouri. In March 1993, in what was described by authorities as a first-of-its-kind slaying, an antiabortion protester shot and killed forty-seven-year-old Dr. David Gunn at his clinic in Pensacola, Florida—the 1993 murder was the one that the pastor who appeared with Kelly said was a justifiable homicide. Later that year, in August, antiabortion extremist Rachelle "Shelley" Shannon, affiliated with the Christian terrorist organization Army of God, whose followers had been bombing clinics since the 1980s, shot and wounded Dr. George Tiller at his clinic in Wichita, Kansas. (In 2009, another antiabortion activist ultimately shot and killed Tiller as he served as an usher during a Sunday morning church service.) "We were created by medical students who were, obviously, feeling the pinch between the constitutional protection of abortion in the U.S. and the reality that abortion providers were being assassinated," MSFC Executive Director Pamela Merritt told me.

MSFC now has more than 220 chapters at medical schools and in residency programs in more than twenty countries. Its fastest-growing region of membership is the global South—there are chapters in India, Nepal, and Malawi. "Medical Students for Choice fills a unique

role helping future physicians reconcile the need for advocacy within their profession," Merritt said.

While abortion is taught in OB-GYN residency programs, it is not part of the core accreditation curriculum at U.S. medical schools, so students interested in becoming OB-GYNs—or family practice physicians, or anyone who anticipates a need to learn the full spectrum of reproductive care—can turn to MSFC for training they aren't getting at their colleges and universities. Three or four times a year, MSFC holds very popular classes taught by alumni that students can attend in person or virtually. In one, students use a papaya as a stand-in for a uterus in order to practice manual vacuum aspiration, which can induce an abortion, and clear retained fetal tissue. (The Reproductive Health Access Project, which also aims to fill gaps in clinical education related to reproductive care but for family physicians, recommends finding "a store supplying the smaller 'Hawaiian' or 'Brazilian' papayas, rather than larger 'Mexican' ones . . . The papayas work best if they are somewhat ripe and not too green, but they do ripen quickly so don't buy them too far in advance.")

Medical Students for Choice was already a part of the pre-*Dobbs* educational safety net, providing trainings, 3- to 9-day stints shadowing abortion providers in clinical settings, and financial assistance to set up externships. After *Dobbs*, depending on the school and state, MSFC programming became an educational lifeline for students who had literally no other route to receive abortion training. "The reality is, medical schools have always been able to fall back, until June of 2022, on the fact that students who are super interested [in learning abortion care] could go to their local clinic and get an elective credit and get training, or the fact that if somebody later goes into residency and decides that they want to be an OB-GYN, then they are going to get that training," Merritt said.

MSFC also partners with the Center for Reproductive Rights to join lawsuits related to abortion and contraception. MSFC, the

National Abortion Federation, Physicians for Reproductive Health, Planned Parenthood, and other similarly aligned groups filed an amicus brief in the *Dobbs* case when it was before the Supreme Court. Since then, the group filed a friend-of-the-court brief in the lawsuit challenging the FDA's approval of the abortion drug mifepristone. Anything where "we feel that medical students have a vested interest," she said.

Merritt also noted that the way that medical education is structured makes student concerns about reprisal for challenging their administrators and schools very real. Many medical schools have for many years shied away from teaching abortion care due to their traditional alignment with the patriarchy, she said.

Plus, she continued, medical schools are bureaucracies that are risk-averse, and their boards often have members who are either small-*c* or politically conservative. The way medical school administrations are structured vests a lot of power with the deans, who make recommendations for students as they match with residency programs, and can ease—or obstruct—residents who need to travel out of state or to another institution for training. "Basically, the people who are going to recommend you for match, for residency, are the same people that our chapter leaders are trying to get to make change. So the fact that we still have people who are eager and participating always inspires me because it is a scary business, the tragedy being that if you run afoul of your dean, and you don't get a certain number of recommendations, you're not going to get a residency. If you get fired from your residency program, you've lost your career—not just a job," Merritt said.

Still another way that MSFC reinforces abortion education is by supporting the medical students who are trying to change school curricula, because the "number one thing—and this predates *Dobbs*— preventing medical students from getting consistent education is the

fact it was not locked into the core accreditation curriculum for medical schools," Merritt said. "So we have an entire passel of resources and support that we provide for that, and it's really tailored to the situation, what kind of administration you have, who are your friends and foes, etcetera . . . a lot of campuses are working on curriculum reform, and even though they might not get a win while they're in med school, they're advancing the ball."

Initial data from the Association of American Medical Colleges on the first post-*Dobbs* residency matching cycle showed that students were already shying away from applying to programs in states that banned or restricted abortion. Learning to perform abortions is a required component of OB-GYN residencies, so in states where abortion is restricted, training doctors would have to spend time at another hospital out of state, which can be costly and logistically complicated. In states with full abortion bans, the number of OB-GYN residency applicants fell by more than 10 percent in the 2022-2023 cycle as compared to the year before. For states with abortion limits, the number of applicants dropped 6.4 percent, AAMC data showed.

The majority of medical residents ultimately build their practices in the state where they trained—and even before *Dobbs*, Wisconsin was facing an OB-GYN shortage.

"The reality that advocates and providers need to wrap their head around is that this has done profound damage to the structure of our system and the distribution of OB-GYN providers in the country already—and that is not going to be fixed anytime soon," Merritt said. Even back in 2016, she said she was thinking: "We need to dig in and really hold the line where we do have adequate care because we're about to lose it big time, including in the entire South."

A one-word synonym for digging in and holding the line is activism, and Medical Students for Choice also aims to provide a

grassroots education about how physicians can—and should—
embrace it as a component of their medical practice. MSFC has
shaped the careers of many doctor-leaders in the reproductive justice
movement. Dr. Diane Horvath, who started Partners in Abortion
Care in College Park, Maryland, founded an MSFC chapter when
she was a medical student in Toledo, Ohio. While Dr. Leah Torres
traces her initial interest in being a physician back to a women's
studies course at the University of Michigan—where she learned
that key medical studies on health issues that disproportionately
affected women nevertheless used all-male subjects—she said she
realized she wanted to be an OB-GYN in her second or third year
of medical school at the University of Illinois Chicago, when she
discovered a newly established chapter of Medical Students for
Choice.

"I went to a meeting or whatever and found my people, because
the whole shtick was abortion, contraception—these are things
that are under studied, if not taught at all, in medical school
curriculum and we are working to change that and make it more
accessible," Torres said. "I thought: If we're not learning about it
in medical school, that's a problem. And so started my political
advocacy."

STUDENTS, INCLUDING MEDICAL students like Blount who
embraced advocacy, were an important part of the coalition working
to elect Protasiewicz in a race that the *New Yorker* described in a head-
line as a HIGH-STAKES ELECTION IN THE MIDWEST'S "DEMOCRACY
DESERT" that COULD CHANGE THE COURSE OF THE ENTIRE COUNTRY.

In a boldfaced headline, it read as hyperbole, but the markers were
there. By many measures, Wisconsin was the most gerrymandered
state in the country. It does not track registered voters by party, but

its statewide races, including for presidents, are often decided by a point or two, indicating a relatively evenly split electorate. In the 2022 midterms, Democrats were reelected as governor (Tony Evers), attorney general (Josh Kaul), and secretary of state (Douglas J. La Follette)—but those were statewide offices. In the state legislative races, meanwhile, Republicans retained a disproportionate 64–35 majority in the Assembly and a 22–11 majority in the Senate. Plus, the *New Yorker* pointed out, the Electoral Integrity Project, founded in 2012 by Harvard University professor Pippa Norris, scored Wisconsin's electoral maps at 23 out of 100 possible points for their democratic attributes—a score that the magazine noted was "on par with that of the Democratic Republic of the Congo."

Before the Protasiewicz-Kelly race, the record for the most expensive judicial election in the country was believed to have been set in Illinois, where $15 million was spent in 2004. The amount of money spent in Wisconsin dwarfed that: By the general election on April 4, more than $45 million was spent, with the candidates' combined campaign expenditures nearing $17 million, and roughly $30 million was spent by outside groups on issue ads and other campaigns, according to records analyzed by OpenSecrets and the nonprofit group Wisconsin Democracy Campaign.

Kelly's campaign raised the relatively modest sum of $2.6 million, with its largest donations coming from the Republican Party of Wisconsin (about $800,000) and Illinois-based billionaire shipping magnates Elizabeth and Richard Uihlein (together the maximum allowed of $40,000). Longtime Federalist Society adviser Leonard Leo, who guided Donald Trump's judicial picks, also gave Kelly's campaign the maximum-allowed donation of $20,000. In outside spending, Fair Courts America—a Uihleins-backed group that promises it is "tracking the woke mob's activity and are ready to fight for free & fair courts at every level of our government"—spent $5.5 million

on Kelly's behalf. The antiabortion Women Speak Out PAC, affili-
ated with SBA Pro-Life America, spent another $2.2 million. Leo's
firm, the Concord Fund, has lobbied for Fair Courts America, while
a Leo-affiliated network of dark money groups has spent millions on
antiabortion cases.

Meanwhile, Protasiewicz's campaign raised $14 million, with
nearly $9 million of that coming from the Wisconsin Democratic
Party, along with strong support from individual donors who identi-
fied themselves as lawyers, from the securities and investments sector,
educators, and health care professionals. In outside spending, A Better
Wisconsin Together Political Fund, which pools money from liberal-
leaning donors like labor unions and Democratic redistricting
groups, spent $6.2 million on Protasiewicz's behalf. A notable indi-
vidual among the fund's backers was Lynde B. Uihlein, who in 1990
founded the nonprofit Brico Fund, which supports feminist, environ-
mentalist, and progressive projects in the state—she is also the
Wisconsin-based cousin of the conservative power couple who
supported Kelly.

It was unclear at first whether the stunning amount of money spent
on the race would increase voter turnout—but the primary offered a
preview. The judiciary had traditionally been an issue that mobilized
conservative voters more than liberal voters, both nationally and
within states, but there were signs that key progressive constituen-
cies like students were more engaged than ever before even though
the general election would happen in an off year, in an odd month.

The *Milwaukee Journal Sentinel* reported in early March that a
dining hall on the University of Wisconsin–Madison campus, which
typically had about fifty voters who participated in spring primary
elections, had 515 ballots cast in the Supreme Court primary. A dorm
on the same campus had a 39 percent turnout rate. A local elections
supervisor told the newspaper that turnout was so high in the primary

that some polling locations had to print more ballots, and there was noticeably high participation among young people and women, two demographic groups that tend to disproportionately back progressive candidates and causes—and support reproductive rights.

Ben Wikler, chair of the Wisconsin Democratic Party, told me that he believed that the backlash among the state's women and young voters to Trump's presidency—and the state GOP's continued insistence that Trump won Wisconsin in 2020 despite all evidence to the contrary—is one reason why Wisconsin was still a swing state, unlike neighboring Iowa or nearby Indiana. "They have refused to let up for even a second," he said.

On April 4, close to 40 percent of Wisconsin's voting-age population cast ballots in the Protasiewicz-Kelly race—a higher turnout than in any other Wisconsin Supreme Court election in nearly 25 years that didn't coincide with a presidential primary. Wikler noted that a "small shift" in any demographic, whether it's increased rural engagement or campus turnout or enthusiasm from Black or Latinx voters—"all of those things can determine a statewide election here."

When the race was called for Protasiewicz, it was a decisive 11-point victory in a state where four of the last six presidential elections were decided by less than a single point. The British newspaper the *Guardian* reported that it "amount[s] to a political earthquake in Wisconsin, one of America's most volatile political battlegrounds." NPR said that "the win by Protasiewicz comes at a pivotal time for the court, and for the Democratic voters who carried her to office." An NBC News headline blared: LIBERALS GAIN CONTROL OF THE WISCONSIN SUPREME COURT FOR THE FIRST TIME IN 15 YEARS. The *New York Times* declared that voters "chose to upend the political direction of their state . . . The result means that in the next year, the court is likely to reverse the state's abortion ban and end the use of gerrymandered legislative maps drawn by Republicans."

If the 1849 abortion ban found its way to the state Supreme Court, the justices would likely vote to overturn it.

For Blount—and her fellow medical students—it was a potentially life-changing opening. Maybe it would be possible to get an education here. Maybe it would be possible to practice medicine here. Maybe it would be possible to build a life here.

"The mental gymnastics here have been really interesting to watch."

Ohio

C OLUMBUS—As Daphne Blount and other students in Wisconsin organized to protect democracy and restore abortion access in their state, abortion rights activists in Ohio were busy readying a ballot measure they hoped to put before voters in November 2023.

In the 2022 midterms, abortion rights won when put directly before voters and the issue bolstered the fortunes of Democratic candidates and proved a liability for Republicans in competitive races up-and-down ballots. Months later, Wisconsin's supreme court contest showed that when a race becomes a referendum on reproductive health care access, abortion rights win in that way too.

These results were a shot across the bow for antiabortion lawmakers everywhere as they signaled a potential path to victory for abortion rights activists in places like Arizona, Colorado and, perhaps most

immediately in Ohio, where polling showed that laws and legislators were out of step with voters on the issue.

Even before the December 2022 launch of Ohioans for Reproductive Freedom—a coalition made up of the ACLU of Ohio, abortion providers, women's groups, and reproductive justice organizations—state antiabortion lawmakers started exploring various antidemocratic end runs that would make it more difficult for Ohioans to pass a ballot measure protecting abortion. "There was a reproductive rights movement afoot, and they started to organize" against it, Representative Allison Russo, the Democratic minority leader in the House, told me of her Republican counterparts.

Ohio is a onetime political battleground that twice backed Democratic president Barack Obama, then twice supported Republican Donald Trump, then continued trending decidedly red. In Ohio's closely watched U.S. Senate race in 2022, Trump-backed Republican J. D. Vance staked out a relatively moderate position on abortion by supporting a 15-week ban, and he prevailed over then Democratic U.S. representative Tim Ryan by about 6 points. In Ohio's gubernatorial election, meanwhile, incumbent Republican Mike DeWine crushed Democrat Nan Whaley, the mayor of Dayton. While the candidates Ohioans sent to the statehouse reflected the state's political leanings overall, they did not necessarily reflect the electorate's will on matters of reproductive health care access. An abortion rights amendment on the ballot would give Republican voters a chance to back reproductive rights without abandoning the candidates from their party.

A majority of Ohioans favor some level of legal abortion access. When asked to choose whether abortion should be legal or illegal in most or all cases, 52 percent of Ohioans said it should be legal. But Ohio's legislature had nevertheless passed a series of restrictive abortion measures over the years, many of which were signed into law. In 2013, for example, Ohio lawmakers updated the state's

Targeted Regulation of Abortion Providers bills, or TRAP laws, related to abortion providers' hospital admitting privileges and transfer agreements, making it more difficult for the state's abortion clinics to operate. In 2020, the state began requiring all aborted fetal tissue to be cremated or buried.

Ohio's GOP-controlled legislature was also among those in the 2019 wave that passed restrictive 6-week abortion bans—in their case, with no exceptions for rape or incest. A state judge put Ohio's ban on hold shortly after it was passed, and it did not take effect until the Supreme Court decided *Dobbs*. Ohio attorney general Dave Yost, a Republican, filed a motion to dissolve that injunction. The 6-week ban went into effect and almost immediately became national news when the *Indianapolis Star* reported that a ten-year-old girl from Columbus, Ohio, traveled to Indiana to have an abortion because she was just past the gestational cutoff. Yost called the very real story a "fabrication"—it wasn't. National antiabortion leaders weighed in. National Right to Life Committee general counsel James Bopp said had the child been forced to carry her rapist's baby to term, they "would hope that she would understand the reason and ultimately the benefit of having the child." Indiana authorities started investigating the physician who performed the abortion and referred her to the state medical board for potential disciplinary action. The story stayed in the news for weeks. Abortion right supporters in Ohio sued, and in mid-September 2022, a Cincinnati-area judge again put the six-week ban on hold. Abortion opponents appealed.

GOP lawmakers in Ohio were able to enact abortion laws without broad electoral support in part because they held supermajorities in the 99-seat house and the 33-seat senate. These supermajorities were achieved and maintained via extreme partisan gerrymandering, according to Herb Asher, an emeritus political science professor at the Ohio State University. "You could say Ohio has moved somewhat

to the right in recent elections, but the major reason [for the superma-jority] is the way the districts are drawn. If you had a balanced, or fair legislature, Republicans would still have a majority, but they very skillfully used the pen to draw lines in such a way that what should be a fifty-five–forty-five [partisan breakdown] is now in the high sixties to thirties," Asher said. "Our legislature, on a whole variety of what we might call social issues, is far more conservative than the citizens of Ohio."

To block voters from directly protecting abortion rights, Ohio Republicans settled on a proposed constitutional amendment of their own. The GOP amendment aimed to raise the threshold to approve citizen-initiated measures from a simple majority to 60 percent—GOP lawmakers just needed to get it in place before the abortion rights amendment was before voters. In November 2022, when Republican secretary of state Frank LaRose and first-term GOP state representative Brian Stewart announced their proposed amend-ment, they said it was to "protect the Ohio Constitution from continued abuse by special interests and out-of-state activists."

Steven Steinglass, a dean emeritus at the Cleveland State Univer-sity College of Law, told a local television station on the day of the LaRose and Stewart announcement that it was a "solution in search of a problem," noting that since 1912, Ohioans had approved just nine-teen of seventy-two citizen-offered constitutional amendments. "I don't think it's entirely a coincidence," he added in an interview with News 5 Cleveland, "that we're looking forward in the next two years to a number of proposed amendments on the ballot," including amendments addressing abortion rights and reducing partisan gerrymandering.

Asher put it bluntly: The LaRose-Stewart proposal, he said, was "indicative of a very conservative legislature that doesn't trust the citi-zens and therefore wants to make citizens weaker."

When the Ohio General Assembly returned after the 2022 midterms for its lame-duck session to close out the year, the Stewart-LaRose measure was under consideration. Hundreds of protesters gathered across the street from the statehouse at Trinity Episcopal Church to protest. "People of faith and goodwill are not fooled by the label of good government affixed to this resolution," said Rev. Jack Sullivan Jr., the executive director of the Ohio Council of Churches, which represents four thousand houses of worship that include Episcopal, Greek Orthodox, and Methodist congregations. "We know gamesmanship and a blatant misuse of power when we see them, and this resolution is rooted in both." Responding to the blowback, then house Speaker Bob Cupp, a Republican, told local news media that it was "doubtful" the measure would get a vote before the general assembly recessed for the year, since "members have a lot of different opinions about it, and some are trying to figure it out."

Stewart acknowledged on the social media website then known as Twitter that the math in December for his proposal was "unworkable." But he also indicated that he believed his bill's failure to move forward in the lame-duck session was a temporary setback, writing: "Looking forward to January." Though he and LaRose denied when they announced the measure that it was directly tied to a potential reproductive rights initiative on statewide ballots, Stewart later sent a letter to all of his Republican colleagues that shed motivational insight. After lamenting the "temper tantrum" from his opponents that prevented the bill's passage before the end of the year, Stewart wrote: "There is a reason that every far left group in Ohio is fighting so hard to preserve their ability to do an end run around us—the elected representatives of the people . . . After decades of Republicans' work to make Ohio a pro-life state, the Left intends to write abortion on demand into Ohio's Constitution."

To many of Stewart's opponents, his measure was an attempt by Republican politicians and special interests to thwart the will of the people. More than 240 bipartisan groups would end up opposing Stewart's measure, along with prominent elected officials from both parties that included Republican former governors John Kasich and Bob Taft, and Democratic former governors Ted Strickland and Dick Celeste. Taft told the *Ohio Capital Journal* that changing the state's constitution "shouldn't be a partisan issue." Strickland called it a "very transparent effort to subvert the will of the people." A bipartisan group of former state attorneys general also announced their opposition.

But Stewart—along with many of his statehouse colleagues—had little to risk when they pressed forward with the measure that was being denounced on both sides of the aisle. In the 2022 midterms, nearly a third of Ohio's state legislators ran unopposed, including Stewart, who was reelected to a second, two-year term by more than 99 percent of the vote. Study after study has shown that a key contributor to uncontested races is partisan gerrymandering, which creates an environment in which it makes little to no sense for a candidate from the less-favored party to spend the time and resources to mount a campaign—and Ohio is one of the most gerrymandered states in the country.

Ohio's voters have tried to change this situation, but to little practical effect. In 2015, more than 70 percent of the state's voters backed a bipartisan constitutional amendment to create the Ohio Redistricting Commission. The seven-member commission tasked with drawing state legislative districts is comprised of the governor, state auditor, secretary of state, one member appointed by the house speaker, one member appointed by the minority party in the house, one member appointed by the senate president and a final member picked by the minority party in the senate. It replaced the former

system, which was a five-member board comprised of the governor, state auditor, secretary of state, and two members picked by party leaders in the legislature. In 2018, Ohioans again approved a constitutional amendment that banned partisan gerrymandering and put the same seven-member commission in charge of drawing U.S. House districts if state lawmakers are unable to reach a consensus. But the system Ohioans hoped would yield better maps resulted in state and federal legislative districts just as partisan and noncompetitive as the maps created by the board that the commission replaced.

The Ohio Redistricting Commission in September 2021 adopted new GOP-drawn state legislative districts in a 5-to-2 vote along party lines. Several voters sued, saying the boundaries gave Republican candidates a disproportionate partisan advantage. The Ohio supreme court, which is elected and was split 4–3 in favor of Republicans, agreed. The commission redrew the maps four more times; the Ohio supreme court struck them down four more times. In the 2022 midterms, Ohioans had cast ballots in legislative and congressional races based on district maps the state's highest court had found to be unconstitutional over and over again, until the clock ran out to redraw them.

Critics of gerrymandering in the state—and the resulting GOP supermajorities—became an important part of the burgeoning coalition of bipartisan groups and individuals opposing the LaRose-Stewart proposal, given that some good government groups were already considering using a separate ballot initiative to combat partisan map drawing. Republican former state auditor and former attorney general Betty Montgomery began speaking against the LaRose-Stewart measure. She would later describe the proposal to the *Washington Post* as a "power grab" that would weaken voters' ability to overcome a legislature that did not represent their interests, and remove a "necessary part of the checks and balances in a

democracy, especially when there is a supermajority, to assure the public is heard."

Stewart, undeterred, made good on his promise to revisit the issue when the legislature convened for its new session. On January 11, 2023, he introduced the Ohio Constitution Protection Amendment. This time, he had more than 30 Republican cosponsors, and, in addition to the higher threshold for passage, there was a new requirement that citizen initiative backers would also have to secure signatures from at least 5 percent of voters in all of Ohio's 88 counties, instead of in 44 as they had to in the past. It also proposed eliminating what's known as a curing period. Of the 26 states that have a statewide initiative or veto referendum process, just two—Ohio and Arkansas—provide a curing period, during which additional signatures can be collected after the initial deadline if some in the original batch were invalid. Asher told me that taken collectively, the three changes would make it "almost impossible for the citizens of Ohio to utilize a provision in the Ohio Constitution that allows citizens to initiate both a constitutional amendment and a statute."

In yet another indication that Stewart's bill was prompted by, and aimed at, a potential reproductive rights amendment, he initially aimed to get it onto ballots in the May 2023 primary elections, when there would be local races to drive Republican turnout that might skew the results in his favor. When that didn't happen, Russo told me "it seemed like it was going to die. I thought their next play would be to try to push it again next year, in a May primary, because really only Republicans will be on the ballot—that seemed to be strategically the thing that made the most sense." But that would be after Ohioans would likely approve a constitutional amendment protecting abortion, which Ohioans for Reproductive Freedom aimed to have on November 2023 ballots.

Instead, what happened was a "full-on assault to create another August special election and to push it in August, because they saw

very clearly that [the reproductive rights amendment] was likely going to qualify and get the signatures that needed to qualify for November," Russo said.

Stewart and his backers had a major problem: A bill that the previous General Assembly had enacted during the lame-duck session at the end of 2022 eliminated most August special elections because of their high cost and abysmal voter turnout—DeWine had just signed it into law in January. Now, Republicans in the statehouse trying to head off a voter-backed measure protecting abortion rights would need to bring August elections back if they wanted to get ahead of the reproductive rights initiative. In April, just three months after he did away with August elections, DeWine announced that if Republicans sent him a bill to revive them, he would sign it.

"All of this is entirely disingenuous," Russo told me. "In December, we had direct quotes from Frank LaRose, from Brian Stewart, from Matt Huffman, who is the senate president—all of these folks, talking about how great it is that we got rid of August special elections, that they're expensive, that we have low turnout, that they're used by groups to pass things without voters really knowing what's happening."

"And yet, you know what? When it is convenient for them, they completely reverse course," Russo added.

Stewart and his cohort couldn't wrangle enough Republican support in the statehouse to pass the bill to get his measure onto ballots in August, and to revive the special election. Instead, the General Assembly approved it via a joint resolution—a procedural maneuver that abortion rights groups quickly challenged directly before the Ohio Supreme Court. While the case moved forward, LaRose began preparing his measure to be on August ballots, ahead of the abortion rights measure in November.

Before Ohioans could weigh in on whether they want to enshrine abortion rights in their state's constitution, they would need to navigate this secondary ballot measure, designed to make it more difficult

for them to participate in direct democracy. Asher characterized it as "taking away power from citizens and really centralizing it in the Republican-led state government."

"The mental gymnastics here have been really interesting to watch," Russo said.

Post-*Dobbs*, antiabortion lawmakers in Ohio's conservative legislature weren't alone in attempting to ensure their own interests would prevail by creating new hurdles for the most direct form of democracy: citizen-offered ballot measures, amendments, referendums, and initiatives.

In Mississippi, where the state supreme court in 2021 struck down the state's ballot measure process in its entirety, there was a proposal to revive them, but with a carve out for abortion or budget-related issues. In Missouri, some antiabortion members of the GOP used the budget argument to try to block another affirmative reproductive rights measure, with polling showing that a majority of the state's voters were open to rolling back the state's near-total abortion ban.

But the GOP effort in Ohio was perhaps the most brazen—and their antidemocratic wrangling would continue, long after Ohioans rejected Stewart's measure and went on to protect abortion rights that November.

"Are they going to put everyone in jail?"

Arizona

PHOENIX—Every weekday at 8 A.M., two certified nursing assistants began their shifts at Camelback Family Planning by staffing a makeshift call center in the clinic's break room, scheduling patients for next-day appointments.

"Camelback Family Planning."

"Yep, you're in the right queue. Have you been here before hon?" one nursing assistant asked.

"The first available tomorrow is eight thirty A.M. . . . yeah, I also have a ten o'clock," she continued, entering the patient's first name, last name, and telephone number onto a shared spreadsheet, where there are two appointment slots every half hour from 8 A.M. to 2:30 P.M., with a break for lunch. "It will be a female doctor, don't worry about that. It's all females who work here. Just bring a photo ID to enter the building."

When she hung up the phone, it immediately rang again.

"The cost will depend on your gestation, which you will find out at your consent [appointment]. We can't touch you for twenty-four hours because of the laws for Arizona state," the nursing assistant explained to a woman who wants to know what type of abortion she would be able to have, and how much money she needed to bring to her appointment. "We don't take insurance for abortions, but we do have financial assistance."

The early and late appointments were the first to go. By 8:20 A.M., there was a short lull in incoming phone traffic, but only five slots remained. They too quickly filled, and by the time the nursing assistants transferred the phones back to the front desk ten minutes later, so the assistants could begin prepping examination and procedure rooms for the day's phalanx of patients, there was just one open appointment slot for the next day.

The clinic used to operate exclusively on a first-come, first-served, walk-in basis for three hours each morning and two hours each afternoon, with appointment slots held for follow-up or second-day visits. But the system became untenable after *Dobbs*, when confusion over the state's abortion bans prompted patients to scramble to get appointments while they still could. Camelback Family Planning became "busier than ever," according to Dr. Gabrielle Goodrick, the clinic's owner, known as "Dr. G" to much of her staff.

Clinic staff would arrive in the morning to a line of patients already snaking from the front door, around the building's corner, and back into the parking lot. Patients would pick up paperwork then return to their cars to fill it out and wait until it was their turn for a consent appointment. Sometimes patients arrived in the middle of the night and waited in lawn chairs. The clinic's neighbors complained about the spectacle.

"Every day you'd come in and see a sea of people all the way out into the parking lot trying to get an abortion," recalled Michele,* a registered nurse who has been with the clinic for a decade. "We finally decided that the system is: We're gonna have them call at eight o'clock in the morning, if they call during the day we say 'What you do is you call right at eight o'clock,' and then you get in the queue and then you get an appointment and we only make it for the next day."

The confusion that prompted this scramble was caused by the presence of three abortion bills on the books in Arizona, the most recent of which was in effect that spring. The previous March, Arizona's Republican-led state legislature had approved a bill providing that "except in a medical emergency, a physician may not intentionally or knowingly perform induce or attempt to perform or induce an abortion if the probable gestational age of the unborn human being has been determined to be greater than fifteen weeks." Now, a little more than a year after that law was approved, Goodrick and the clinic's non-physician staff—six in the front office, six registered nurses, three certified nursing assistants, plus one or two rotating medical residents—had to think creatively about how to best deliver abortion care that comported with state law.

The clinic had implemented administrative tweaks, such as the call-in system, but had also drawn on their medical expertise to outmaneuver ban-writing, non-doctor legislators in order to deliver the most expansive abortion care that they could. In a clinic where a registered nurse topped her scrubs with an I DISSENT shirt honoring Supreme Court justice Ruth Bader Ginsburg, and where a wall calendar whose artwork on the page for May declares MIND YOUR OWN UTERUS and the fallopian tubes form middle fingers, they were prepared to fight.

* Only first name used for privacy

Goodrick believed that Camelback Family Planning might be the only of Arizona's seven clinics providing abortions up to 16 weeks, including the full 15th week. "I'm an outlier, but I've read the law, and the law says you can't have an abortion over 15 weeks," Goodrick said. The National Abortion Federation did not fund abortions during that final six days, and the organization asked Goodrick's employees to sign an affidavit that NAF funds would not be used during that window. But the clinic had been reporting abortions up to 15 weeks and six days to the state without issue since the 15-week ban kicked in. Goodrick was worried the state's other clinics are being "overly cautious." This has been particularly true after the results of the November 2022 elections, which were an existential relief for Goodrick and other abortion providers in Arizona. Goodrick had applied for medical licensure in other states, just in case, but had tried not to dwell on the catastrophic impact a single election could have on her continued ability to care for patients.

In the gubernatorial race, Democrat Katie Hobbs eked out a less-than-one-percentage-point win over Republican Kari Lake. In the attorney general contest, Democrat Kris Mayes beat Republican Abraham Hamadeh by just 280 votes in a recount. These two women were now a protective buffer between Goodrick and an antiabortion state legislature in which Republicans cling to slim majorities.

In mid-May, Camelback Family Planning was just a couple of weeks into piloting a "hybrid" abortion program that serves patients through 27 weeks of pregnancy, Goodrick explained. It was in conjunction with a Los Angeles–area clinic, and she and the doctors there aimed to eventually publish their findings in a medical journal. Goodrick hoped the hybrid program could serve as a model for doctors open to "working together and getting creative" about providing abortion care across state lines.

Before *Dobbs*, about 7 percent of Camelback Family Planning's abortion patients were after 16 weeks, and Goodrick said that even then, only three providers in the state offered abortion care at that point or later—in part because many doctors do not have the training to provide surgical abortion care in the later stages of pregnancy, and that training is getting harder and harder to find. To serve these patients and those even farther along, who, as Goodrick put it, are often grappling with "seriously bad shit in their pregnancies" like fetal abnormalities incompatible with life, six years ago she started providing induction abortions—an alternative to surgical abortion that is common in Europe but not often done in the United States in an outpatient setting. In an induction abortion, medication is used to stop the fetal heartbeat, then soften the cervix and induce labor.

While *Roe* was in place, Goodrick offered the procedure as an option to patients, some of whom wanted to deliver their fetuses intact—a particularly important medical service for patients who wanted to grieve desired pregnancies that had gone horribly wrong by having the opportunity to hold their fetus or arrange a burial. With *Roe* gone, the procedure presented a route for Goodrick to continue caring for patients who were ending pregnancies after the state's 15-week limit.

"I started six years ago in July, in anticipation of not having doctors that are trained in D&Es, and especially in late D&Es," Goodrick said, using the acronym for dilation and evacuation, a surgical abortion procedure used after the first trimester of pregnancy that involves dilating the cervix, then using forceps or other medical instruments to remove the fetus and placenta. "I didn't realize then that this would actually work well in this new world in terms of travel."

In summer 2022, after the *Dobbs* ruling, as Goodrick and her clinic sorted out which Arizona abortion laws would apply and when, she first considered opening a second, smaller clinic in California close to the Arizona border, about a three-and-a-half-hour drive to the west.

One of the doctors who works part time at her clinic lives there—a mostly retired OB-GYN with a sister in Phoenix. But Goodrick did not want to use that clinic for the first appointment for a D&E abortion when doctors often insert what is called a laminaria stick to dilate the cervix, since the drive from Palm Desert to Phoenix is desolate, and through areas that might be hostile to abortion care.

But in the crush of legal confusion in the fall, as the Phoenix clinic closed, then reopened, then closed, then reopened, and they sorted through how to interpret and apply the 15-week abortion ban, Goodrick didn't have the bandwidth to open a second clinic in a different state, so she "let it drop," she said. "I missed doing that kind of care, but I figured: I guess it's done." But she couldn't stop thinking about how another option would be to send patients to California for the first stage of an induction abortion, and then they could return to Phoenix to deliver. "They could go into labor, but if they did, it would be a stillbirth. They could go to any hospital. There's no laminaria, there's no evidence there. They could just go in and say: 'I feel like I'm in labor.'"

Then, a couple of months earlier, induction abortion had come up on an encrypted group message on the platform Signal between women abortion providers. Even though her experience was that "clinics don't usually work together, that's just the way it is," Goodrick sent the Los Angeles–area doctor a private message explaining that while their California clinic was seeing an influx of patients from Arizona, hers was limited in the care it could provide, even though she was experienced in providing abortion care beyond her state's 15-week ban. Maybe, if the clinics teamed up, Arizona patients wouldn't be waiting three or four weeks to get into the California clinic for a three-day procedure and could instead complete it back in Arizona, she said. Though Goodrick had typically done induction abortions at an earlier point in pregnancy than the Los Angeles-area clinic, where abortion is

legal without exception until fetal viability, the doctors developed a plan to jointly care for Arizona patients after 15 weeks' gestation. The doctors anticipated that many of them would be seeking care due to severe fetal brain and heart abnormalities, which are typically diagnosed between 20 and 25 weeks of pregnancy.

The process they came up with works like this: An Arizona patient, usually 20 weeks or more pregnant (before that point, it is possible to travel to California or elsewhere and complete an abortion in a single day), would go to the clinic outside Los Angeles, which is about a five-and-a-half-hour drive away or a short flight. There, if they opt for an induction abortion, doctors would administer an injection that stops the fetal heartbeat, then provide medication that causes the lining of the uterine to start breaking down. Ashleigh, a nurse at Camelback, described that medication as "a signal to the body that 'we're not going to be pregnant anymore.'" To complete the process in California would typically be a three-day commitment that required figuring out transportation, lodging, leave from jobs, and potentially child care. Now "they're in and out of there in thirty minutes," Goodrick said, and patients return to Arizona to deliver their fetus.

The pregnancies are terminated in California, where it is fully legal until the fetus is viable, usually between 24 and 26 weeks of pregnancy. In some states, participating in any stage of an abortion procedure is considered providing an abortion—but Goodrick's lawyers told her that is not the case under Arizona's law, wherein the second phase of this process, once the fetus does not have a heartbeat, is essentially considered birth care. "I talked to the lawyers, and they said it's completely legal—which is unusual," Goodrick said with the wry smile of someone who is used to getting warnings about legal uncertainties.

"There are no laws saying that you can't help someone who has a pregnancy with no fetal heart tones, there's no reason you can't help that person out," Ashleigh added.

The clinic's first three patients who opted for a bifurcated induction abortion had made the trip to California and back the week before. Two more were scheduled to go the next day and complete the process at Camelback Family Planning. One of those patients was an Arizona woman who called the Los Angeles clinic directly after finding out late in her pregnancy that the fetus would not survive. That realization, and her subsequent decision to seek abortion care, was delayed for two months because Arizona law protects medical providers who withhold information that could lead a patient to abort an abnormal fetus, which is exactly what the patient's initial obstetrician did. Arizona law also bans all abortions based on chromosomal abnormality alone, but since this fetus had both life-ending brain and heart development issues, that ban did not apply, but now that it was after the 15-week mark, the patient and her partner "were waiting for the baby to die," Goodrick said.

When the patient contacted the California clinic, she said she wanted to deliver the baby so she could hold it, then have a funeral. They told her about the joint program with Camelback Family Planning. "If you want an intact delivery, we're the only ones, I've had people come from out of state, even from California, because [induction abortion] is just not done in this country, I don't know how to explain it," Goodrick told me. "It's not for everyone, but because we use so much sedation, the patients get excellent pain control, they usually don't remember anything" unless they want to.

Once Goodrick had sorted out the legal and the medical aspects of providing after-care for abortions beyond 15 weeks, the two clinics needed to figure out a joint financial model—something that, to this point, had not really existed in most of the country. An induction abortion falls on the high end of the cost scale, about $2,400, according to a Camelback Family Planning coordinator. Though it would save money on travel costs to be able to return to Arizona for the induction phase, Goodrick knew the majority of the clinic's patients would

still need most or all of it paid for by an outside funder. NAF didn't fund first-day-only appointments at the California clinic, so the cost of providing the injections and medication would be covered by organizations such as Aid Access, founded in 2018 by the Dutch physician Dr. Rebecca Gomperts. Gomperts's feminist network of "doctors, activists, and advocates for abortion rights" has provided free or low-cost abortions to patients around the world, whether by shipping medication directly to patients or by performing procedures on ships in international waters, where the law is not that of the nearest country but that of the country from which the ship hails.

Then, since NAF *did* fund stillbirth care, the group was underwriting the deliveries at Camelback Family Planning, as were the abortion funds Tucson Abortion Support Collective, or TASC, and Indigenous Women Rising. The Abortion Fund of Arizona was supporting care at both clinics. In 2022, that fund alone provided more than $160,000 to six hundred patients who received abortion care at the state's clinics, and another $24,000 to subsidize fuel, hotel, child care, and other ancillary financial barriers that lower-income patients in particular face when seeking an abortion.

Goodrick tapped a thirty-one-year-old staffer from California named Gelsey† to navigate the complicated web of funding for the joint process on behalf of the clinic's patients. Gelsey—a history major dressed in a red buffalo plaid flannel over a black NIN T-shirt the day we spoke at the clinic—graduated from college during the COVID-19 pandemic and briefly worked at a pharmacy before applying to Camelback Family Planning. She wasn't specifically looking to work in a health care setting when she was scouring major job search websites in late 2021 for what she called her first "office" job. She passed on openings she saw at antiabortion centers— often called crisis pregnancy centers—because she knew they were

† Only first name used for privacy

often religiously affiliated and did not square with her abortion-rights-supporting brand of feminism. She clicked when she saw a position at Camelback Family Planning: "I saw this . . . and it was just, you know, 'We're pro-woman and pro-choice, vehemently, politically, in all capital letters,'" she said.

The application asked for a short essay. Gelsey thought to herself, "I was built for this." She wrote a five-paragraph submission about the state of abortion, politics, and her passion for reproductive rights. She'd been eyeing then president Donald Trump's conservative appointments to the Supreme Court as she came of political age and wanted to "be in on the action," she explained. "I wanted to help give women and people assigned female at birth the care that they need. I'm pro-women and pro-LGBTQ+ and I know that that it's important to have this access to care."

"If you had told me in high school that I might work in an abortion clinic? I'd have been *stoked*," Gelsey said as she smiled and crossed one combat boot–clad leg over the other. She said she wanted to stay in the reproductive justice movement, either by continuing to help fund abortions for people who need them, or maybe by becoming a lawyer working on policy or challenging restrictive laws. With Gelsey navigating funding on behalf of Camelback's patients, Goodrick can focus on bolstering the methods they've already come up with to provide abortion care while figuring out new ones.

My visit to the clinic took place just days after judges on the conservative Fifth U.S. Circuit Court of Appeals seemed sympathetic to arguments made by a group of antiabortion lawyers challenging the U.S. Food and Drug Administration's 2000 approval of mifepristone, one of two drugs typically used for medication abortions. The Alliance for Hippocratic Medicine was being represented by lawyers with the Alliance Defending Freedom (ADF), an Arizona-based antiabortion law firm founded in the early 1990s

by high-profile men from the Christian conservative movement, including the founder of Campus Crusade for Christ, the founder of Focus on the Family, and the former staff executive director of President Ronald Reagan's Meese Commission into pornography. While the Center for Arizona Policy (CAP) pushed to enact dozens of antiabortion laws in Arizona, ADF exported its model bills across the country and functioned as a one-stop shop for lawmakers interested in banning abortion. The organization worked with Mississippi's Republican lawmakers to write and enact the 2018 law at the center of the *Dobbs* case. Then ADF lawyers helped defend it in the subsequent series of court challenges that went all the way up to the Supreme Court, leading to the overturning of *Roe*. Now, in the mifepristone lawsuit, they were trying to cut off the most widely used abortion method nationwide.

When I'd mentioned the ADF lawsuit to Goodrick several weeks earlier, ahead of my trip, she was both skeptical and defiant: "Come after me, really, let's go to trial. You're banning a medicine? Honestly, bring it on. That's ridiculous. I'm too old for this." Now, though, the federal appeals court had signaled they might block access to the drug. If it ended up at the Supreme Court, any adverse decision would affect all clinics providing medication abortions using mifepristone, whether in a political blue state or red state.

Her clinic, like most, was using mifepristone for medication abortions early in pregnancy. But, if access to that drug was blocked, Goodrick said she had a plan for that, too. There was a second drug used in most medication abortions—misoprostol—that could be used on its own. It's not as good, but it works. And there was also another commonly prescribed medication that can easily take mifepristone's place. It would be more expensive—in part because it would require prescribing multiple doses—but it would be just as effective and more comfortable for the patient than using misoprostol alone,

Goodrick said. At a recent conference in Europe, one of the doctors discussed a study on using the drug in this way and Goodrick said she thought to herself: "Why aren't people talking about this?"

Nearly one year after *Dobbs*, Goodrick had managed to stay ahead in the cat-and-mouse game that providing abortion care in the United States had become. It had required rethinking how she runs the clinic, and revising how she provided health care. There were backup plans, then backup plans for the backup plans. It had been exhausting. "I wish the national organizations would just say: "Keep providing abortions, see what happens,'" she told me. "What, are they going to put everyone in jail? Yeah, probably. But maybe that's what has to happen. These laws . . . these are all unconstitutional. I don't know what the solution is, but I know it's *not* providing abortions only until fourteen weeks and six days, or doing things like that—I know it's not this."

"That's like letting the bullies win," she finished.

Summer 2023

The "Pandora's box" of fetal personhood

Washington

WASHINGTON—It had been exactly one year since the Supreme Court overturned *Roe*.

The country's most high-profile antiabortion groups—Students for Life of America, Concerned Women for America, Susan B. Anthony Pro-Life America, Live Action, and Focus on the Family—were at a "National Celebrate Life Day" in the nation's capital. The day had been billed as a time to "lay out a vision of where to go next: achieving national protection for preborn Americans under the Fourteenth Amendment of the Constitution."

They were gathered on a stage set up at the base of the Lincoln Memorial, where Dr. Martin Luther King Jr. delivered his famous "I Have a Dream" speech at the March on Washington in 1963. Speakers present included Kristan Hawkins, the president of Students for Life, which coordinated the event; Donald Trump's vice president,

Mike Pence, who was already in the midst of his own short-lived 2024 White House bid; and Lynn Fitch, the first woman attorney general of Mississippi, who defended the abortion ban in the *Dobbs* case, and was the first Republican in the role since Reconstruction.

When King spoke in 1963, it was to a crowd of more than two hundred thousand; people filled the area at the base of the memorial and stretched down either side of the reflecting pool. The crowd marking the *Dobbs* anniversary was much smaller, maybe a thousand or two—park police did not provide a crowd count—and many were there because they fervently believed that ending abortion to protect fetuses was the civil rights cause of their time.

After singing "The Star-Spangled Banner," and chants of "USA! USA!" from the crowd, King's niece, the antiabortion activist Alveda King, kicked things off by leading the crowd again in song, this time "God Bless America." Then she addressed the group: "Sadly, we have heard a lot of people talking recently, erroneously reporting that America is no longer a Christian nation. What malarkey!" she said. "Today we have been called to the intersection of faith and culture in a society that is targeting our children every day with leftist ideology, gender confusion, skin-color shame." She stated that sixty million fetuses had been aborted in the forty-nine years since *Roe* was decided—a statistic that is often cited by antiabortion groups but is difficult to confirm due to the way abortion data is reported and collected. She quoted her civil rights leader uncle multiple times, drawing parallels between the movement for racial equality and the movement to bestow upon fetuses the rights of already born humans. "My uncle also once said injustice anywhere is a threat to justice everywhere. Could there be any greater injustice than robbing the lives of our nation's most vulnerable citizens, our unborn babies? Thankfully, because of the commitment and dedication of Students for Life—give a hand clap and thank God for Students for Life—to equip students to protect life, the victory grows with every

generation!" King said. "The fight continues, at the state level, to ensure that every unborn baby is given the civil right to life, liberty and the pursuit of happiness!"

One year after the court fulfilled the antiabortion movement's longtime goal to toss *Roe* into what Pence frequently called the "ash heap of history," the movement was regrouping to figure out its next steps. "We gather here knowing that we've not come to the end of this cause—you've come to the end of the beginning, and the work for life goes on all across America," Pence said.

The groups had one nearly universal goal: the desire to establish fetal personhood.

As the sanctioned speakers at "National Celebrate Life Day" pressed those in attendance to win over the "hearts and minds" of the American public, two men directly across the stage held a professionally printed sign the size of a small billboard: "YOU CAN'T END ABORTION IF MOMS CAN STILL GET AWAY WITH MURDER . . . Most abortions are now self-abortions . . . Just mom and a pill . . . Treat the real victims with respect. Require justice from ALL who harm them."

While most at the gathering acted as if those two men were a side show hailing from the antiabortion movement's extremist fringes—and in many ways they were—the larger movement's rejection of their rhetoric belied the fact that establishing fetal personhood would, by nearly every legal expert's account, open the door to prosecuting people who have abortions—something that most mainstream leaders in the antiabortion movement said they did not want.

Once that door is opened, though, decisions about whom to prosecute—and for what—would be made by state and local prosecutors, not antiabortion leaders or even most elected lawmakers writing antiabortion legislation. The event had been advertised as an opportunity to unite and demand "A 14th Amendment for All," which can be considered a synonym for achieving fetal personhood via

either a Supreme Court ruling or by passing individual state statutes or a national law. Hawkins told the crowd in front of the memorial that there "must be an America where every human being is recognized as the unrepeatable person as they are, with equal rights and equal protection under the Fourteenth Amendment guaranteed."

"There is very little daylight when it comes to substance," the abortion law historian Mary Ziegler told me of the various factions within the antiabortion movement seeking fetal personhood. "But there's a pretty big divergence in the sense that some of the groups think it's a really bad idea, politically, to focus on that because voters aren't there, and you have to kind of meet voters where they are and make concessions. Then you have other groups that don't think that's necessary or even productive."

Fetal personhood has been a hard sell to the American public: 59 percent oppose giving fetuses legal rights and even more oppose giving those rights to all fertilized eggs—an application that would cover not only the earliest days of pregnancy but potentially ectopic pregnancies, and embryos frozen to use for later IVF procedures. From a legal standpoint, Ziegler described fetal personhood as a Pandora's box, with unpredictable and unintended effects that might make even antiabortion conservatives balk in addition to their abortion-rights-supporting, typically more liberal counterparts. If a fetus is a person, its parent should be able to declare it as a dependent for tax purposes, or apply for government benefits on its behalf. In Florida, a lawyer had already unsuccessfully argued that a pregnant woman should be freed from jail ahead of trial because her fetus should be considered a person under the state and federal constitutions and was therefore being subjected to "unlawful and illegal detention."

Ziegler told the *Guardian* newspaper at the time of the Florida case that fetal personhood "has the potential to establish that abortion is always illegal and potentially to expose women to punishment or

make it a violation of the Florida constitution . . . it would mean that you can't imprison people who are pregnant, no matter what crime" because it would be unlawful detention of an innocent fetus—a pill that might be hard to swallow for law-and-order conservatives, given that an estimated 58,000 people who enter jail and prison each year are pregnant.

Fetal personhood has always been the antiabortion movement's end game. In *Roe*, the lawyers representing Texas argued that a fetus was a person, and should therefore receive all of the protections that the Fourteenth Amendment guarantees, starting with "life." Ergo the "right to life" movement. The Supreme Court, as it was constituted in 1973, disagreed with that premise, finding that a "person" as stated in the Fourteenth Amendment must be able to survive outside the womb, thereby establishing the right to an abortion up to the time of fetal viability. The Supreme Court's 2022 ruling in *Dobbs* found that the Fourteenth Amendment did not protect the federal right to an abortion, but the court did not extend Fourteenth Amendment rights to unborn fetuses. Several months later, the same justices passed up another opportunity to weigh in when they declined to hear a petition brought by a Catholic group and two [formerly] pregnant women in Rhode Island appealing their state supreme court's decision that fetuses were not "persons" with Fourteenth Amendment rights.

Much of the legal wrangling over abortion comes down to defining one word: person. To do that, on some level, requires deciding at what point in fetal development the zygote turned multicellular organism turned embryo turned fetus becomes a human being. Is "when does life begin" the same question as "when does a cellular mass become a person?" Then, no matter what your answer to that question, given the profound disagreement on the subject, who gets to decide on behalf of everyone else? Should our policies and rights as U.S. citizens be grounded in science? In philosophy? In religion? In politics?

The developmental biologist Scott Gilbert noted in a 2012 event at the Science & Justice Research Center titled "When Does Personhood Begin?" that he could not answer the question posed by his own lecture, but could "say with absolute certainty that there's no consensus among scientists." "Some scientists will say it begins at fertilization, where the zygote gets a new genome, where the sperm and egg combine, their nuclear materials, which actually is a long process ending with a two-cell stage. Some scientists will say it's at implantation, where you get a pregnancy. Other scientists will say it's at Day 14, gastrulation, where the embryo becomes an individual, where you can no longer form twins and triplets, so that you have one embryo giving rise to, at best, only one adult. Some scientists will say it's at week 24 to 28 when you see the beginnings of the human specific electroencephalogram, and saying if we're willing to say that death is the loss of the EEG, perhaps personhood is the acquisition of the EEG. Still others say it's at birth or during the perinatal period where a successful birth is possible."

Wilton D. Gregory, the archbishop of Washington and the first Black cardinal in the U.S. Catholic Church, said during a September 2021 event at the National Press Club that "the Catholic Church teaches and has taught that life, human life, begins at conception." But, Gregory said, there was still debate among theologians about when in the fertilization process the moment of conception occurs. Texts used by most branches of modern Judaism teach that life does not begin until birth, when a fetus becomes a person as it emerges from the birth canal and takes its first breath. In Islam, a human life begins 120 days after conception—about four months into pregnancy—when the soul enters the fetus in a religious process known as "ensoulment," an idea that goes all the way back to ancient Greece. Even within religions, the point of ensoulment has been a moving goal post, adjusted based on scientific knowledge at the time and shaped by medical realities like a high incidence of miscarriage,

which could result in religious limbo for an ensouled but unbaptized fetus.

These fundamental questions about the beginning of life and personhood have divided doctors, theologians, philosophers and yes, politicians, since they were first posed thousands of years ago. Disagreements over the answers are already shaping U.S. law and policy—and as the antiabortion movement pursues across-the-board fetal personhood, more and more of these clashes will end up in the courts, which will have to weigh at what point a fetus has Fourteenth Amendment protections, and at what point those fetal rights supersede those of the adult human being carrying them.

Fetal personhood can create a "slippery slope" of pregnancy regulation and criminalization, Rebecca Kluchin, a history professor who studies reproductive medicine, told me. "How do you know how much can you regulate a pregnant person? Can you regulate what she eats? Can you put her in jail for drinking? What it ends up being is policing of women and pregnant persons." Kluchin said her research shows that "What ends up happening if fetal personhood laws are passed, is that a fetus goes toe to toe with the person carrying it, and the pregnant person is almost always overridden, which means that a pregnant person has fewer rights than a non-pregnant person."

Fetal personhood has already been used to justify taking away people's authority to make decisions about their own pregnancies and health care—and has at times exposed pregnant people to potential legal liability, or even criminal charges. Kluchin has examined cases where women giving birth have refused a cesarean section but doctors either overrode their decision or asked the courts to intervene—a practice discouraged by the American Medical Association. "Almost all of the women are poor women of color," Kluchin says. "They're laboring, and someone says 'Have a C-section' and they say 'I don't want it' so a judge is called in the middle of the night and they're not even there, they're literally not even allowed in their own court

hearing." The parent loses custody of their fetus—and the autonomy to make their own health care decisions—until they give birth.

Pregnant people have also been kept alive against their wishes or those of their families when health care providers and courts ascribe personhood to the fetuses they are carrying—even when continuing the pregnancy won't lead to a live birth. There are at least twenty-eight states with laws that override the health directives of pregnant people in comas. One high-profile case was in Texas, where a thirty-three-year-old woman collapsed from a suspected blood clot in her lungs while she was 14 weeks pregnant with her second child. The state kept her on life support for two months, even though her fetus was not viable, and against the wishes of her husband, who said the "smell of death" was in her hospital room. Her family went to court to have the life supports removed.

Prosecutors across the country have already applied chemical endangerment statutes to unborn fetuses that were originally designed to protect born children from exposure to illegal drugs and other controlled substances.

In California, a woman was arrested and spent sixteen months in jail for a stillbirth after the hospital reported meth in her system and she was charged with "manslaughter of a fetus." A judge eventually dismissed the case.

An Alabama woman is serving an eighteen-year prison sentence because a court—but not the medical examiner—concluded that drug use caused her to lose a pregnancy.

Shortly after the *Dobbs* decision, another Alabama woman who had just found out she was pregnant was arrested after police found marijuana in her car during a traffic stop. She spent three months in jail, even after she was diagnosed with a high-risk pregnancy due to a condition that causes blood to pool in the uterine wall. She could not get the drug treatment she needed for release—because drug

treatment programs said she was not addicted and therefore did not need it.

Still another Alabama woman was likewise jailed for allegedly exposing her fetus to drugs—but she wasn't even pregnant. She was released after a urine sample she provided in jail revealed as much. She sued for false imprisonment after local law enforcement warned they would arrest her again if she got pregnant in the coming months.

Meanwhile, Oklahoma has prosecuted women for using legally prescribed medical marijuana during pregnancy even when their babies were born healthy, and trace amounts were only present in the meconium, an infant's first stool.

Then there is the criminalization of bad pregnancy outcomes, including both miscarriages and stillbirths—something that Robin Marty at the West Alabama Women's Center had been warning about since even before the *Dobbs* decision.

A California mother was charged with murder after deciding on an at-home birth for her third child. The mother chose home birth in part because she lost custody of her first two children, who were born healthy, after the hospital reported her for drug use, which she said was prescribed medication for addiction. During her third pregnancy, she went into labor early. She passed out while giving birth, and when she regained consciousness, her newborn was not breathing. The San Diego district attorney charged her with murder and child endangerment for her decision to have an "unattended delivery"—despite the medical examiner listing the cause of death as an accident, and a new state law that prohibited the criminalization of pregnancy loss.

The Marshall Project, a nonprofit newsroom that covers criminal justice issues, in a July 2023 collaboration with AL.com, the *Frontier* (Oklahoma), *Mississippi Today*, the *Post and Courier* (South Carolina), and the *Guardian*, found: "These [chemical endangerment] laws have

been used to prosecute women who lose their pregnancies. But prosecutors are also targeting people who give birth and used drugs during their pregnancy."

The advocacy group Pregnancy Justice, formerly known as the National Advocates for Pregnant Women, has for more than twenty years defended people charged with crimes related to their pregnancies. They also challenge laws that could be used to criminalize various aspects of pregnancy. The group takes the position on fetal personhood that "it is not possible to add fertilized eggs, embryos, and fetuses to the community of constitutional persons without subtracting people with the capacity for pregnancy." When the organization partnered with Fordham University in 2013 to track arrests and forced interventions related to pregnancy, they found more than four hundred cases between when *Roe* was decided in 1973 and 2005. From 2006 to 2020, that number nearly quadrupled. Dana Sussman, the organization's then acting executive director, told NPR the week after the *Dobbs* ruling that she estimates two or three hundred of the cases in that period involved the loss of a pregnancy.

Leaders in the antiabortion movement have historically not pushed to apply fetal personhood in ways that would lead to criminalizing pregnant people, and their incrementalist approach served them well while they waited for the case that would bring down *Roe*. More than seventy organizations and antiabortion leaders wrote in an open letter between the leak of the *Dobbs* draft and the release of the opinion: "Let us be clear: We state unequivocally that we do not support any measure seeking to criminalize or punish women and we stand firmly opposed to include such penalties in legislation."

But now that *Roe* was gone, the challenge for traditional leaders— like the conservative attorney James Bopp, who advises the National Right to Life Committee, and SBA List's Marjorie Dannenfelser—was that the antiabortion movement's uncompromising grassroots wing was "ascendant," Ziegler told me. She had written about how

Trump's suggestion during his 2016 campaign that women should be punished for having abortions "revealed that punishing women has become far more than an abstraction." As the antiabortion movement's ascendant wing pushes for fetal personhood—which both Bopp and Dannenfelser support—it has led to what the Marshall Project called the "significant shift toward criminalizing mothers" using preexisting laws, not newly enacted abortion bans.

Alabama's Republican attorney general Steve Marshall has been notably creative on this front. Alabama's abortion ban exempted women from criminal liability, but Marshall said in January 2023 that he could use preexisting chemical endangerment statutes to prosecute pregnant people who self-administered medication abortion. "The Human Life Protection Act targets abortion providers, exempting women 'upon whom an abortion is performed' . . . It does not provide an across-the-board exemption from all criminal laws, including the chemical-endangerment law—which the Alabama Supreme Court has affirmed and reaffirmed protects unborn children," Marshall said. His own spokesperson appeared to "back away" from the plan to prosecute women, according to the *Washington Post* in a story headlined TALK OF PROSECUTING WOMEN FOR ABORTION PILLS ROILS ANTIABORTION MOVEMENT, by telling the newspaper: "The attorney general's beef is with illegal providers, not women."

When Alabama approved its abortion ban back in 2019, the bioethics and constitutional law expert Michele Bratcher Goodwin described how the state already "led the nation in charging pregnant women under its chemical endangerment statute." "Let us be clear: Anyone who thinks it is the recently passed Alabama abortion law alone that sets the state apart on reproductive health is wrong. Alabama police and prosecutors strategically wield power and influence with hospitals and medical clinicians to ferret out women who 'endanger' their pregnancies," she wrote in the *New York Times*. Goodwin noted that an investigation by the nonprofit newsroom

ProPublica and AL.com showed that Alabama's chemical endanger-
ment law had been used to arrest at least 479 people for endangering
their pregnancies.

Shortly after the *Dobbs* leak, Charles Donovan—an adviser to the
antiabortion Charlotte Lozier Institute—and Dannenfelser wrote in
the *Washington Post* that "the pro-life movement has never abided,
and will not now abide, criminal charges against women who seek
or have abortions." But depending on how fetal personhood is estab-
lished, that decision could rest with prosecutors like Marshall, who
has already tipped his hand. When CNN ran an opinion piece
about a woman in Alabama who was charged with manslaughter
after her fetus died when she was shot five months into her preg-
nancy, Dannenfelser wrote on Twitter: "Outrageous lies intended to
make America fear our own ability to pass merciful and just laws. In
this article—No mention of unborn victims of violence acts' hold
women harmless clauses!!!"

David Cohen, a professor at Drexel University's law school who
studies gender and the Constitution and writes about abortion from
the abortion rights perspective, called the practical realities of fetal
personhood a "PR issue" for leaders in the mainstream antiabortion
movement. "If I hire someone to kill you, I am usually, in almost
every jurisdiction, just as if not more culpable than the person I
hired to kill you. If you believe a fetus is a person, that's exactly the
situation of a pregnant person who goes to an abortion provider
and pays them money to kill their fetus, right? Under personhood,
there is no logical reason why they shouldn't be treated the same,
and the person who's pregnant could be considered a murderer," he
told me.

Republican lawmakers are already trying to include criminal
penalties for pregnant people in antiabortion bills, though in nearly
all cases thus far they have faced such blowback that the efforts were
dropped or stalled. One of the first attempts was in Louisiana, where

a GOP lawmaker in May 2022 introduced a pre-*Dobbs* "abolition of abortion" bill that would pave the way to charge abortion patients with murder. The provision was so unpopular that the Baptist minister and former outreach director for an antiabortion center who helped write it opened a Twitter account to defend it. It wasn't enough: then Governor John Bel Edwards, a rare antiabortion Democrat in statewide office, threatened to veto any ban containing such a provision. Edwards went on to sign into law an abortion ban that stiffened criminal penalties for abortion providers but not patients.

A GOP lawmaker in South Carolina introduced legislation in January 2023 to change the state's criminal code to declare fertilized eggs a "person" from the point of conception and "ensure that an unborn child who is a victim of homicide is afforded equal protection under the homicide laws of the state"—the potential punishment for getting an abortion in the state could therefore include the death penalty. The bill gained twenty-four Republican cosponsors—and made headlines—before some lawmakers started withdrawing their support, with one telling NBC News he signed on to sponsor it "in error."

In Oklahoma, where providing an abortion is already a felony under a 1910 law with no exceptions for rape or incest, a Republican in the state senate introduced a bill to amend the state's abortion restrictions to clearly state that a pregnant patient could face felony charges if they induce an abortion. It did not go anywhere, though, and the state attorney general clarified that the 1910 ban does not create criminal liability for the pregnant person.

Rhetoric from within the antiabortion movement was already moving in the direction of criminalizing abortion patients before *Dobbs*, too. Several months prior to the decision, the activist Abby Johnson, who once worked as a Planned Parenthood clinic director and has said she had two abortions she now regrets, said on a podcast hosted by the Trump-aligned conservative political group Turning

Point USA that she thought the "culture is changing" around abortion. "When I first became pro-life, I was very much against prosecution of women in all cases," she began. But "if we really believe that the unborn, the preborn, are human beings, then I think we have to act like it, and if we're gonna act like it . . . now I'm not saying that, you know, we have to lock every woman up or whatever . . . but I have come to a position where I believe that there does need to be due process."

Shortly after, Bradley Pierce, the president of Abolish Abortion Texas and the Foundation to Abolish Abortion as well as counsel for the conservative nonprofit legal group Heritage Action, which aims to defend "God-given parental rights," called Johnson's evolution a welcome "bombshell" within the movement because what she was describing was applying the Fourteenth Amendment and its due process clause to fetuses. A self-described "abolitionist lawyer," Pierce went on to explain on his own podcast that a "big difference" within the antiabortion movement post-*Roe* is "where we come down on equal protection." "That means that the same laws that protect you and me as born persons should be the same laws that protect them as preborn persons," he told listeners.

Two days before the *Dobbs* anniversary, Ziegler participated in an Aspen Ideas Health panel titled "The Fall of Roe and Its Unintended Consequences." Even though fetal personhood is the desired apex of the antiabortion movement, Ziegler explained how the various groups and stakeholders were nevertheless "very fractured right now." "There are lots of ways that banning abortion could affect things we don't conventionally think of as abortion that have been largely left off the table this year, in part in response to 2022," when Democrats did better than expected in the midterms, and Republicans struggled to sell their restrictive abortion policies to voters, she said.

Ziegler noted that a major antiabortion group in Washington had material online stating that the birth control pill is an abortifacient

(this is misinformation, as oral contraception prevents the fertilization of an ovum by blocking its release)—Students for Life of America has this on its website. The group has also led the charge for Republican lawmakers to rethink the inclusion of rape and incest exceptions in abortion bans. Hawkins, the group's president, told the *Boom Clap* podcast that "sexual assault actually helps prevent a lot of pregnancies itself because of your body's natural response." It sounded a lot like a statement made by conservative Republican U.S. representative Todd Akin back in 2012 that ended his political career: "If it's a legitimate rape, the female body has ways to try to shut that whole thing down," Akin told a St. Louis television station. A decade later, as the antiabortion movement aims for personhood, there is a need to figure out how that might square with at least protecting those who are pregnant due to rape or incest from being prosecuted for their own victimization. Hawkins's adoption of Akin's science-be-damned argument was an early attempt to mollify a public that was not yet willing to bring criminal charges against abortion patients, and that largely opposed abortion bans without exceptions.

Ziegler predicted at Aspen that we were in a moment when the Overton Window on abortion policy was shifting. The Overton Window is a concept introduced in the 1990s by Joseph P. Overton with the Mackinac Center for Public Policy, a conservative think tank based in Michigan, to explain to potential donors why politicians are limited in what they can support by what the public will accept. Policies thought by the public to be legitimate options are inside the Overton Window. Policies thought to be extreme or unachievable or impossible are outside the Overton Window. The window can shift when outside-the-window proponents—usually not the politicians themselves but grassroots activists, lawyers, lobbying groups, and advocacy organizations—convince a large enough slice of the public that their idea is acceptable. Politicians can then advocate for and enact those policies without fear of electoral reprisal. Ziegler said that

one dynamic she noticed in the 2022 midterms was Republican politicians promoting policies outside the Overton Window, which led to their losses. "The ordinary political rules of abortion have changed in fundamental ways since *Dobbs* came down," she said. "We've seen more of a trend, in states, of politicians embracing positions that are less and less popular."

If the antiabortion movement wants to achieve fetal personhood, it will likely have to answer some of the thorny questions raised by abortion bans without exceptions, and explain why extending Fourteenth Amendment rights to fetuses will not result in pregnant people having fewer rights than the fetuses they are carrying.

Right now, the public is not ready. But antiabortion advocates are already on a mission to win over "hearts and minds." In other words, they want to shift the Overton Window.

"I think there's been a deliberate kind of tabling of those issues, with a belief that people will get used to it, that the resistance will soften, that this will become the new normal, and that then the Overton Window can shift again," Ziegler said on the Aspen panel.

"And I think that's something that is likely to happen," she added.

For the abortion rights movement to succeed, they will need to make sure that it doesn't.

"We haven't let go of the fight."

Alabama

T USCALOOSA—In the weeks before the first anniversary of the *Dobbs* decision, Robin Marty considered using Twitter's "mute" function to block the posts that mentioned the ruling from appearing in her feed.

Marty didn't go through with it, but she and Dr. Leah Torres at the West Alabama Women's Center did decide that there is "no point in paying attention" to the *Dobbs* anniversary because it was the "worst thing that could possibly have happened to the clinic," Marty said. She anticipated that the national abortion rights organizations would "suck all the attention and resources out of the room" anyway, and most anniversary-related donations wouldn't trickle down to clinics like theirs that don't operate under a well-known umbrella organization. Marty and Torres decided instead to peg all of the clinic's fundraising and media efforts to their own first anniversary of becoming a nonprofit community health center that provides

reproductive care—minus abortion—in a part of the country where it is desperately needed.

"We are going to celebrate the positive and also acknowledge the fact that we haven't let go of the fight," Torres said.

Marty agreed. "We didn't want to be a part of that depression, we wanted to celebrate our wins . . . instead of acknowledging the death of abortion access in Alabama, we chose to celebrate the fact that a year later we are still here as a nonprofit clinic in a state that nobody thought we would be able to make it in," she said.

One year after *Roe* fell, the clinic that used to be the largest abortion provider in Alabama has provided more than 1,475 individual services to patients. Their wins included the provision of 461 pregnancy tests, 89 annual exams, 42 screenings for sexually transmitted diseases and infections, 61 birth control consultations, 18 birth control prescriptions, 143 packages of birth control pills, and 12 HIV-related treatments. They had 25 prenatal patients and 70 patients who were receiving gender-affirming care. About 90 percent of the clinic's patients were female, 75 percent were Black and 80 percent were uninsured or on the government's Medicaid insurance program for low-income Americans. While most of the clinic's pregnant patients began coming in for care during their first trimester, in the three-month period ahead of the *Dobbs* anniversary, there was a "dramatic increase in patients who are in their second or third trimester and have not yet received any prenatal care," they noted in an annual report for donors. The clinic's monthly operating budget was about $84,000 and of the $1 million it brought in over the first year, all but $28,000 came from grants, foundations and small-dollar donations. Patients paid an average of $20 per appointment, but no one was—or would be—turned away if they do not have the financial resources to pay for care. The clinic usually has about three months' operating costs in the bank.

They are already a year into the fight—and it hasn't been easy.

"Signing off on a year almost feels like this is our new normal. And then every year we're going to be like: 'Oh, this is when our lives ended.' And it's like: No. We are not going to acknowledge that, because we're going to have our rights back. So we're not going to live in a world of anniversaries of this date. We are going to live in a world where we keep fighting," Torres said.

Every victory has been tempered by a setback that sometimes made it feel like one step forward, two steps back. In the spring, when Torres, and therefore the clinic, was approved as a Blue Cross Blue Shield provider, they thought it would be a game changer. Months later, due to bureaucracy, they have a "pile of Blue Cross Blue Shield claims that hopefully at some point we'll get paid for but who knows," Marty said. The West Alabama Women's Center's first prenatal patients were about to give birth, but Torres won't be able to do the deliveries, because they can't do deliveries at the clinic, and the local hospital still won't give her admitting privileges.

"Everything that we thought was 'best day ever! we would find out a month or so down the road that it fucking didn't happen," Marty said. Now, after a year of navigating forms and red tape, the clinic is getting close to being approved for 340B pharmacy privileges, which would enable them to provide drugs and STI testing at steeply discounted prices to uninsured patients. Marty on the one hand, "feel[s] like [it] is going to be the thing that turns everything around," and on the other, knows that the "goalposts keep moving" as they try to keep the clinic open.

"We need to acknowledge," Torres interjected as the three of us discussed the clinic's future, "that it wasn't like: 'Yay, we got 340B!' It was like the third, fourth, 20th time around, we got 340B, and it was the backdoor connection with the person who's on the other side of the state, who knows a guy, who knows a guy—it's not straightforward."

I asked them what it felt like, day after day, to keep showing up at a clinic in a state that has taken away their ability to provide the type of care the West Alabama Women's Center was founded to provide—and thrown up barrier after barrier to provide the other desperately needed types of reproductive care that would allow it to stay open.

"I know what hard work is, but this is impossible, drowning," Torres said.

"Grinding," Marty added. "Because it's not even just drowning, it's drowning and assuming that it'll be over, but then it doesn't . . . it doesn't happen, so you just keep going."

On the worst days, Marty fantasizes about moving her family back to Minnesota, which has become a refuge for those fleeing abortion-hostile states, and where she wouldn't need to worry about her own daughter's continued ability to receive health care. "Every day, every fucking day—sorry Leah—I think to myself how much easier it would be to just not be doing this," she said. "There are these dark thoughts in the back of my mind sometimes, that I wish Leah would just quit, because then it wouldn't be my fault," she said.

"She hired the wrong doctor for that, and she knows it," Torres said.

Torres said the idea of leaving presents her with a "moral dilemma." Her own parents have seen the toll it has taken on her to keep going. They have encouraged her to move elsewhere, to a state where the type of health care she trained for years to provide—enduring sleepless nights, missing family celebrations, shedding countless tears, spending hundreds of thousands of dollars—isn't a Class A felony. Her bad-day fantasy is working at Starbucks, or being a park ranger. But she knows she can't abandon this clinic that she chose specifically because it provided a route to provide the broadest spectrum of quality, empathetic reproductive health care to people with

few to no other options. "Honestly, we're so, so very needed here, I wish more people around the nation understood that," she said.

"But to say I'm sort of in an existential crisis doesn't quite do it justice," she added.

In addition to strategizing about how to keep the clinic open—figuring out fundraising as a nonprofit, getting approved to take private insurances, pivoting to gender-affirming care—the bigger picture of how the country will regain abortion rights features prominently in the two women's headspaces.

While Torres believes that "everything ends with the Supreme Court," she also thinks that Americans who support representative democracy—and the lawmakers who represent them—must pursue structural changes that include eliminating the Electoral College, preventing partisan gerrymandering, expanding the Supreme Court and setting term limits for justices, so that "other generations aren't screwed over by decisions like *Dobbs.*" "That is how we get our rights back," she told me.

Marty, meanwhile, has been spending a lot of time thinking about a very specific period in U.S. history that, on its face, has almost nothing to do with abortion: Prohibition. "And the parallels between where we are right now and the time of Prohibition, and how long Prohibition lasted, and how it was so extraordinarily unpopular, and really hard, in a lot of ways, to enforce."

"This is, in a lot of ways, our generation's version of Prohibition, because it is essentially a vice squad that has come in, gotten into power, and gets to make these wacky decisions that the rest of the country just simply doesn't believe in," she said.

Marty isn't the only person who made this connection.

David Frum, a former speechwriter for Republican President George W. Bush, wrote in the *Atlantic* shortly after the *Dobbs* ruling that "the great debate on alcohol offers, a century later, a fascinating parallel with the contemporary one on abortion." He noted that

Prohibition was a movement rooted in conservative, rural, religious America that pushed to police more liberal-leaning big cities. "Many of the men and women poised to cast Republican ballots . . . may be surprised to discover that anti-abortion laws they had assumed were intended only to prohibit others also apply to them," he wrote, noting that *Dobbs*'s cascading impacts could include the end of in vitro fertilization, the policing of miscarriages, and blowback for private sector employers who offer abortion-supportive benefits such as travel subsidies.

"Prohibition and *Dobbs* were and are projects that seek to impose the values of a cohesive and well-organized cultural minority upon a diverse and less-organized cultural majority. Those projects can work for a time, but only for a time. In a country with a representative voting system—even a system as distorted in favor of the rural and conservative as the American system was in the 1920s and is again today—the cultural majority is bound to prevail sooner or later," Frum wrote.

There are two routes to amend the Constitution. Either two thirds of the House and Senate—or two thirds of the states via conventions called for that purpose—can propose an amendment. Then, it must be ratified by three quarters of the state legislatures or state conventions. The Eighteenth Amendment, which established Prohibition, is the only one of the twenty-seven amendments to the Constitution that has been repealed. That was done via the Twenty-First Amendment, the only one to have been ratified via state conventions. With Congress impossibly deadlocked, it is the state ratification process by which Marty believes the country could establish the right to abortion, thereby overturning *Dobbs*.

Frum noted that "in the 1920s, formerly diffuse anti-Prohibition factions coalesced around a single issue: repeal," writing: "The pro-choice coalition is diffuse, too. It spans party, ideology, class, and race . . . they may not all agree on what they want. More and more,

they agree on what they do *not* want. As the anti-Prohibitionists once did, they have the numbers. With the numbers, sooner or later come the votes." Frum did not spell out how he anticipated the cultural majority would eventually overcome the cultural minority on abortion, except to say that Republican races up and down ballots would likely become referenda on abortion rights, and that that dynamic would only intensify as they enact more abortion restrictions. "Republican politicians who indulged their pro-life allies as a low-cost way to mobilize voters who did not share the party's economic agenda are about to discover that the costs have jumped, and that many of the voters who *do* share the party's economic agenda care more about their intimate autonomy," he portended.

Amending the Constitution by any route is onerous, and the Twenty-First Amendment is comparatively one of the most expediently ratified. The most recent amendment, the Twenty-Seventh, which mandates that changes to congressional lawmakers' salaries not take effect until after the next House election, was ratified in 1992—more than 202 years after it was first proposed—thanks to a college student who wrote a paper for a government class that spurred a movement.

"We have to have a constitutional amendment, I think that's the direction to go, that's the way to move forward, is to have each state start to put forth a vote on an amendment to the Constitution that says that a person has the right to bodily autonomy," Marty told me.

The states were, of course, already doing a version of this post-*Dobbs*—but amending their state constitutions instead of pursuing an amendment to the U.S. Constitution. This too, was a heavy—and expensive—organizing lift. Marty still sees these ballot amendments as less a permanent solution and more of a "voter-outreach project" to increase turnout in the political battleground states that will determine control of the Senate and White House. Plus, she reminded me, there are states like Alabama, where citizens cannot

get amendments onto the ballot—along with states that are trying to make it harder, or attempting to specifically prohibit measures related to abortion.

Fifty years ago, when the antiabortion movement was figuring out what to do next after *Roe*, one of its first moves was introducing the Human Life Amendment, which would have overturned *Roe* via constitutional amendment. Versions were reintroduced over the years, and the Senate Judiciary Committee held hearings in multiple congresses. It came up for a vote only once, however, and fell substantially short of the three-quarters vote it needed to be approved by the upper chamber. While at the same time the movement chipped away at its protections in a series of cases that went all the way to the Supreme Court. The antiabortion movement eventually overturned *Roe*, of course, but by a decades-long push to install friendly judges at all levels of the federal judiciary. The recruitment effort culminated during Republican Donald Trump's presidency when he cemented the court's 6–3 conservative majority. The legal effort culminated during the successor presidency of Democrat Joe Biden, when *Dobbs* dealt *Roe* its final blow.

After *Dobbs*, the abortion rights movement, which had in the past faced criticism for allowing national leaders to gatekeep on strategy, increasingly began embracing a more decentralized, everything-but-the-kitchen-sink approach to protecting abortion access where it still existed, and fighting to get it back where it didn't.

On the *Dobbs* anniversary, David Cohen, Greer Donley, and Rachel Rebouché—a trio of Pennsylvania law professors—published a roadmap to restoring abortion rights in the *New York Times*. "To state the obvious," they wrote, "overturning Dobbs is not going to be simple. The work will be daunting, requiring a multipronged and complex attack. It will also require patience." They agreed with Marty that congressional lawmakers should begin drafting proposals for

abortion-protective constitutional amendments: "The hurdle to amend the Constitution is almost impossibly high. Nonetheless, introducing such an amendment, something the anti-abortion movement first did the same month that *Roe* was decided, is an important step in communicating that *Dobbs* need not be the permanent law of the land."

They emphasized the role of public discourse, that abortion rights supporters needed to compete with their antiabortion counterparts to win over the hearts and minds of the American public, and plant the mental seed that *Dobbs* is bad law. "The anti-abortion side, even in the face of many defeats, talked about *Roe* for half a century as bad law that would not last. We need to do the same with *Dobbs*," they wrote.

The lawyers urged the Democratic Party to include overturning *Dobbs* in its platform with the same weight that the Republican Party committed to overturning *Roe* in theirs. It must become a litmus test for Biden and future Democratic presidents as they consider the nomination of judges at all levels of the judiciary. They urged scholars to "develop a persuasive, consistent and multidisciplinary response to the flawed history and theory in the *Dobbs* majority;" researchers to "document the harms that Dobbs has wrought;" and funders to devote resources even in the face of short-term losses. And, finally, that "lawyers will need to bring cases raising novel issues so that judges can protect abortion rights in new ways." Many of these efforts will likely face setbacks, but "even if cases and briefs in federal courts lose in the short term, having abortion cases in the pipeline is essential. The Supreme Court will not always look as it does today," they wrote.

Cohen told me that "there are a bunch of cases that have been brought in the past year that are attempting to do some of the creative things that we were referring to." He pointed to cases pointing out conflicts between abortion restrictions and EMTALA laws, which require emergency rooms to treat patients that come to them for care. There were also cases related to the abortion drug mifepristone, like

one in Washington state that sought to protect access to the drugs well as preemption cases in North Carolina and West Virginia that argued FDA approval of mifepristone preempts abortion restrictions in those states. Cohen also saw promise in challenges grounded in religious liberty, such as the case brought by the Jewish women in Kentucky. It's not just the "usual suspects" such as Planned Parenthood, the American Civil Liberties Union and the Center for Reproductive Rights, he told me, but Democratic attorneys general, drug manufacturers, doctors and everyday citizens.

Donley, his co-author, told me that while the abortion rights movement has historically been "top down," with "really powerful national organizations that have set the policy tone," she believed that "one of the things that is a little exciting about this moment in time is that . . . you're starting to see a different kind of strategy" that could lead to "entirely new ways of thinking about abortion rights." She too pointed to the religious liberty cases. "They challenge stereotypes and conceptions that people have had about abortion in terms of thinking about who gets abortions, and who supports abortion rights, and take away the power of the antiabortion movement having the monopoly on religious liberty and morality when it comes to abortion," she said.

In the year after *Dobbs*, the Center for Reproductive Rights filed lawsuits challenging abortion bans in Arizona, Florida, Georgia, Louisiana, Mississippi, North Dakota, Oklahoma, South Carolina, and Texas. They asked the courts to clarify the scope of the "medical emergency" exception in Texas's ban. The center's lawyers filed a friend-of-the-court brief in federal appeals court defending the FDA's approval of mifepristone, and they brought a case in federal court in Virginia on behalf of independent abortion providers that sought to preserve access to medication abortion. They also challenged a Montana health department rule that effectively prohibited Medicaid patients from accessing abortion care.

The national American Civil Liberties Union helped file lawsuits related to abortion restrictions in Kentucky, Tennessee, West Virginia, North Carolina, Arkansas, Texas and elsewhere, often working in concert with local ACLU chapters and the Center for Reproductive Rights.

And they are about to add one more state to their list: Alabama.

On July 31, a little more than a year after the "worst thing that could possibly have happened" to the West Alabama Women's Center did, the clinic, along with Dr. Yashica Robinson, the medical director at another independent clinic, filed a lawsuit that sought to prevent Alabama attorney general Steve Marshall and other prosecutors in the state from going after those who assist Alabamians who travel across state lines for abortion care. They were represented by the national ACLU and the ACLU of Alabama. A parallel case was brought by the Lawyering Project on behalf of the Yellowhammer Fund. The ACLU's opening brief argued that "No Alabama law authorizes such prosecutions. Nor could it. That would be a blatant extraterritorial overreach of state power that not only contravenes the Due Process Clause, the First Amendment, and the fundamental constitutional right to travel, but also the most foundational principles of comity upon which our federalist system rests."

It could take years for a case like theirs to reach its final conclusion, but things got off to a promising start when the clinic's lawsuit was assigned to a best-case-scenario judge in federal court in Alabama. Given the underlying constitutional issues raised by the case—and the tenacity of the parties on both sides—it is not improbable that it could end up before the Supreme Court after a series of challenges and appeals. Marty can't talk about the case in much detail, on advice from the clinic's lawyers, but she said in a statement when the lawsuit was filed that "Alabama is our home, and we won't leave or stop fighting until everyone in our state is able to access the care they need."

Marty and Torres at the West Alabama Women's Center, along with the hundreds, or even thousands, of Americans actively working to resist the *Dobbs* ruling and its impacts, have laid down a marker: They refuse to live in a world where they observe anniversaries of the date they lost their rights—they are fighting to create the world in which they get them back.

Afterword

Spring 2024

UNITED STATES OF AMERICA—For the first few months of 2024, I tried to decide how to end this book: How could I leave readers with the most up-to-date information possible as abortion access continued to ebb and flow across the country, and any single court ruling or election could change everything in an instant?

Nearly two years after the U.S. Supreme Court decided *Dobbs v. Jackson Women's Health Organization*, ending the federal right to abortion, the legal "turmoil wrought by *Roe* and *Casey*" that conservative justice Samuel Alito said would only be prolonged if the court did anything but gut the 1973 and 1992 rulings had given way to the rapidly snowballing "interjurisdictional abortion wars" that were predicted by since-retired liberal justice Stephen Breyer in his *Dobbs* dissent.

By January 2024, forty lawsuits had been filed challenging abortion bans in twenty-three states, and twenty-two of those were still pending at trial or appellate levels, according to a tracker jointly

maintained by the Brennan Center for Justice and the Center for Reproductive Rights.

Then, in mid-February, the Alabama Supreme Court relied on fetal personhood to decide a lawsuit brought by three couples whose fertility clinic had accidentally destroyed their frozen embryos. This, I thought, might be a natural ending for a book that opened at the West Alabama Women's Center on the day *Dobbs* was decided.

The embryos at the center of the case were created through in vitro fertilization, or IVF, and the plaintiff couples cited Alabama's Wrongful Death of a Minor Act. After the state's high court agreed that frozen embryos had the same legal rights as already born children under the act, several clinics and hospitals in Alabama halted IVF procedures. Three weeks later, seeking to quell intense bipartisan backlash, Alabama's GOP-controlled legislature approved a narrowly crafted bill that established immunity from prosecution for doctors and other clinic workers providing IVF treatments with frozen embryos. GOP governor Kay Ivey quickly signed it into law, calling it an "important, short-term" measure.

But the new legislation did not settle the underlying questions of when life begins or when embryos begin to have legal and state constitutional rights. Some health care providers resumed offering IVF, others did not. Barb Collura, the head of RESOLVE: The National Infertility Association, said federal legislation was needed to protect access to assisted reproductive technologies. Dana Sussman, the deputy executive director of Pregnancy Justice, told the *Alabama Reflector* that there was no way to establish rights for embryos without "the sacrifice of the rights of the pregnant people, of people with the capacity for pregnancy, because that's what happens when you designate embryos as children."

Then, shortly after Alabama's IVF ruling and the hastily passed legislation it prompted, Democrat Marilyn Lands flipped a state House seat in a special election after explicitly campaigning on

protecting abortion rights—including by telling her own decades-old abortion story about a devastating fetal diagnosis. A new congressional map would also be in place for the November 2024 elections, following a two-year court battle that had twice ended up before the Supreme Court. After courts determined that Alabama Republicans had drawn a map that violated federal law by diluting the voting power of the state's Black residents, a special master created a new majority-Black congressional district, as well as a near-majority Black district. Political analysts believed the new map could result in Alabama electing a second Democrat to the U.S. House of Representatives.

It was not yet clear as I wrote this whether these two voting-related developments in Alabama were a harbinger of any broader political shift, but they were a signal that in a post-*Dobbs* country, GOP-backed abortion restrictions were creating openings for Democrats in states that had long been political safe havens for deeply conservative—and often evangelical—politics.

I next considered concluding this book with one or both of two major abortion cases pending before the Supreme Court—each had the potential to cut off abortion access for millions of Americans. The first challenged regulatory changes that eased access to mifepristone, one of the two drugs commonly used in medication abortions; the second asked whether a state's abortion ban took precedence over a decades-old federal law that requires nearly all hospitals to offer emergency medical care.

The mifepristone case was brought by member doctors of the Alliance for Hippocratic Medicine, which formed in Texas in the wake of *Dobbs* to challenge the Food and Drug Administration's approval of medication abortion, which by 2023 accounted for 63 percent of all abortions in the country, up 10 percent from just three years prior. The antiabortion movement knew that state-level abortion bans would increase demand for abortion mediation that

could be shipped or obtained out of state; it was therefore one of their top priorities to make mifepristone harder to get. The Alliance for Hippocratic Medicine had financial backing from deep-pocketed, high-profile figures in the conservative movement. It was also represented by attorneys with the Alliance Defending Freedom, or ADF, the conservative Christian advocacy group and law firm founded in the 1990s in Arizona.

Lower courts narrowed the scope of *U.S. Food and Drug Administration v. Alliance for Hippocratic Medicine* before it got to the justices. Instead of examining the FDA's underlying approval of mifepristone, the Supreme Court reviewed regulatory changes in 2016 and 2021 that expanded access to the drug. During the March 26 oral arguments, some of the conservative justices seemed skeptical that the antiabortion doctors had been personally harmed by these regulatory changes. If they hadn't, they did not have the standing to bring the case. Though it is not possible to predict the outcome of Supreme Court cases with any certainty, the general consensus among court watchers was that it seemed unlikely the justices would substantially reduce access to mifepristone.

In late April, however, when the Supreme Court heard the second abortion-related case in its pipeline, legal analysts agreed that at least some of the conservative justices seemed open to a decision that could have life-or-death implications for pregnant patients in the twenty-two states with abortion bans, particularly in the handful that did not have exceptions to protect the health of the pregnant parent, like Idaho, where the case originated.

The case, *Idaho and Moyle v. United States*, asked the court to determine whether a 1986 federal law that required nearly all hospitals to provide stabilizing medical treatment in emergency situations covered abortion care for pregnant patients. The Biden administration argued that the Emergency Medical Treatment and Labor Act, known as EMTALA, meant that hospitals in states with abortion bans still

needed to treat patients experiencing pregnancy loss or complications, including by providing abortion care if it is medically required.

Both the federal trial and appeals court sided with the Biden administration that EMTALA preempted the state's abortion ban and put it on hold. In January 2024, when the Supreme Court agreed to hear Idaho's appeal (Alliance Defending Freedom lawyers also assisted Idaho), it lifted the injunction on the ban and the abortion ban took effect. In the three months that followed, St. Luke's Health System, the state's largest employer and its only nonprofit hospital network, said that it had to airlift six patients to neighboring states for emergency abortion care. Idaho Republican attorney general Raúl Labrador said that St. Luke's airlifted patients "just to make a political statement" and their report was "misinformation," though he did not offer any evidence that refuted the hospital's claims. St. Luke's, meanwhile, told National Public Radio that the patients were sent for out-of-state abortions "to protect their health and prevent material deterioration and/or loss of organ function."

If the Supreme Court found that abortion bans took precedence over EMTALA, it would exacerbate already tenuous access to emergency abortion care for people living in states with restrictive laws. Headlines from around the country since *Dobbs* already indicated what was at stake. In Texas, a woman miscarried in the lobby restroom after the emergency room refused to admit her. When Physicians for Human Rights assessed the impact of Oklahoma's restrictive ban on emergency care, the medical advocacy group found that "not a single hospital in Oklahoma appeared to be able to articulate clear, consistent policies for emergency obstetric care that supported their clinicians' ability to make decisions based solely on their clinical judgement and pregnant patients' stated preferences and needs." One pregnant Oklahoman was told that "a pregnant patient's body would be used as an 'incubator' to carry the baby as long as possible." Another woman developed a life-threatening

blood clot 14 weeks into her pregnancy, then found out at 20 weeks that her fetus did not have a skull or most of its brain. She decided that "carrying her to term sounded like the most torturous thing I could do to myself, my husband and our unborn child," she told the *Oklahoman*. For a week she left desperate messages with hospital staff—who were trying to figure out what they could legally say given the state's strict abortion laws—before traveling hundreds of miles to New Mexico to end her high-risk, nonviable pregnancy.

I expected the Supreme Court to decide both of the abortion cases—mifepristone and EMTALA—in June 2024, when the justices often release their most awaited and controversial decisions near the end of the court's term. There was also continued uncertainty in states where abortion had gone back and forth between legal and banned in some capacity in the nearly two years since the Supreme Court decided *Dobbs*.

Here was where things stood in the states covered in this book where abortion access was in flux at the time of my writing this in May 2024:

In Wisconsin, abortion had been legal until 22 weeks' pregnancy since September 2023, when a state judge affirmed that a pre–Civil War law prohibited feticide but not "consensual" abortion. Abortion rights advocates were still challenging state restrictions like the gestational limit and a twenty-four-hour waiting period. But with an ideologically liberal majority on the Wisconsin Supreme Court, any appeal that reached it would likely be decided in favor of abortion rights. Fights also continued over Wisconsin's voting maps. Democrats—joined by voting rights proponents—challenged the Republican-drawn maps that had led to the GOP winning six of the state's eight U.S. House seats in the 2022 elections and holding a lopsided, roughly two-thirds majority of each state legislative chamber. A bipartisan deal paved the way for new state-level maps—and they were expected to make the 2024 state legislative

elections some of the most competitive in recent history. But in March 2024, the state Supreme Court declined to take a case challenging the map used for congressional races, preserving the Republican advantage at the federal level.

In Kentucky, the defeat of the proposed constitutional amendment prohibiting abortion had allowed legal challenges to the state's legislative abortion ban to proceed. But the Kentucky Supreme Court ruled in February 2023 that abortion providers did not have the standing they needed to bring the case—they needed a plaintiff who had been directly impacted. In December 2023, the American Civil Liberties Union filed a class-action lawsuit on behalf of a pregnant Jane Doe who wanted an abortion at 8 weeks' gestation, but the ACLU quickly withdrew the case after the plaintiff's fetus no longer showed cardiac activity. At the time of this writing, the lawsuit brought by three Jewish women from Kentucky in October 2022 was ongoing. The women are all mothers who said they wanted to expand their families, but the state's laws would prevent them from receiving the fertility or prenatal treatments that they needed. "Jews do not consider life to begin at conception; this religious belief is forced on them by the government," the women's lawyers said in a court filing. Among the laws they cited was Kentucky's Religious Freedom Restoration Act, enacted in 2013.

In Ohio, abortion was protected until fetal viability. In August 2023, Ohioans had overcome Republican lawmakers' attempts to make it harder to approve ballot measures. Then, in November, they approved Issue 1 protecting abortion rights, voting 56 percent in favor and 43 percent against. By spring 2024, a movement was underway to get enough signatures to put another measure onto November 2024 ballots that would create a fifteen-member redistricting commission. The Citizens Not Politicians amendment aimed to overcome the extreme partisan gerrymandering in the state that had resulted in Ohio's Supreme Court rejecting GOP-drawn voting maps multiple

times. If created, current or former politicians, political party officials, and lobbyists would be banned from serving on the commission.

In Arizona, abortion had been mostly legal through 15 weeks since October 2022. Then, the Arizona Supreme Court ruled on April 9, 2024, that the 1864 law making providing or obtaining an abortion a felony was still in effect—the ban that was enacted when Arizona was a territory, not yet a state, during the Civil War, and more than 50 years before women could vote; the one that had caused a rift between Republican lawmakers and conservative lobbyists in the days and weeks after *Roe* fell.

Arizona Supreme Court justice John R. Lopez wrote on behalf of himself and three other justices that "a policy matter of this gravity must ultimately be resolved by our citizens through the legislature or the initiative process. Today, we decline to make this weighty policy decision because such judgments are reserved for our citizens." Lopez was appointed by former Gov. Doug Ducey in 2016 after Republicans added two more seats to the state's highest court—a move that liberal critics described as court packing to ensure an enduring conservative majority. The vice chief justice dissented, along with the chief justice.

I had just sat down at a Washington restaurant for lunch. I knew the decision would come that Tuesday, and roughly at what time, so I apologized to my dining companion in advance and left my phone out on the table so I could see news alerts as they started coming in. My colleagues at *The 19th*—Shefali Luthra, Grace Panetta, Jessica Kutz—parsed the ruling when it landed. They quickly deciphered that the 1864 ban would not take effect right away, there would be at minimum a fourteen-day stay, and potentially as many as ninety days before the full gestational ban would replace the 15-week ban.

This time, I was the reporter who texted Dr. Gabrielle Goodrick of Camelback Family Planning to ask for her response to her life's work again becoming illegal in the state where she practiced

medicine—or would become, without legislative or legal action. This, I knew, would be my ending, because it so perfectly encapsulated the turmoil wrought by Alito's *Dobbs* decision.

One week prior, a coalition of organizations aiming to put a measure before Arizonans enshrining abortion protections in the state's constitution had announced they had enough signatures for it to be on ballots in November. However, even if the ballot measure succeeded, there could be a months-long period during which the 1864 law would be in place. National Republicans knew the potential political fallout: even GOP presidential candidate Donald Trump, who had cemented the U.S. Supreme Court's antiabortion majority, said the archaic Arizona ban went "too far."

But when Arizona Democrats rushed to repeal the 1864 ban, only two GOP state senators helped them get the bill out of the upper chamber and onto Democratic governor Katie Hobbs's desk. Shawnna Bolick, the only Republican woman who voted to repeal, delivered a more than twenty-minute personal speech ahead of the vote that detailed one pregnancy that involved weeks of bed rest and another than ultimately ended around 11 weeks when an incomplete miscarriage required a surgical abortion procedure to remove pregnancy-related tissue. "Until we have a better choice in this matter, I side with saving more babies' lives," said Bolick, who said she was worried that without repeal, Arizonans would be more likely to vote to for the ballot measure.

Goodrick was at the Senate vote—her first time at the state house in years. She watched as the votes passed the threshold for passage, then as the vote was called. She attended a post-repeal press conference held by Democratic lawmakers. Then, she called me. Due to legislative procedure, there might still be a short period when the 1864 ban briefly kicked in ahead of the repeal taking effect. Goodrick nevertheless said she was feeling hopeful that in November, Democrats would gain control of at least one of the state house chambers;

Democratic representative Ruben Gallego would prevail in his U.S. Senate race against Republican Kari Lake; and the referendum to add abortion protections to Arizona's constitution would pass.

"I wanted to witness it—it's historic," she told me of the vote. "It's moving—and it's our first stop to taking back Arizona, out of the hands of MAGA Republicans that are not doing what's best for our state. They do not represent the people and they don't want to give up that control. But this is their last hurrah."

I asked her whether she was at all worried that repealing the 1864 ban might remove the impetus to vote for the constitutional amendment for some voters—maybe those who were inclined to support some restrictions, or even the 15-week ban, but were not okay with an across-the-board prohibition with few exceptions. The type of voters Bolick was worried would back the ballot measure if the 1864 law was not repealed.

"Well, if we don't win, and Katie Hobbs is out in two years, [Republican lawmakers] are going to be voting for a six-week ban, or a total ban. The lives of women—and my clinic, and people's reproductive choices—are at the whim of elected officials who don't always have the best interest of Arizonans at heart when they vote," Goodrick responded.

"Putting this in the Constitution is where it needs to be, no question," she added.

Amanda Becker
May 2024

ACKNOWLEDGMENTS

The actual writing of a book is a solitary process—but the reporting that precedes it and all of the work that comes after to get it ready for publication are truly team efforts.

To the doctors, health care workers, lawyers, experts, students, and voters who took the time to speak to me, who let me follow them around, who shared their worries and their dreams, and who explained things I would never otherwise understand, I am forever in your debt. Your passion and persistence are an inspiration.

This book would not exist without my agent, Lauren Sharp at Aevitas. I cold emailed her in March 2022 at the recommendation of another journalist and she not only saw what was coming—the fall of *Roe v. Wade*—she knew the importance of being ready to tell this story. Then, she helped me figure out which part of it was mine to tell. Thank you for believing in this project from day one.

To my editor, Grace McNamee at Bloomsbury: At every step of this process I have felt so fortunate to be working with you. It is a leap of faith for an editor to work with a first-time author and vice versa— thank you for trusting me and knowing I could do this, and for answering my myriad of questions along the way. To the entire Bloomsbury crew—Rosie Mahorter, Katie Vaughn, Kenli Manning, Jillian Ramirez, Suzanne Keller, and Myunghee Kwon—you are the best in the business. I am so lucky.

To Ena Alvarado, who expeditiously fact-checked the manuscript, thank you for your diligence and attention to detail—you saved me from my tired brain so many times.

I found out that this book was a reality on the day I arrived for fellowship orientation at the Nieman Foundation for Journalism at Harvard University. I write for a living and I do not have the words to fully convey how much that year meant to me. Thank you to everyone at the Nieman Foundation, but especially Ann Marie Lipinski and James Geary. To the Louis Stark Nieman Fellowship, know that you are providing a gift whose value cannot be measured.

To my fellow 2022–2023 fellows—Fahim Abed, Adefemi Akin-sanya, Dotun Akintoye, Sheikh Sabiha Alam, Deborah Berry, Olga Churakova, Ashish Dikshit, Pinar Ersoy, Darryl Fears, Danny Fenster, Elisabeth Goodridge, Angie Drobnic Holan, Renée Kaplan, Natasha Khan, Tanya Kozyreva, Romy Neumark, Bopha Phorn, Taras Prokopyshyn, Kristofer Ríos, Moises Saman, Alex Smith, Ruth Tam, and Jorge Valencia—you will always be my apogee newsroom. I respect you all and love you so much.

While the Nieman isn't a book-writing fellowship, courses I was able to take at Harvard informed my thinking about writing, democracy, and U.S. politics, and I can see their impact on this book. Participants in Steve Almond's nonfiction writing workshop for Nieman read some of the earliest drafts of these chapters. Discussions in Claire Messud's fiction workshop prompted me to rethink how to develop characters and interiority even for nonfiction. I was completely out of my depth in Anna Jabloner's feminist science and technology studies course and I am a better journalist because of it. I learned so much about worldwide antidemocratic movements from Steve Levitsky. It was an honor to study organizing with Marshall Ganz, whose work is cited in these pages. Dan Rothstein and Luz Santana, what you are doing to support participation in this democracy is inspiring and your course was a joy.

I was able to do the Nieman fellowship in no small part because I work for one of the most supportive, special newsrooms in the business: *The 19th*. Helping to launch a nonprofit startup in the early

months of a global pandemic was a wild ride—I am so proud of what we have built together and what's to come. Gratitude in particular for CEO and cofounder Emily Ramshaw, who not only gave me her full backing to do the Nieman but did not flinch when I called her the first week I was out of the office to let her know that afterward I would also be writing this book. Emily, you are the embodiment of supportive leadership.

I've been a reporter for nearly twenty years now and journalists I've worked with along the way are now some of my dearest friends. I would like to give a special shout-out to these folks who repeatedly—really, quite often—listened and provided me with guidance: Abha Bhattarai, Christina Bellantoni, Jason Dick, Lilly Ana Fowler, Ginger Gibson, Errin Haines, Zachary Hale, Catherine Ho, Fawn Johnson, Abby Livingston, Tory Newmyer, Jim Oliphant, Neda Semnani, Drew Tewksbury, Amy Walters, and John Whitesides. Emily Cadei, you are family. Alicia Lozano, I can't imagine my life without you in it. Joe Stephens, I'm not sure where I'd be or what I'd be doing without your example.

There are several editors who at various points in my career opened doors—thanks to Paul Singer, Marilyn Thompson, and Andrea Valdez for those opportunities. Marc Cooper, too, as a beloved teacher and early editor—I still laugh at some of your edit notes when I rediscover them.

Noah Black was the first "outsider" I trusted to read these pages. Who knew rainy-day cupcakes would lead to this decade-long friendship? I appreciate you to my core—let's plan a trip to somewhere far away.

My friendships with women are the relationships that have most shaped my life. To those in my circle from Ursuline Academy, or with whom I shared a home at Delta Gamma, I cannot disentangle my story from our stories. I found sisterhood again in 1519—somehow, even making binders with you was fun. Diana Sayed, you get your

own category—our bond spans oceans. To my D.C. Commune: I can't wait to grow old(er) with you, the exemplar of chosen family.

Finally, to the family I was born into: Thank you. For everything, but specifically the support and educational opportunity that set me up to succeed in the work that I have chosen to do. Every day, I feel your love. Every day, I hope you feel mine.

Amanda Becker
June 2024

SOURCES

I covered politics, then gender and politics specifically, for more than a decade before the Supreme Court overturned *Roe v. Wade*. Then after, as I continued to report and also wrote this book. Over that time, I read hundreds of news articles that contributed to my base of knowledge about abortion politics—it would be impossible to list them all here. For the sake of brevity, I have included full citations only for any fact that isn't sourced directly in the text or is not easy to find. When there is dialogue, I observed it firsthand. When there are descriptions of physical clinic settings, they are from my own observations. I also conducted hundreds of interviews—sometimes a half dozen or more with a single person. I have noted for each chapter which interviews and books informed my overall thinking, even if they are not quoted directly.

Some public opinion polling that I return to again and again for consistency across years and geography is "Abortion Attitudes in a Post-Roe World: Findings from the 50-State 2022 American Values Atlas," Public Religion Research Institute, February 23, 2023, www.prri.org/research/abortion -attitudes-in-a-post-roe-world-findings-from-the-50-state-2022-american -values-atlas/ as well as the Pew Research Center's annual polling on abortion views, which can be found for 1995–2021 at www.pewresearch.org /religion/fact-sheet/public-opinion-on-abortion/#CHAPTER-h-views -on-abortion-1995-2021, last accessed in November 2023, and by state at www.pewresearch.org/religion/religious-landscape-study/compare/views -about-abortion/by/state/, accessed November 2023.

CHAPTER ONE: "STOP."

Interviews with Robin Marty, Leah Torres, Chad Jackson, and Mary Ziegler. While I covered the Tea Party's rise, Kate Zernike's *Boiling Mad: Behind the Lines in Tea Party America* (New York: St. Martin's Griffin, 2011) was a great mental refresher on that recent period in political history. Ziegler's *Abortion*

and the Law in America: Roe v. Wade to the Present (New York: Cambridge University Press, 2020) has been an indispensable guide.

3 **Robin Marty was live:** CNN Headline News, *The LEAD Now*, WJLA, Los Angeles, California, June 24, 2022.

4 **It was 10:12 A.M. EDT:** Supreme Court of the United States, *Dobbs, State Health Officer of the Mississippi Department of Health, et al., v. Jackson Women's Health Organization, et al.*, June 24, 2022.

4 **The Supreme Court's 6–3 decision:** Elizabeth Nash and Lauren Cross, "26 States Are Certain or Likely to Ban Abortion Without Roe: Here's Which Ones and Why," Guttmacher Institute, www.guttmacher.org /article/2021/10/26-states-are-certain-or-likely-ban-abortion-without -roe-heres-which-ones-and-why, accessed July, 2023.

4 **Marty is someone who:** Rewire News Group, "About Us," www.rewire newsgroup.com/about-us, accessed June 2023.

5 **Marty's caution was warranted:** Feminist Majority Foundation Press Release, Anti-Abortion Violence Watch Newsletter, July 22, 1997; Jason Morton, "Man Charged in Ramming of Abortion Clinic," *Tuscaloosa News*, April 27, 2006.

7 **Off-camera, Marty read her texts:** Amy Howe, "Supreme Court Over-turns Constitutional Right to Abortion," *SCOTUSblog*, June 24, 2022.

8 **The consensus that developed:** www.youtube.com/watch?v=f2GBMHi _2_4, accessed June 2023.

9 **Traveling out of state:** www.oyez.org/cases/1991/91-744, accessed June 2023.

9 **For the next three decades:** Elizabeth Nash and Joerg Dreweke, "The U.S. Abortion Rate Continues to Drop: Once Again, State Abortion Restrictions Are Not the Main Driver," September 18, 2019; "Communities Need Clinics 2021, Independent Clinics: Leading the Fight to Sustain Abortion Access in the United States," Abortion Care Network, November, 2021.

10 **In other words, having to travel:** T. C. Jatlaoui, L. Eckhaus, M. G. Mandel, et al., "Abortion Surveillance—United States, 2016," MMWR Surveillance Summary 2019; 68 (No. SS-11):1–41, Table 2.

10 **When *Dobbs* was decided:** www.guttmacher.org/state-policy/explore /requirements-ultrasound, accessed May 2023; www.kff.org/womens

-health-policy/state-indicator/ultrasound-requirements, accessed May 2023.

11 **In those 2010 midterms:** *Historic Documents of 2010,* CQ Press, 2011; Michael Memoli, "State Legislative Gains Give Republicans Unprecedented Clout to Remake Districts," *Los Angeles Times,* November 3, 2010.

11 **Obama took office amid the Great Recession:** Theodore Johnson, "The Role of Racial Resentment in Our Politics," Brennan Center for Justice, November 23, 2022; Craig Fehrman, *Author in Chief: The Untold Story of Our Presidents and the Books They Wrote* (New York: Avid Reader Press/Simon & Schuster, 2020); *Thomas Jefferson and Race,* C-SPAN, Washington, D.C., February 16, 2020; Roger Wilkins, *Jefferson's Pillow: The Founding Fathers and the Dilemma of Black Patriotism* (Boston: Beacon Press, 2002).

12 **The Tea Party was meant to be leaderless:** D. Tope, J. T. Pickett, and T. Chiricos, "Anti-Minority Attitudes and Tea Party Movement Membership," *Social Science Research,* May 2015, 51:322–37, doi:10.1016/j.ssresearch .2014.09.006, epub 2014 Oct 19, PMID: 25769870; Robb Willer, Matthew Feinberg, and Rachel Wetts, "Threats to Racial Status Promote Tea Party Support Among White Americans," Stanford University School of Business, May 2016; *The View,* ABC, New York, May 6, 2010, accessed via Kremer's personal YouTube feed in June 2023, www.youtube.com/watch ?v=FprPZy9Mvxk&list=UUb3gDxG_GkmVx7MuDVvdqZQ.

13 **You can trace the political throughline:** Tyrone Beason, "Keli Carender Takes Tea Party's Mixed Messages to the Streets," *Seattle Times,* May 15, 2010; Adam Liptak, "Health Act Arguments Open with Obstacle from 1867," *New York Times,* March 27, 2012; Carender's X feed, twitter.com /search?q=abortion%20(from%3Akelicarender)&src=typed_query, accessed June 2023.

13 **If Obama had any chance:** Tea Party signs, collected by NAACP, accessed via www.youtube.com/watch?v=PWbmEUIQOCQ in June 2023; Liz Halloran, "Obama Humbled by Election 'Shellacking,'" NPR, November 3, 2010; Chris Riotta, "GOP Aims to Kill Obamacare Yet Again After Failing 70 Times," July 29, 2017.

14 **After the Tea Party wave:** "More State Abortion Restrictions Were Enacted in 2011–2013 than in the Entire Previous Decade," Guttmacher Institute, January 2014.

15 **As the explosion of antiabortion laws picked up:** *Visible Voices* podcast, episode 119, www.thevisiblevoicespodcast.com/episodes/Bru SKKjrjɪTTmGllZTrm-g, accessed July 2023.

15 **At the same time:** Wendy Weiser, "The State of Voting in 2014," Brennan Center for Justice, June 17, 2014; *Shelby County v. Holder*, 570 U.S. 529, 2012.

16 **But antiabortion forces had not waited:** Elizabeth Nash, Lizamarie Mohammed, Olivia Cappello, and Sophia Naide, "State Policy Trends 2019: A Wave of Abortion Bans, but Some States Are Fighting Back," Guttmacher Institute, December 2019.

17 **Alabama had a Republican trifecta:** Alabama HB314, the "Human Life Protection Act," 2019, www.legiscan.com/AL/text/HB314/2019, accessed June 2023; Meghan Keneally, "Alabama Governor Signs Controversial Abortion Ban into Law but Will Face Likely Legal Challenges," ABC News, May 15, 2019.

17 **The Human Life Protection Act:** Alabama HB314, the "Human Life Protection Act," 2019; www.legiscan.com/AL/text/HB314/2019, accessed June 2023; Mike Cason, "Democrats Take Walk on Alabama Abortion Ban," AL.com, May 1, 2019.

18 **After Alabama passed its ban:** X account @realDonaldTrump, twitter .com/realDonaldTrump/status/1129954110747422720, accessed June 2023; Ryan Miller, "Televangelist Pat Robertson: Alabama Abortion Law 'Has Gone Too Far,' Is 'Ill-Considered,'" *USA Today*, May 16, 2019; Ronna McDaniel on *CNN This Morning*, CNN, May 17, 2019; Amanda Becker, "Alabama Abortion Law Draws Some Criticism, Mostly Silence from National Republicans," Reuters, May 16, 2019.

18 **Even Clark Forsythe:** Catherine Trautwein, "Alabama's Abortion Ban Was Meant to Overturn Roe. Can It?" PBS: *Frontline*, May 24, 2019.

19 **After her call to the clinic:** Emily Shugerman, "Clinics Turn Away Patients in Trigger-Law States After Abortion Decision," *Daily Beast*, June 24, 2022.

20 **Within hours of the *Dobbs* ruling:** Howard Koplowitz, "Federal Judge Lifts Injunction on Alabama's 2019 Abortion Ban After Roe v. Wade Overturned," AL.com, June 24, 2022.

20 **Days after the clinic reopened:** Matt Clark, "The Good News Is, AG Marshall Will Enforce Abortion Ban," *1819 News*, a project of the conservative Alabama Policy Institute, July 15, 2022.

CHAPTER TWO: "WOMEN ARE NOT WITHOUT
ELECTORAL OR POLITICAL POWER."

Much of this chapter draws from the majority and minority opinions in
Dobbs, State Health Officer of the Mississippi Department of Health,
et al., v. Jackson Women's Health Organization, et al., Certiorari to the U.S.
Court of Appeals for the 5th Circuit, No. 19-1392, argued December 1,
2021—Decided June 24, 2022. They can be accessed on the Supreme Court's
website at www.supremecourt.gov/opinions/21pdf/19-1392_6j37.pdf.

Another court document critical to this chapter is the Brief for Amici
Curiae American Historical Association and Organization of American
Historians in Support of Respondents filed in the Dobbs case. It can
be accessed via the American Historical Association's website at www
.historians.org/news-and-advocacy/aha-advocacy/aha-amicus-curiae-brief
-in-dobbs-v-jackson-womens-health-organization-(september-2021),
accessed November 2023.

22 **It prompted the public's disapproval:** "Positive Views of Supreme Court
 Decline Sharply Following Abortion Ruling," Pew Research Center
 report, September 1, 2022.

22 **At the time of oral arguments:** Elizabeth Nash and Lauren Cross, "26
 States Are Certain or Likely to Ban Abortion Without Roe: Here's
 Which Ones and Why," Guttmacher Institute, www.guttmacher.org
 /article/2021/10/26-states-are-certain-or-likely-ban-abortion-without
 -roe-heres-which-ones-and-why, accessed July, 2023. Jasmine Mithani,
 "Here's When Each Trigger Law Banning Abortion Could Go into
 Effect," The 19th, June 24, 2022, www.19thnews.org/2022/06/timeline
 -state-trigger-laws-abortion-bans, accessed July 2022.

23 **In Louisiana, for example:** Sam Karlin, "Louisiana's Abortion Ban,
 Explained: Here's a Timeline of the Rollercoaster of Abortion Access,"
 Advocate, July 29, 2022.

24 **In Michigan, there was an 1846 ban:** Beth LeBlanc, "What Loss of
 Roe Means for Women Who Want Abortions in Michigan," Detroit
 News, June 24, 2022.

24 **In Wisconsin:** Veronica Stracqualursi, "Wisconsin GOP Abruptly Ends
 Special Session Called by Democratic Governor to Repeal 19th Century
 Abortion Law," CNN, June 22, 2022.

25 **"Physicians are struggling every day"**: Jack Resnick, testifying before the U.S. House Committee on Energy and Commerce Subcommittee on Oversight and Investigations hearing, "Roe Reversal: The Impacts of Taking Away the Constitutional Right to an Abortion," July 19, 2022, www.ama-assn.org/press-center/press-releases/ama-president-testifies -house-committee-hearing-roe-reversal-impact, written testimony accessed July 2023.

28 **The explosion of abortion regulation:** Annalies Winny, "A Brief History of Abortion in the U.S.," *Hopkins Bloomberg Public Health*, Fall/Winter 2022; "Before Roe: The Physicians' Crusade," NPR, *Throughline*, May 19, 2022; Alex Samuels and Monica Potts, "How the Fight to Ban Abortion Is Rooted in the 'Great Replacement' Theory," *FiveThirtyEight*, July 25, 2022; Horatio Robinson Storer, *Why Not? A Book for Every Woman* (Boston: Lee and Shepard, 1866).

29 **The abortion law historian Mary Ziegler:** Jennifer Schuessler, "The Fight over Abortion History," *New York Times*, May 4, 2022.

29 **Despite state-level restrictions:** Rachel Benson Gold, "Lessons from Before Roe: Will Past Be Prologue?" Guttmacher Institute, March 1, 2003.

29 **As Katha Pollitt:** Katha Pollitt, "Abortion in American History," *Atlantic*, May 1997.

30 **Alito's opinion also did not dwell:** Ken Armstrong, "Draft Overturning Roe v. Wade Quotes Infamous Witch Trial Judge with Long-Discredited Ideas on Rape," ProPublica, May 6, 2022.

30 **The self-described "lifelong registered Republican":** Jesse Armstrong, "Alito Boasted of His Work Against Quotas and the Right to an Abortion," *Associated Press*, November 14, 2005; Bill Sammon, "Alito Rejected Abortion as a Right," *Washington Times*, November 24, 2005.

31 **When President George H. W. Bush:** Adam Liptak, "Few Glimmers of How Conservative Judge Alito Is," *New York Times*, January 13, 2006; Edwin Meese, "Did the Conservative Legal Movement Succeed? That All Depends on Whether the Supreme Court Overrules Roe v. Wade," *Washington Post*, November 29, 2021.

32 **It took just six weeks:** "Positive Views of Supreme Court Decline Sharply Following Abortion Ruling," Pew Research Center report, September 1, 2022.

CHAPTER THREE: "WHAT AM I GOING
TO DO ABOUT IT?"

Interviews with Dr. Diane Horvath and Morgan Nuzzo. Background interviews with other clinic staff.

35 **Third trimester care is rare:** K. Kortsmit, A. T. Nguyen, M. G. Mandel, et al., "Abortion Surveillance —United States, 2020," Morbidity and Mortality Weekly Report Surveillance Summaries 2022, 71 (No. SS-10):1–27.

35 **Then, in April 2022:** Ayana Archie, "Maryland Lawmakers Expand Who Can Perform Abortions After Overriding Governor's Veto," NPR, April 11, 2022.

36 **Horvath does not call:** "ACOG Guide to Language and Abortion," American College of Obstetricians and Gynecologists, www.acog.org /contact/media-center/abortion-language-guide/, accessed November 2023.

36 **Less than one percent of the abortions:** K. Kortsmit et al., "Abortion Surveillance."

37 **Lawmakers often take public sentiment into account:** K. Kimport, "Is Third-Trimester Abortion Exceptional? Two Pathways to Abortion After 24 weeks of Pregnancy in the United States," *Perspectives on Sexual and Reproductive Health*, June 2022, 54(2):38-45, doi:10.1363/psrh.12190, epub 2022, Apr 10, PMID: 35403366; PMCID: PMC9321603.

37 **In 2021, there were 358:** Communities Need Clinics 2021, "Independent Clinics: Leading the Fight to Sustain Abortion Access in the United States," Abortion Care Network, November 2021.

39 **This button was a necessity:** "2021 Violence and Disruption Statistics," annual report from the National Abortion Federation, May 19, 2022, www.prochoice.org/wp-content/uploads/2021_NAF_VD_Stats_Final .pdf, accessed November 2023.

41 **This idea:** "Abortion Is a Common Experience for U.S. Women, Despite Dramatic Declines in Rates," Guttmacher Institute, October 19, 2017.

CHAPTER FOUR: "YOU MUST STAND UP."

Interviews with Dr. Gabrielle Goodrick, Ashleigh, J. Charles "Chuck" Coughlin, and Karan English.

For a refresher on Republican politics in the 1980s, I relied on Randall Balmer, *Bad Faith: Race and the Rise of the Religious Right* (Grand Rapids, MI: Eerdmans, 2021); Michele McKeegan, *Abortion Politics: Mutiny in the Ranks of the Right* (New York: Free Press, 1982); Tanya Melich, *The Republican War Against Women: An Insider's Report from Behind the Lines* (New York: Bantam, 1996); and Scott Ainsworth and Thad Hall, *Abortion Politics in Congress: Strategic Incrementalism and Policy Change* (New York: Cambridge University Press, 2010).

For general information about abortion in Arizona in 2022, see www.gutt macher.org/fact-sheet/state-facts-about-abortion-arizona, accessed July 2023.

47 **By the time:** "Arizona's 15-week Abortion Ban Was Set to Take Effect Saturday," Associated Press, September 23, 2023.

47 **In the fall of 2022:** www.abortionfinder.org, accessed May 2023; K. Kortsmit, A. T. Nguyen, M. G. Mandel, et al., "Abortion Surveillance— United States, 2020," Morbidity and Mortality Weekly Report Surveillance Summaries 2022, 71 (No. SS-10):1–27.

48 **Goodrick, like Robin Marty:** drgabriellegoodrick.wordpress.com, accessed November 2023.

50 **For starters, Arizona's electorate is unique:** Arizona Secretary of State.

51 **Arizona was the birthplace:** Suzanne McGee, "How Barry Goldwater Brought the Far Right to Center Stage in the 1964 Presidential Race," History Channel, October 20, 2020.

52 **By 1994, Goldwater spoke openly:** Bart Barnes, "Barry Goldwater, GOP Hero, Dies," *Washington Post*, May 30, 1998; Barry Goldwater, "The Gay Ban: Just Plain Un-American," *Washington Post*, June 10, 1993; Lloyd Grove, "Barry Goldwater's Left Turn," *Washington Post*, July 28, 1994.

53 **The Center for Arizona Policy:** www.azpolicy.org, and CAP Action tax filings via Guidestar.org.

54 **The money that CAP Action:** State of Arizona Campaign Finance Report, Independent Expenditure Report, 2020 CCEC General Tuesday Trigger, October 13, 2020.

56 **Ahead of the 2016 election:** "Who is Arizona's Independent Voter?" Morrison Institute for Public Policy at Arizona State University, 2015.

57 **Political observers worried:** Sarah Smallhouse, "Don't Like Your Choices in November? Let's Fix Arizona's Broken Election Process," *Arizona Republic*, September 29, 2022.

58 **Around noon, Goodrick got a message:** Ray Stern, "Roe v. Wade Has Been Overturned. What Is the Law for Abortions in Arizona Now?" *Arizona Republic*, June 24, 2022.

58 **Goodrick scrambled to protect:** Nina Lakhani, "Abortion Is Still Legal in Arizona. But Confusion and Fear Abound," *Guardian*, August 15, 2022.

59 **Arizona Republican attorney general:** X account of Mark Brnovich, @General Brnovich, x.com/GeneralBrnovich/status/1542275229925249024?s=20, accessed August 2023.

59 **The 15-week ban was set:** "Arizona Judge: State Can Enforce Near-Total Abortion Ban," Associated Press and 12News, September 23, 2022; Eliza Fawcett, "Arizona Judge Reinstates Strict Abortion Ban from 1864," *New York Times*, September 23, 2022.

61 **Then, on October 7:** Ray Stern, "Arizona Appeals Court Puts Hold on Territorial Abortion Ban; Planned Parenthood to Resume Procedure," *Arizona Republic*, October 7, 2022.

61 **The year before:** Ben Giles, "Arizona Republicans Enact Sweeping Changes to State's Early Voting List," NPR, May 11, 2021.

CHAPTER FIVE: "IT'S UP TO YOU TO DECIDE
WHETHER THAT IS A RISK YOU'RE WILLING TO TAKE."

Interviews with Robin Marty, Clare Daniel, Amy Irvin, and Jordan Williams. Background interviews with students at Tulane events and audience members at book readings.

Robin Marty and Amanda Palmer, *Handbook for a Post-Roe America: The Complete Guide to Abortion Legality, Access, and Practical Support* (New York: Seven Stories Press, 2021).

69 **Much of Marty's talk:** "Alabama's Attorney General Says the State Can Prosecute Those Who Help Women Travel for Abortions," Associated Press, August 31, 2022.

70 **Facing criminal liability:** Sam Karlin, "Louisiana's Abortion Ban, Explained: Here's a Timeline of the Rollercoaster of Abortion Access," *Advocate*, July 29, 2022.

71 **When *Roe* fell, Williams knew:** www.newcomb.tulane.edu/scholars, accessed November 2022.

CHAPTER SIX: "WHICH WAY DO I NEED TO
VOTE TO SUPPORT WOMEN'S RIGHTS?"

Interviews with Laura Weinstein, Emily Albrink Katz, Rachel Sweet, Lisa Sobel, Jessica Kalb, and Sarah Baron.

Michael Schudson, *The Good Citizen: A History of American Civic Life* (New York: Free Press, 2011); Donald Green and Alan Gerber, *Get Out the Vote: How to Increase Voter Turnout* (Washington, D.C.: Brookings Institution Press, 2015), and Elizabeth McKenna and Hahrie Han, *Groundbreakers: How Obama's 2.2 Million Volunteers Transformed Campaigning in America* (New York: Oxford University Press, 2014).

77 **By signing up at the information session:** "The Public, The Political System and American Democracy," Pew Research Center, April 26, 2018.

77 **In Italy, economists found:** Enrico Cantoni and Vincent Pons, "Do Interactions with Candidates Increase Voter Support and Participation? Experimental Evidence from Italy," *Economics & Politics* 33, no. 2 (July 2021): 379–402; Steven Erlanger, "In France, Using Lessons from Obama Campaign," *New York Times*, April 21, 2012.

77 **Nonpartisan canvassing in New Haven:** A. S. Gerber and D. P. Green, "Does Canvassing Increase Voter Turnout? A Field Experiment," *Proceedings of the National Academy of Sciences USA*, September 14, 1999, 96(19):10939-42.

78 **To lead this "ground game":** Michael Ganz, "2009 Organizing Obama: Campaign, Organization, Movement," Proceedings of the American Sociological Association Annual Meeting, San Francisco, CA, August 8–11, 2009.

80 **An analysis by the nonpartisan website:** www.ballotpedia.org/2018 _ballot_measures, accessed December 2022.

80 **In liberal-leaning California:** ballotpedia.org/California_Proposition
 _10,_Local_Rent_Control_Initiative_(2018), accessed December 2022.

81 **In 2020, again in California:** ballotpedia.org/California_Proposition
 _22,_App-Based_Drivers_as_Contractors_and_Labor_Policies_
 Initiative_(2020); George Skelton, "It's No Wonder Hundreds of
 Millions Have Been Spent on Prop. 22. A Lot Is at Stake," *Los Angeles
 Times*, October 16, 2020.

82 **The man at the brick colonial:** ballotpedia.org/Ballot_measure_read
 ability_scores,_2017, accessed December 2022.

82 **But here's the reality:** Emily Schmidt, "Reading the Numbers: 130
 Million American Adults Have Low Literacy Skills, but Funding
 Differs Drastically by State," APM Research Lab, March 16, 2022;
 National Center for Education Statistics data on the Program for the
 International Assessment of Adult Competencies (PIAAC).

CHAPTER SEVEN: "WE ARE AT A TOTAL
STALEMATE IN CONGRESS."

Interviews with Cecile Richards, Mary Ziegler, and Alisa Von Hagel.

Randall Balmer, *Bad Faith: Race and the Rise of the Religious Right*
(Grand Rapids, MI: Eerdmans, 2021), and Scott H. Ainsworth and Thad E.
Hall, *Abortion Politics in Congress* (New York: Cambridge University Press,
2011).

Sections of this chapter are also adapted from Amanda Becker, "Why
Didn't Congress Codify Abortion Rights?" *The 19th*, January 26, 2022.

97 **There was a time:** Jeff Diamant, "Three in Ten or More Democrats and
 Republicans Don't Agree with Their Party on Abortion," Pew Research
 Center, June 18, 2020.

98 **The first rumblings of realignment:** Sean Salai, "Remembering Nixon's
 Catholic Coup: An Interview with Pat Buchanan," *America: The Jesuit
 Review of Faith and Culture*, August 5, 2014.

98 **Nixon won a second term:** "Presidency: Nixon Landslide of Historic
 Proportions," *CQ Almanac*, 1972.

99 **Nixon's reaction:** Nina Totenberg, "Tape Reveals Nixon's Views on
 Abortion," NPR, *All Things Considered*, June 23, 2009.

99 **Two years after** *Roe*: Abortion Trends by Party Affiliation, Gallup, news.gallup.com/poll/246278/abortion-trends-party.aspx, accessed January 2023.

101 **Four years later, the 1980 presidential campaign:** Randall Balmer, "The Religious Right and the Abortion Myth," *Politico*, May 10, 2022.

101 **The Republican Party's continued embrace:** Douglas Martin, "Mary D. Crisp, 83, Feminist G.O.P. Leader, Dies," *New York Times*, April 17, 2007.

102 **Clinton marked** *Roe*'s **twentieth anniversary:** Carol Jouzaitis, "Clinton Lifts Abortion Gag Rule," *Chicago Tribune*, January 23, 1993.

103 **It kicked off a period:** Thomas Waldron, "Christian Coalition Unveils Social 'Contract with the American Family,'" Baltimore *Sun*, May 18, 1995.

105 **In the 2010 midterm elections:** Julie Rovner, "Planned Parenthood: A Thorn in Abortion Foes' Sides," NPR, *Morning Edition*, April 13, 2011.

105 **In January 2016:** Molly Redden, "Clinton Leads Way on Abortion Rights as Democrats Seek End to Decades-Old Rule," *Guardian*, July 26, 2016; Eesha Pandit, "Hillary Clinton's Abortion Game-Changer: Why Her Call for Abandoning the Hyde Amendment Is So Important," Salon.com, January 15, 2016.

CHAPTER EIGHT: "THAT'S THE WHOLE PURPOSE OF THE CLINIC EXISTING."

Interviews with Diane Horvath and Morgan Nuzzo.

110 **The Society of Family Planning's #WeCount project:** www.societyfp .org/research/wecount/, accessed April 2023.

112 **In a pink rose protest:** Judy Thomas and Katie Bernard, " 'Summer of Mercy' Changed Abortion Rights in Kansas Forever," *Kansas City Star*, August 1, 2022.

CHAPTER NINE: "I WANT TO BE THE SAFETY NET."

Interviews with Leah Torres, Robin Marty, and Chad Jackson.

117 **"On July 11":** Robin Marty, "An Alabama Abortion Clinic Reinvents Itself for a Post-Roe World," *Time*, July 28, 2022.

117 **A September 2010 article:** Lori Freedman, Uta Landy, Philip Darney, and Jody Steinauer, "Obstacles to the Integration of Abortion into Obstetrics and Gynecology Practice," *Perspectives on Sexual and Reproductive Health,* September 2010.

118 **When Roe was decided in 1973:** Eyal Press, *Absolute Convictions: My Father, a City, and the Conflict That Divided America* (New York: Henry Holt, 2006).

118 **Regulations—including TRAP laws:** K. Kortsmit, A. T. Nguyen, M. G. Mandel, et al., "Abortion Surveillance—United States, 2020," Morbidity and Mortality Weekly Report Surveillance Summaries 2022, 71 (No. SS-10):1–27; "Induced Termination of Pregnancy Statistics, Alabama Public Health, www.alabamapublichealth.gov/healthstats /assets/2021_itop_annual_report.pdf, accessed November 2023.

118 **Another reason:** Tess Solomon, Lois Uttley, Patty HasBrouck, and Yoolim Jung, "Bigger and Bigger: The Growth of Catholic Health Systems," Community Catalyst, 2020.

119 **But antiabortion sentiment within health networks:** www.acog.org /news/news-articles/2020/11/hospital-admitting-privilege-mandates -undermine-physician-practice-and-unduly-burden-womens-access -to-abortion#:~:text=Physicians%20who%20provide%20abortion %20care,stigma%2C%20and%20fear%20of%20harassment, accessed September 2023.

119 **Ohio is a good example:** www.prochoiceohio.org/resources/abortion -clinics-faq/, accessed September 2023.

119 **Admitting privileges have also been a battlefront:** U. D. Upadhyay, A. F. Cartwright, V. Goyal, E. Belusa, and S.C.M. Roberts, "Admitting Privileges and Hospital-Based Care After Presenting for Abortion: A Retrospective Case Series," Health Services Research, April 2019, 54(2):425–36.

120 **Much of Alabama meets the definition:** https://www.statista.com /statistics/1240400/maternal-mortality-rates-worldwide-by-country/, accessed September 2023; March of Dimes, www.marchofdimes.org /peristats/data?reg=99&top=23&stop=641&lev=1&slev=4&obj=18 &sreg=01, accessed September 2023; Hadley Hitson, "'We Don't See Any Improvement': Maternity Care Deserts Grow Across Alabama," *Montgomery Advertiser,* November 22, 2022.

121 **For a brief period:** "Alabama Court Blocks De Facto Ban on Birth Centers in Case Brought by Midwives and Doctors," ACLU of Alabama, September 30, 2023; *Oasis Family Birthing Center LLC on Behalf of Itself and Its Patients v. Alabama Department of Public Health*, Circuit Court of Montgomery Alabama, CV-2023-901109.00.

CHAPTER TEN: "WE HAD TO MEET THEIR
REALLY HELLACIOUS CREATIVITY."

Interviews with Quinton Zondervan, Kristen Strezo, Rebecca Hart Holder, Polly Crozier, David Cohen, Greer Donley, Rachel Rebouche and Carol Rose.

124 **In Massachusetts:** Crisis Pregnancy Center Map, www.crisispreg nancycentermap.com, accessed November 2023.

127 **Jonathan F. Mitchell:** American Bar Association Supreme Court Preview, May 4, 2022, www.americanbar.org/groups/public_education /publications/preview_home/whole-woman-health-v-jackson-us-v -texas/#:~:text=Texas's%20S.B.,from%20hearing%20challenges%20 to%20it, accessed November 2023; Michael Schmidt, "Behind the Texas Abortion Law, a Persevering Conservative Lawyer," *New York Times*, September 12, 2021.

127 **Mitchell was a known figure:** ProPublica's Trump Town database, www .projects.propublica.org/trump-town/staffers/jonathan-f-mitchell, accessed November 2023.

128 **The lawmaker who introduced SB8:** Bryan Hughes, "The Texas Abortion Law Is Unconventional Because It Had to Be," *Wall Street Journal*, September 12, 2021; Roger Severino, "Texas' Absolutely Genius Victory for Life," *National Review*, September 2, 2021.

128 **Hughes was a member:** Patrick Svitek, "The Texas GOP Lawmaker Behind the Abortion Ban, Voting Restrictions Bill and More," *Texas Tribune*, September 17, 2021; Mya Jaradat, "These Christian Lawmakers Are on the Offensive Against Abortion," *Deseret News*, July 20, 2021; Henry Larson and Francesca D'Annunzio, "A Group of Far-Right Christian Lawmakers Aim to Merge Church and State," NEWS21, *AZ Mirror*, September 11, 2023.

132 **Healey's office:** "AG Healey Warns Patients About Crisis Pregnancy Centers," press release, July 6, 2022, www.mass.gov/info-details/crisis -pregnancy-centers-cpcs, accessed November 2023.

CHAPTER ELEVEN: "WE NEED TO DIG IN
AND REALLY HOLD THE LINE."

Interviews with Daphne Blount, Pamela Merritt, Ben Wikler, Diane Horvath, and Leah Torres. Background interviews with six other medical students in Wisconsin.

139 **Blount and her friends:** Erin Gretzinger, "Did Wisconsin Supreme Court Candidate Dan Kelly Appear at an Event Headlined by a Pastor Who Has Said Killing Abortion Providers Is 'Justifiable Homicide'?" *Wisconsin Watch*, March 27, 2023.

144 **It was a time when violence:** "Violence to Abortion Providers," Feminist Majority Foundation, www.feminist.org/our-work/national-clinic -access-project/violent-attacks-on-abortion-providers-murders -attempted-murders-kidnapping/, accessed October 2023; Student Poverty Law Project, www.splcenter.org/fighting-hate/intelligence -report/2015/signers, accessed October 2023.

144 **MSFC now has more than 220 chapters:** www.msfc.org, accessed October 2023.

145 **While abortion is taught:** The Reproductive Health Access Project, www.reproductiveaccess.org/wp-content/uploads/2014/12/mva _training_using_papayas.pdf, accessed October 2023.

147 **Initial data from:** Brendan Murphy, "After Dobbs, M4s Face Stark Reality When Applying for Residency," Association of American Medical Colleges, July 31, 2023.

148 **Students, including medical students like Blount:** Dan Kaufman, "A High-Stakes Election in the Midwest's 'Democracy Desert,'" *New Yorker*, March 28, 2023.

150 **The *Milwaukee Journal Sentinel* reported:** Kelly Meyerhofer and Hunter Turpin, "Young Voters Can Help Democrats. Will Enough of Them Cast Ballots in Wisconsin Supreme Court Race?" *Milwaukee Journal Sentinel*, March 11, 2023.

151 **When the race was called:** Sam Levin, "Liberal Judge's Wisconsin
Supreme Court Race Win Shows a Shake-up in US Politics," *Guardian*,
April 5, 2023; Reid Epstein, "Liberal Wins Wisconsin Court Race,
in Victory for Abortion Rights Backers," *New York Times*, April 4,
2023.

CHAPTER TWELVE: "THE MENTAL GYMNASTICS HERE HAVE BEEN
REALLY INTERESTING TO WATCH."

Interviews with Allison Russo, Herb Asher, and Rachel Sweet.

154 **Even before the December 2022 launch:** www.ohioansforreproductive
freedom.org/, accessed November 2023.
156 **Ohio Republicans settled on:** Morgan Trau, "Ohio Republicans Intro-
duce Legislation to Make It More Difficult for Citizens to Amend
Constitution," *News5 Cleveland*, ABC, November 17, 2022.
157 **When the Ohio General Assembly returned:** Nick Evans, "Resolution
Requiring Supermajority for Amendments 'Doubtful' to Pass During
Ohio Lame Duck Session," *Ohio Capital Journal*, December 14, 2022.
157 **Stewart acknowledged:** X account of @BrianStewartOH, December 16,
2022, x.com/BrianStewartOH/status/1603753650656092163?s=20.
158 **To many of Stewart's opponents:** Morgan Trau, "Taft Among Former
Ohio Governors Who Say Ohioans Should Get to Decide on Abortion,"
Ohio Capital Journal, May 5, 2023.
159 **The Ohio Redistricting Commission:** Susan Tebben, "Republican
Majority Gerrymanders Ohio for Another Four Years," *Ohio Capital
Journal*, September 16, 2021.
159 **Critics of gerrymandering in the state:** Annie Gowen, "Ohio's GOP
Supermajority Tests Limits of Democracy Before Abortion Vote," *Wash-
ington Post*, October 6, 2023.
161 **Stewart and his backers had a major problem:** Jo Ingles, "DeWine Says
He'll Sign August Elections Bill, After Signing Earlier Law Elimi-
nating Most of Them," *Statehouse News Bureau*, April 24, 2023.
161 **Stewart and his cohort couldn't wrangle:** Joint Resolution, Ohio
General Assembly, search-prod.lis.state.oh.us/solarapi/v1/general_
assembly_135/resolutions/sjr2/EN/06/sjr2_06_EN?format=pdf,
accessed November 2023.

162 **In Mississippi:** Emily Wagster Pettus, "Mississippi Advances Initiative Process, but Not for Abortion," Associated Press, March 8, 2023.

CHAPTER THIRTEEN: "ARE THEY GOING TO PUT EVERYONE
IN JAIL?"

Interviews with Dr. Gabrielle Goodrick and with Michele, Ashleigh, and Gelsey. Background interviews with other staff at Camelback Family Planning.

172 **My visit to the clinic:** Erik Eckholm, "Legal Alliance Gains Host of Court Victories for Conservative Christian Movement," *New York Times*, May 11, 2014.

CHAPTER FOURTEEN: THE "PANDORA'S BOX" OF FETAL
PERSONHOOD

Interviews with Mary Ziegler, Rebecca Kluchin, and David Cohen.

180 **Fetal personhood has been a hard sell:** Geoffrey Skelley and Holly Fuong, "How Americans Feel About Abortion and Contraception," FiveThirtyEight, July 12, 2022.

180 **Ziegler told the *Guardian* newspaper:** Julia Carrie Wong, "Lawyer Argues Fetus of Jailed Pregnant Woman Is Being Illegally Detained," February 27, 2023.

182 **The developmental biologist Scott Gilbert noted:** "When Does Personhood Begin?" Swarthmore College, www.swarthmore.edu/news-events /when-does-personhood-begin#:~:text=Some%20scientists%20will%20 say%20it,with%20a%20two%20cell%20stage, accessed August 2023.

182 **Wilton D. Gregory:** NPC Headliners Luncheon: Archbishop of the Roman Catholic Archdiocese of Washington, D.C., Cardinal Wilton Gregory, September 8, 2021, www.press.org/events/npc-headliners -luncheon-archbishop-roman-catholic-archdiocese-washington-dc -cardinal-wilton, accessed August 2023.

184 **Pregnant people have also been kept alive:** Caleb Hellerman, Jason Morris, and Matt Smith, "Brain-dead Texas Woman Taken Off Ventilator," CNN, January 27, 2014;

184 **In California, a woman was arrested:** Nigel Duara, "Meth, a Mother, and a Stillbirth: Imprisoned Mom Wants Her 'Manslaughter' Case Reopened," Cal Matters, May 10, 2022, https://calmatters.org/justice /2022/02/stillbirth-prison-manslaughter/.

184 **An Alabama woman is serving:** Cary Aspinwall, "These States Are Using Fetal Personhood to Put Women Behind Bars," *Marshall Project*, July 25, 2023.

185 **A California mother was charged with murder:** Sam Levin, "She Was Jailed for Losing a Pregnancy. Her Nightmare Could Become More Common," *Guardian*, June 4, 2022.

186 **The advocacy group Pregnancy Justice:** Pregnancy Justice Report, September 2023, www.pregnancyjusticeus.org/rise-of-pregnancy-crim inalization-report/, accessed September 2023.

187 **When Alabama approved its abortion ban:** Michele Bratcher Goodwin, "I Was Raped by My Father. An Abortion Saved My Life," *New York Times*, November, 30, 2021.

188 **Shortly after the *Dobbs* leak:** Marjorie Dannenfelser and Chuck Donovan, "Opinion: The Road Beyond Roe for the Pro-Life Movement," *Washington Post*, May 13, 2022; Dannenfelser X post, x.com /marjoriesba/status/1533466808509947906?s=20, accessed August 2023.

188 **Republican lawmakers are already trying:** Zoe Richards, "Louisiana House Removes Murder Charge for Women from Abortion Bill," NBC News, May 12, 2022.

189 **A GOP lawmaker in South Carolina:** Ken Tran, "South Carolina GOP Lawmakers Consider Death Penalty for People Who Have Abortions," *USA Today*, March 14, 2023.

189 **Rhetoric from within the antiabortion movement:** Clip of Abby Johnston discussing prosecution of abortion patients, www.youtube.com /watch?v=aYasKCCHWio&t=1s, accessed August 2023.

190 **Two days before the *Dobbs* anniversary:** "The Fall of Roe and Its Unintended Consequences," Aspen Ideas Festival, www.aspenideas.org /sessions/the-fall-of-roe-and-its-unintended-consequences, accessed August 2023.

CHAPTER FIFTEEN: "WE HAVEN'T LET GO OF THE FIGHT."

Interviews with Robin Marty, Leah Torres, David Cohen, Greer Donley, and Rachel Rebouché.

197 **David Frum:** David Frum, *"Roe* Is the New Prohibition," *Atlantic*, June 27, 2022.
199 **Amending the Constitution:** Matt Largey, "The Bad Grade That Changed the U.S. Constitution," NPR, *All Things Considered*, May 5, 2017.
200 **On the** *Dobbs* **anniversary:** David Cohen, Greer Donley, and Rachel Rebouché, "We Need to Talk About Overturning the Dobbs Decision," *New York Times*, June 24, 2023.
202 **In the year after** *Dobbs*: Cases Archive, Center for Reproductive Rights, reproductiverights.org/cases/, accessed August 2023.
203 **The national American Civil Liberties Union:** Reproductive Freedom Court Cases, ACLU, www.aclu.org/court-cases?issue=reproductive -freedom, accessed August 2023.

AFTERWORD: SPRING 2024

205 **By January 2024:** "State Court Abortion Litigation Tracker," Brennan Center for Justice, January 11, 2024, accessed May 2024, www .brennancenter.org/our-work/research-reports/state-court-abortion -litigation-tracker.
205 **Then, in mid-February:** Supreme Court of Alabama, *LePage v. Center for Reproductive Medicine*, SC-2022-0515, February 16, 2024.
205 **The embryos at the center:** Aria Bendix, "Three Alabama Clinics Pause IVF Services After Court Rules That Embryos Are Children," NBC News, February 21, 2024; Kim Chandler, "Alabama Governor Signs Legislation Protecting IVF Providers from Legal Liability into Law," Associated Press, March 7, 2024.
206 **But the new legislation:** Emily Cochran, "Hospital at Center of Alabama Embryo Ruling Is Ending I.V.F. Services," *New York Times*, April 4, 2024; Alander Rocha, "Alabama Passed a New IVF Law. But Questions Remain," *Alabama Reflector*, March 11, 2024.

206 **Then, shortly after Alabama's:** Grace Panetta, "She Won an Alabama Swing District. Her Supporters Want More Women to Do the Same," *The 19th*, April 16, 2024; Brian Lyman and Jemma Stephenson, "Federal Court Selects New Alabama Congressional Map," *Alabama Reflector*, October 5, 2023.

207 **The mifepristone case:** *"Alliance for Hippocratic Medicine v. FDA,"* Center for Reproductive Rights, accessed May 2024; Amanda Becker, "Dark Money Is Flowing to Groups Trying to Limit Medication Abortion. Leonard Leo Is Again at the Center," *19th News*, January 4, 2024.

208 **In late April, however:** "Idaho and Moyle, et al. v. United States," American Civil Liberties Union, https://www.aclu.org/cases/idaho -and-moyle-et-al-v-united-states, accessed May 2024.

209 **If the Supreme Court found:** Amanda Seitz, "Emergency Rooms Refused to Treat Pregnant Patients, Leaving One Woman to Miscarry in a Lobby Restroom," *Los Angeles Times*, April 20, 2024; "No One Could Say: Accessing Emergency Obstetrics Information as a Prospective Prenatal Patient in Post-Roe Oklahoma," Physicians for Human Rights, April 25, 2023.

210 **In Wisconsin, abortion:** "Interactive Map: US Abortion Policies and Access After Roe," Guttmacher Institute, https://states.guttmacher.org/ policies/wisconsin/abortion-policies, accessed May 2024; Kelsey Jukam, "Wisconsin Judge Declares 1849 Law Does Not Apply to Consensual Abortions," Courthouse News Service, December 5, 2023; Megan O'Matz, "Wisconsin Picks New Legislative Maps That Would End Years of GOP Gerrymandering," ProPublica, February 16, 2024; Baylor Spears, "Wisconsin Supreme Court Declines to Hear Congressional Map Challenge," *Wisconsin Examiner*, March 1, 2024.

210 **In Kentucky, the defeat:** "Jane Doe, et al. v. Daniel Cameron, et al.," American Civil Liberties Union, www.aclu.org/cases/jane-doe-et-al -v-daniel-cameron-et-al, accessed May 2024; "Update on Kentucky Abortion Ban Class Action," American Civil Liberties Union, www .aclu.org/press-releases/update-on-kentucky-abortion-ban-class -action, accessed May 2024; Deborah Yetter, "Jewish Women Cite Kentucky's Religious Freedom Law in Contesting State Abortion Ban," *Kentucky Lantern*, May 12, 2023; Sarah Ladd, "Louisville Judge

Hears Arguments in Jewish Women's Challenge of Kentucky's Abortion Ban," *Kentucky Lantern*, May 13, 2024.

211 **In Ohio, abortion:** "Ohio Issue 1 Election Results: Establish a Constitutional Right to Abortion," *New York Times*, accessed May 2024; www .citizensnotpoliticians.org, accessed May 2024.

211 **Then, the Arizona Supreme Court:** Shefali Luthra, Grace Panetta and Jessica Kutz, "Arizona Upholds an 1864 Ban on Abortion—Making It Illegal in the State," *The 19th*, April 9, 2024; Hank Stephenson, "Where Court Packing Is Already Happening," *Politico*, October 12, 2020; Alex Tabet, "Arizona Abortion Rights Amendment Backers Say They've Gathered Signatures Needed for 2024 Ballot," NBC News, April 2, 2024; Adam Edelman, "Arizona Gov. Katie Hobbs Signs Repeal of 1864 Abortion Ban," NBC News, May 2, 2024; Rio Yamat, "An Arizona Judge Helped Revive an 1864 Abortion Law. His Lawmaker Wife Joined Democrats to Repeal It," Associated Press, May 15, 2024.

INDEX

A NOTE ON THE AUTHOR

AMANDA BECKER is a longtime national political correspondent and 2023 Nieman Fellow. She has covered Washington for *The 19th*, and has reported on the U.S. Congress, the White House, and elections for nearly two decades. Becker previously worked at Reuters and CQ Roll Call. Her work has appeared in the *New York Times*, the *Washington Post*, *USA Today*, and *Glamour* magazine. Her political coverage has also been broadcast on National Public Radio. She lives in Washington, D.C.